INSIDE AN *Osprey's* NEST

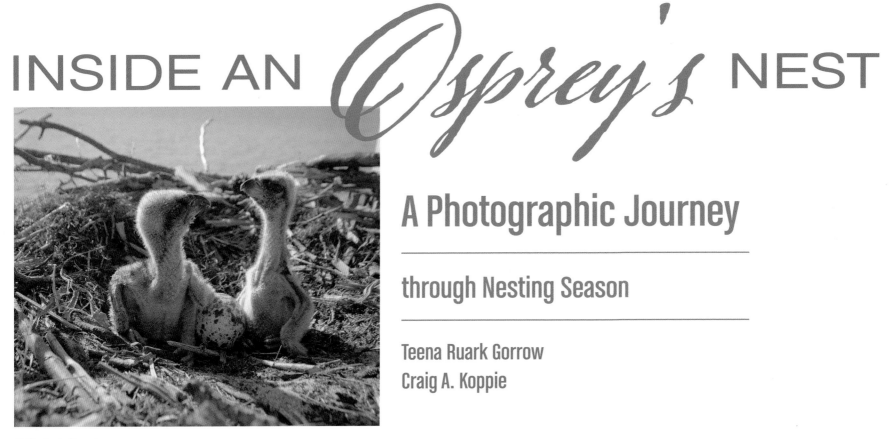

© Craig A. Koppie

A Photographic Journey

through Nesting Season

Teena Ruark Gorrow
Craig A. Koppie

Schiffer Publishing Ltd

4880 Lower Valley Road • Atglen, PA 19310

Other Schiffer Books by Teena Ruark Gorrow and Craig A. Koppie:
Inside a Bald Eagle's Nest: A Photographic Journey through the American Bald Eagle Nesting Season, ISBN 978-0-7643-4464-0

Other Schiffer Books on Related Subjects:
Birds & Marshes of the Chesapeake Bay Country, Brooke Meanley, ISBN 978-0-8703-3207-4

Birds of Cape May, New Jersey, Kevin T. Karlson, ISBN 978-0-7643-3534-1

Birdlife at Chincoteague and the Virginia Barrier Islands, Brooke Meanley, ISBN 978-0-8703-3257-9

Cover design by Ro S

Photographs © 2016 by Teena Ruark Gorrow and Craig A. Koppie. Other photographs provided courtesy of the Harrison family, Peter C. McGowan/ USFWS, Paul Kenneth Ruark, Wayne Dennis Gorrow, Ernie Beath, and Alexa Boos as noted. Front cover: Craig A. Koppie. Back cover: Nest photo by Craig A. Koppie, osprey photo by Teena Ruark Gorrow

Type set in ChaletComprime/Korinna BT

ISBN: 978-0-7643-5200-3
Printed in China

Published by Schiffer Publishing, Ltd.
4880 Lower Valley Road
Atglen, PA 19310
Phone: (610) 593-1777; Fax: (610) 593-2002
E-mail: Info@schifferbooks.com
Web: www.schifferbooks.com

For our complete selection of fine books on this and related subjects, please visit our website at www.schifferbooks.com. You may also write for a free catalog.

Schiffer Publishing's titles are available at special discounts for bulk purchases for sales promotions or premiums. Special editions, including personalized covers, corporate imprints, and excerpts, can be created in large quantities for special needs. For more information, contact the publisher.

We are always looking for people to write books on new and related subjects. If you have an idea for a book, please contact us at proposals@schifferbooks.com.

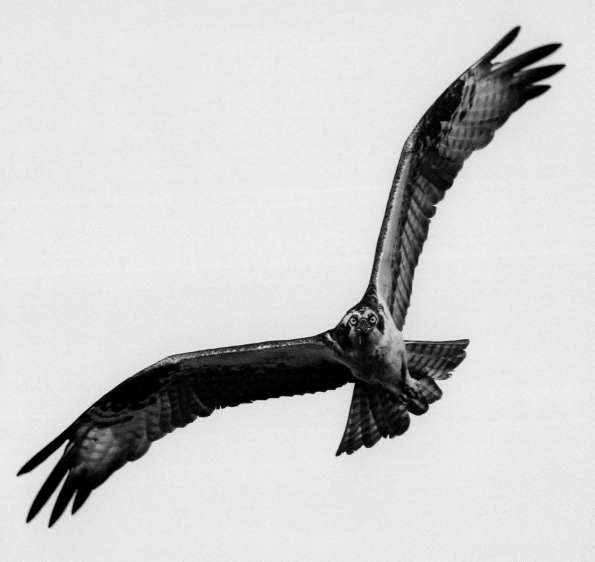

© Teena Ruark Gorrow

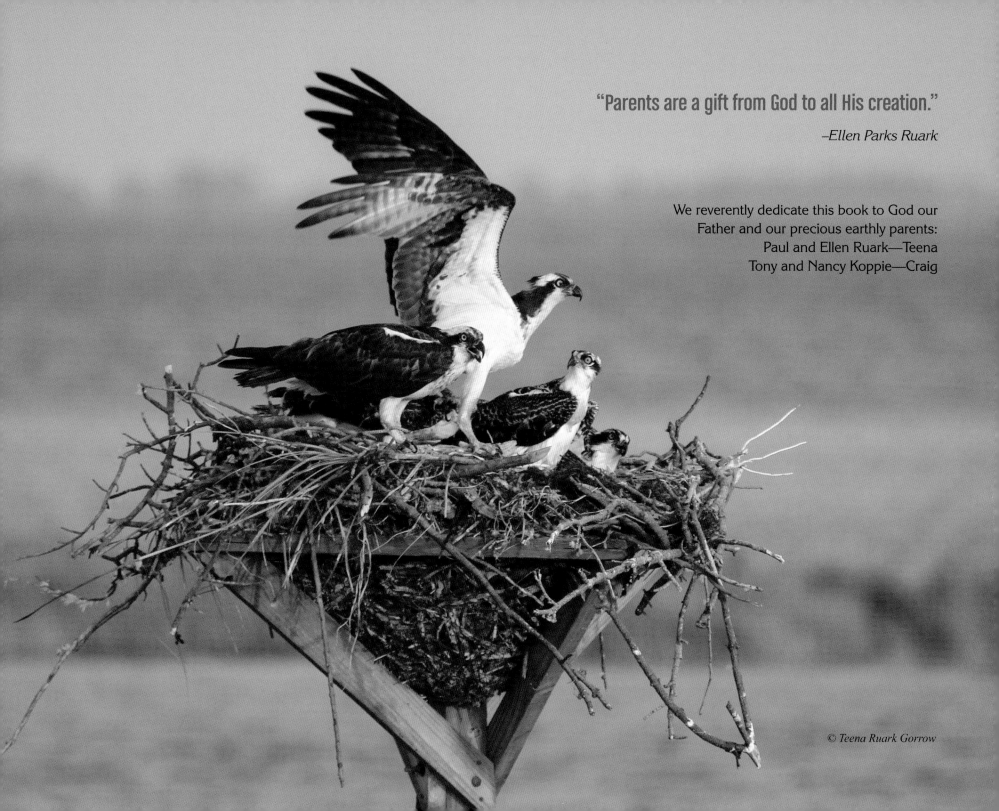

"Parents are a gift from God to all His creation."

–*Ellen Parks Ruark*

We reverently dedicate this book to God our
Father and our precious earthly parents:
Paul and Ellen Ruark—Teena
Tony and Nancy Koppie—Craig

© *Teena Ruark Gorrow*

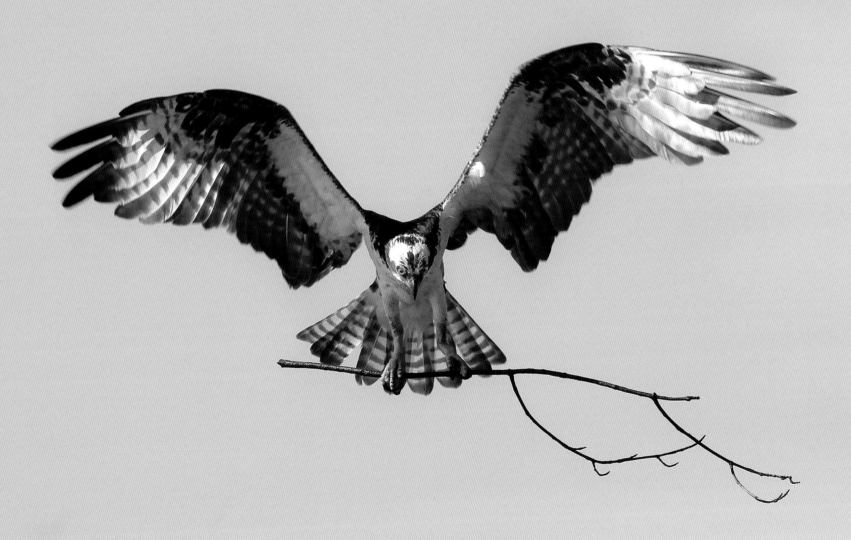

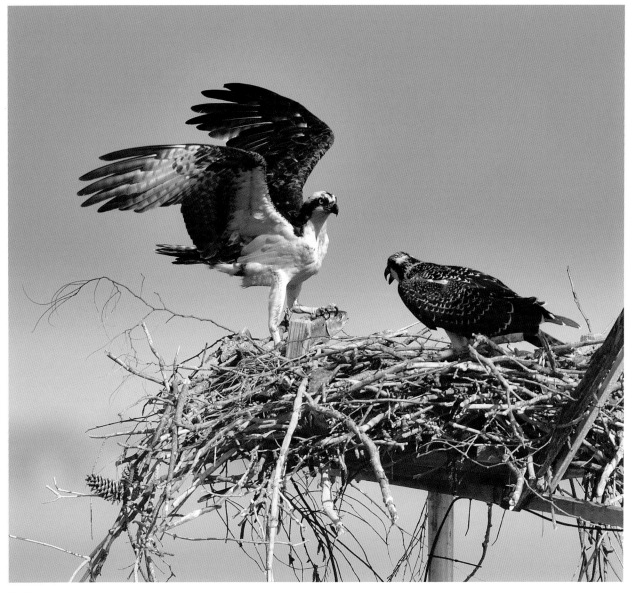

© Craig A. Koppie

Ospreys are considered an indicator species of the health of our waterways. Their populations were severely reduced throughout much of their range due to the negative impact of the pesticide DDT. In New England and other parts of this country, populations were virtually eliminated. The Chesapeake Bay population declined to less than 1,000 pairs. Following the ban on DDT in 1972, osprey populations began to recover to the point that the Chesapeake Bay alone contains several thousand nesting pairs. This population was aided greatly by concerned citizens who placed nesting platforms along our waterways. Thanks to the concerted efforts of biologists and volunteers, this spectacular species can now be observed in large numbers in many parts of the United States.

—Mitchell A. Byrd, Center for Conservation Biology and College of William & Mary, October 2, 2015

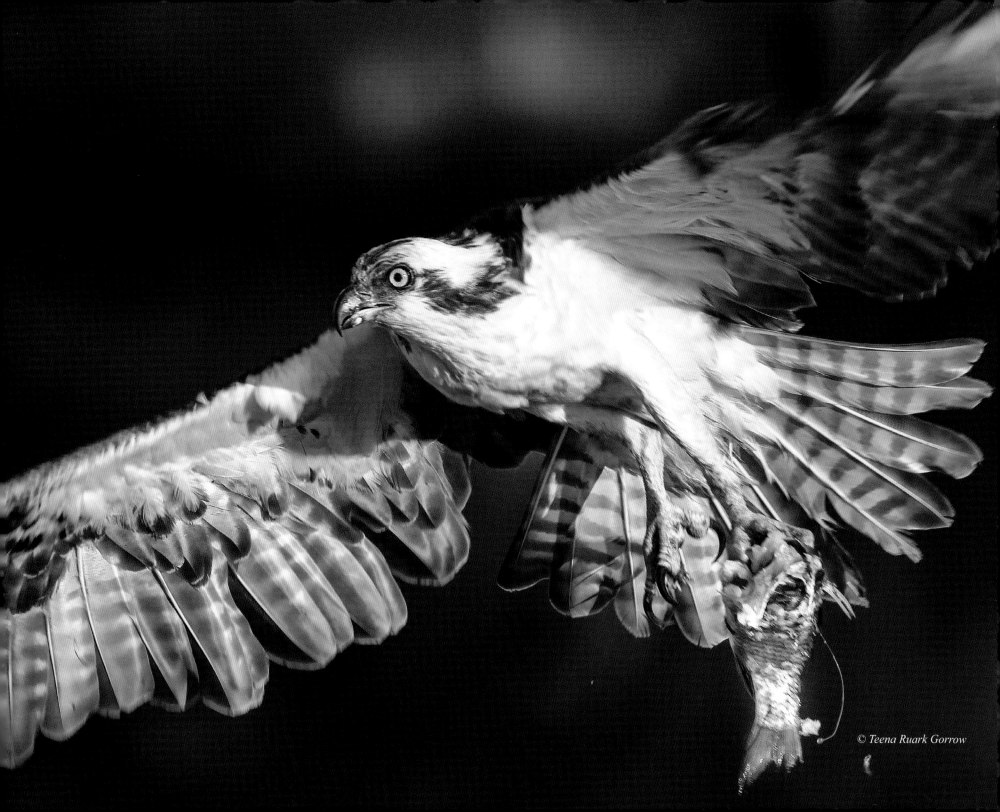

© Teena Ruark Gorrow

CONTENTS

FOREWORD

There is undeniable beauty in wild things like osprey. On the Chesapeake Bay, seeing an osprey catch a fish and feed its hungry chicks is a thrilling experience, one that can change our perspective and engender a love for the environment.

In the 1950s and 1960s, ospreys were decimated by the chemical DDT. Thanks to the dedication of conservationists, DDT was banned and these majestic creatures have made a comeback. This is one of the greatest environmental conservation success stories in history.

The distribution and abundance of ospreys reflect the health of the bay. As predators near the top of the food chain, we can gauge that the more ospreys we see nesting here, the more fish the ecosystem is able to support for their hunts.

New technology offers us the chance to bring the Chesapeake to the public like never before. For the past several years, the Harrison family graciously agreed to let us share their osprey nest with the world via a state-of-the-art osprey-camera and streaming technology. In 2015, there were more than 1 million visitors to the webcam from around the world.

Please join us in celebrating the magic of the Chesapeake with *Inside an Osprey's Nest*. You can see many of these ambassadors to the Chesapeake on your next visit to the Captain John Smith Chesapeake National Historic Trail, which stretches over 3,800 miles and traverses most of the Chesapeake Bay and its great rivers.

Special thanks to Craig Koppie, Teena Ruark Gorrow, the Shared Earth Foundation, Skyline Technology Solutions, the Harrison family and you, the readers, for sharing the ospreys' journey with us. Please visit our website to learn more about the Chesapeake Conservancy and to view the Osprey cam, www.chesapeakeconservancy.org.

—Joel Dunn, President and CEO,
Chesapeake Conservancy,
October 11, 2015

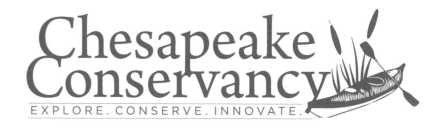

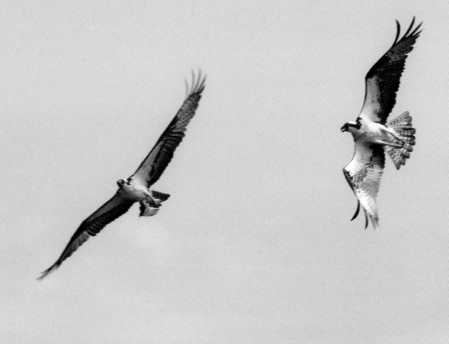

ACKNOWLEDGMENTS

© *Teena Ruark Gorrow*

We lovingly recognize our spouses, Wayne Gorrow and Pam Koppie, and extend sincere appreciation to Richard Harrison, Linda Harrison, Julia Harrison, Gregory Harrison, Investigative Options, Inc., and Dr. Paul R. Spitzer; Joel Dunn, Jody Hedeman Couser, and Chesapeake Conservancy; Shared Earth Foundation and Skyline Technology Solutions; Randy Loftus, Peter C. McGowan, Robbie Callahan, and the US Fish and Wildlife Service; Dr. Mitchell A. Byrd; Ellen Parks Ruark, Paul Kenneth Ruark, Ernie Beath, Alexa Boos, and Kool Ice; and Pete Schiffer and the team at Schiffer Publishing.

INTRODUCTION

Without a doubt, ospreys are among wildlife's most magnificent creatures. Capable navigators flying thousands of miles during migration and skilled anglers with the ability to plunge beneath the water's surface to snatch a fish, these remarkable raptors have won the hearts of bird watchers and nature lovers worldwide.

While ospreys are now observed in abundance, that was not always the case. Like the American bald eagle, ospreys experienced devastating health effects and reproductive failures from widespread human use of dangerous pesticides like DDT. By the 1970s, their numbers had plummeted to catastrophic levels. Federal actions were put into place that imposed migratory bird protection and banned DDT. These measures, along with the work of dedicated scientists, conservationists, and citizens, have helped ospreys recover. Even so, the ospreys' plight continues today as they face ongoing threats, many of which are directly related to human activity. For example, severe or fatal injuries result when ospreys become entangled in discarded fishing line, balloon ribbon, and kite string.

Newly mated ospreys, Tom and Audrey, are the focus of this true story and have a problem of their own. They build a nest and mate on an over-water platform in the Chesapeake Bay watershed, but their eggs do not hatch. Through an unlikely series of events involving two other breeding osprey pairs and their ill-fated nests, US Fish and Wildlife Service biologists swap two of Tom and Audrey's unviable eggs with two osprey hatchlings. The willing foster parents successfully raise the chicks as their own and also care for an interloper in need of help.

While observing nesting season with Tom and Audrey, we felt inspired by the pair's perseverance, dedication, and commitment to raising a family.

Considering their many selfless acts, we reflected on the meaning of parenthood in general and what it has meant to experience firsthand the blessing of wonderful parents in our own lives.

Photographs include those captured during US Fish and Wildlife Service foster events, through webcam video streaming made possible by the Harrison family and the Chesapeake Conservancy, and during nest observations at the Harrisons' home with telephoto lenses from a blind or nearby dock. Photographs of other ospreys living along the Chesapeake are also included. General information about threats to ospreys and the Poplar Island Foster Program can be found in appendices A and D as offered by Peter C. McGowan, environmental contaminants biologist with the US Fish and Wildlife Service, Chesapeake Bay Field Office. The history of the Harrison family's osprey nest platform and information about the Chesapeake Conservancy can be found in appendices B and C, respectively. A glossary of terms is in appendix E, while appendix F presents other resources including tips on what to do if you find an injured or orphaned bird.

We hope you will feel inspired by Tom and Audrey and enjoy their uplifting story. Please encourage the protection of ospreys' habitat by recycling trash, fishing line, and tackle.

—Teena Ruark Gorrow and Craig A. Koppie

An osprey family nest rests on a navigational buoy near a busy dock in the Chesapeake Bay watershed. © *Teena Ruark Gorrow*

INSIDE AN OSPREY'S NEST

The Chesapeake Bay, with its stunning views and abundant aquatic resources, is the largest estuary in the United States. Approximately 200 miles long and comprised of 11,684 miles of shoreline, the bay watershed includes portions of Maryland, Delaware, Virginia, Pennsylvania, New York, and West Virginia, as well as the District of Columbia. Millions of people live, work, and play in the bay area. In addition, the Chesapeake provides important habitat to thousands of animal, plant, and fish species.

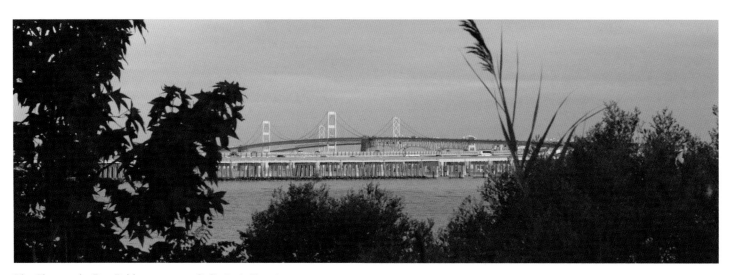

The Chesapeake Bay Bridge at sunset. © *Craig A. Koppie*

Sunset. © *Teena Ruark Gorrow*

Sailing on the Chesapeake.
© Craig A. Koppie

The sun sets over the Chesapeake Bay.
© Teena Ruark Gorrow

The historic Hooper Strait Lighthouse is on display at the Chesapeake Bay Maritime Museum in St. Michaels, Maryland. © Teena Ruark Gorrow

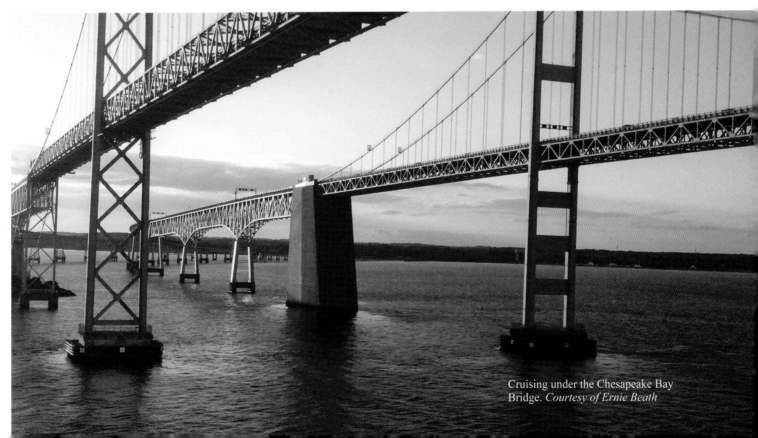

Cruising under the Chesapeake Bay Bridge. Courtesy of Ernie Beath

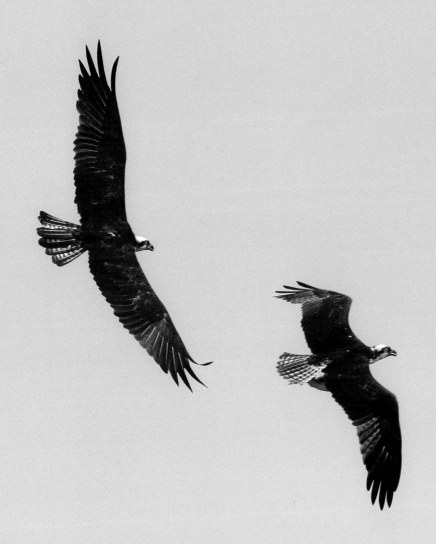

Mated ospreys glide across the sky.
© *Teena Ruark Gorrow*

The osprey, *Pandion haliaetus*, is one of the creatures most frequently observed on the Chesapeake Bay. This large hawk is found on every continent across the globe except Antarctica. Commonly known as a fish hawk, it migrates thousands of miles from wintering grounds to summer nesting locations when it is time to breed.

The Chesapeake Bay is renowned for annually hosting one of the world's largest breeding osprey populations. Each spring, thousands of nesting ospreys return to the bay watershed to reunite with their mates, build nests, and raise young.

Soaring over shorelines, plunging into waterways for fish, and perching on marine platforms, these raptors are readily visible along the Chesapeake from March through August. Experienced pairs tend to arrive at their nest sites earlier than those with less breeding know-how and are often seen by late February.

An adult osprey observes nearby activity.
© *Teena Ruark Gorrow*

When selecting a nest site, ospreys identify a shallow body of water with a plentiful food supply and nearby trees. To help safeguard against climbing predators, they often construct over-water nests on the steel supports of bridges, channel markers, navigational buoys, fishing piers, jetties, and manmade nesting platforms. Because ospreys are relatively tolerant of humans, they also build nests on private pavilions or docks beside waterfront properties. Assembled with sticks, bark, grasses, vines, and sod, osprey nests are conspicuous and often include debris.

Views of over-water osprey nests along the Chesapeake Bay.
Photos © Teena Ruark Gorrow

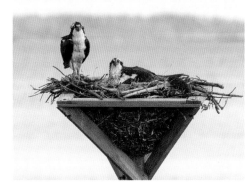

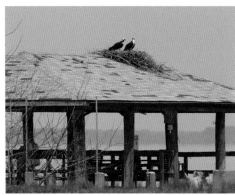

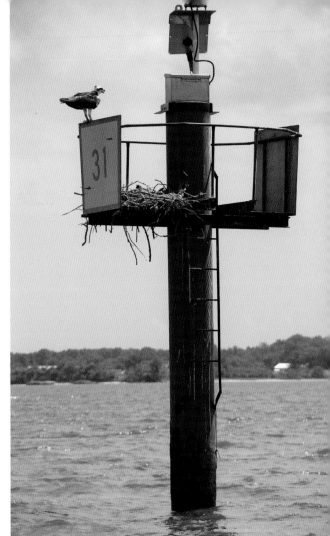

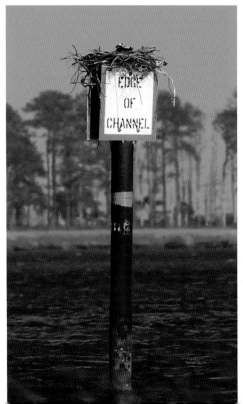

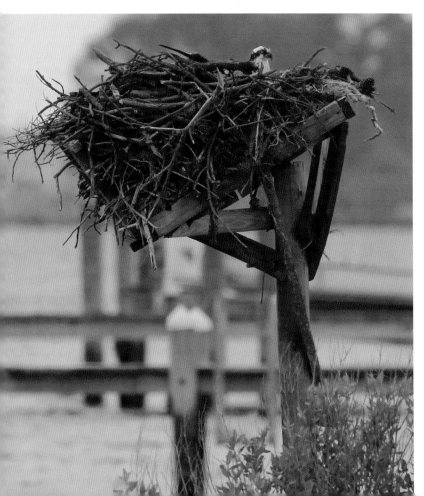

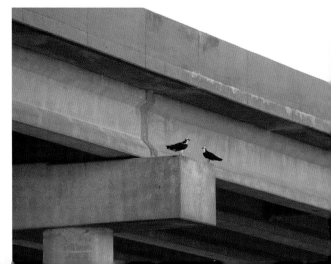

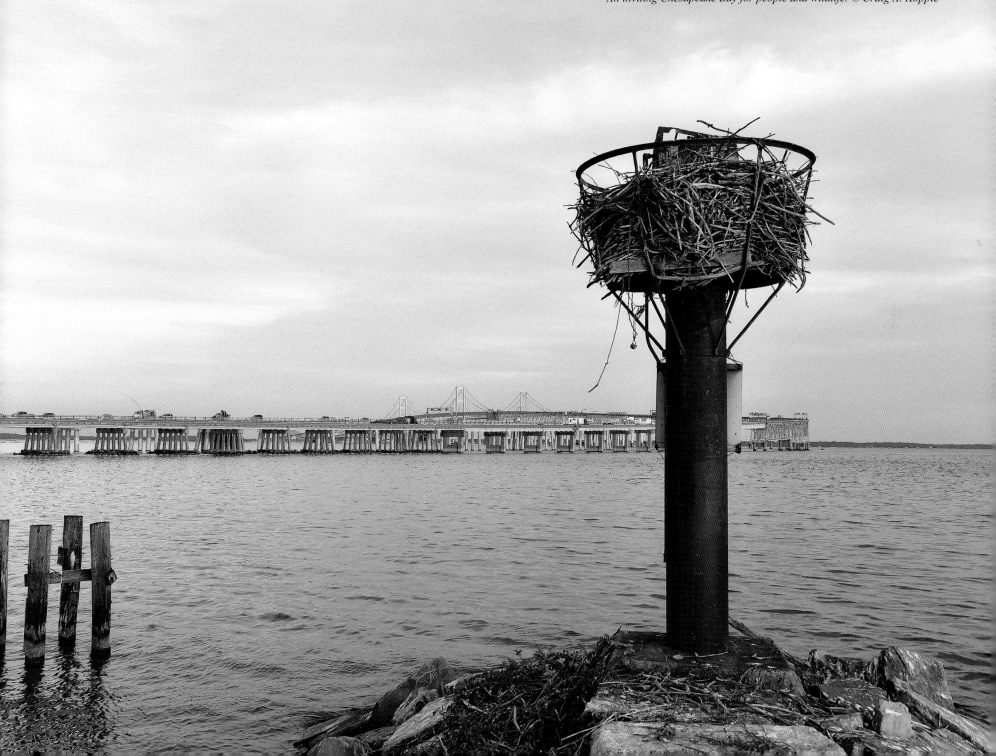

An inviting Chesapeake Bay for people and wildlife. © Craig A. Koppie

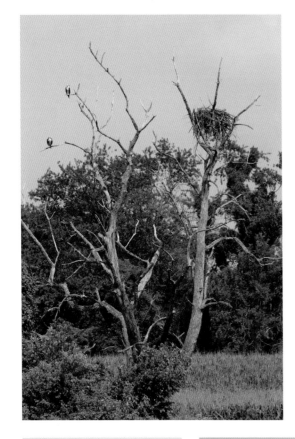

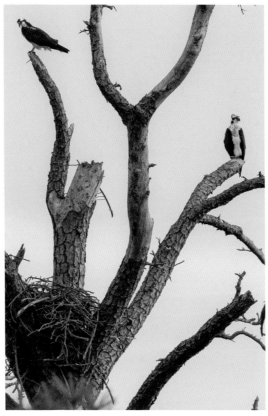

When constructing on-land nests, ospreys sometimes choose snags with an open treetop or crotch between the trunk and branches. They are also notorious for claiming tall, artificial structures resembling dead trees, such as towers, utility poles, television antennas, road signs, and stadium lights. Likewise, chimneys and rooftops on uninhabited buildings are places these raptors elect to call home.

Views of on-land osprey nests along the Chesapeake Bay.
Photos © Teena Ruark Gorrow

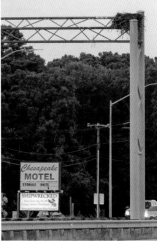

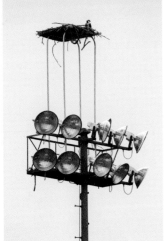

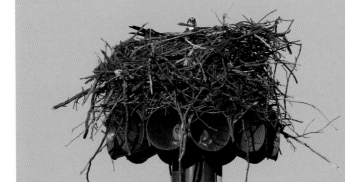

Courtesy of Paul Kenneth Ruark

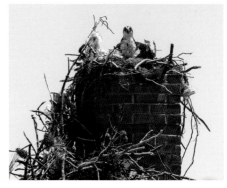

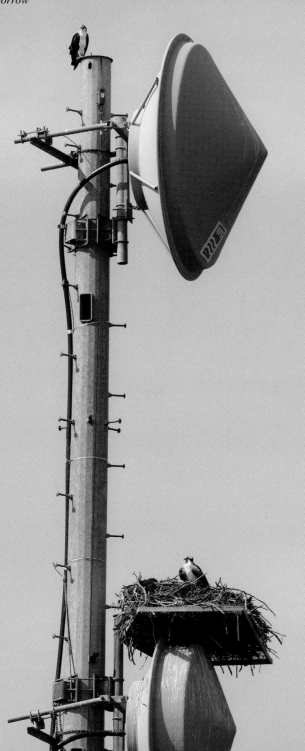

© Teena Ruark Gorrow

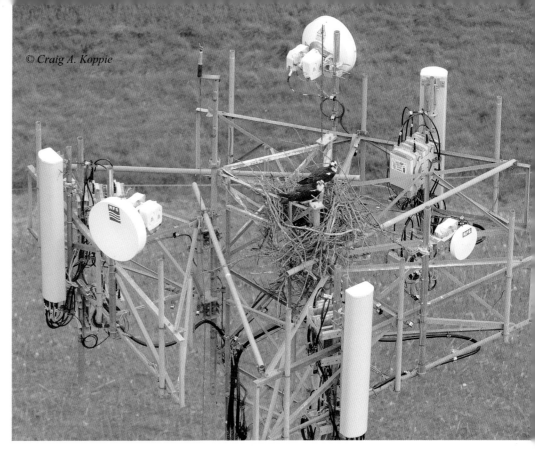

© Craig A. Koppie

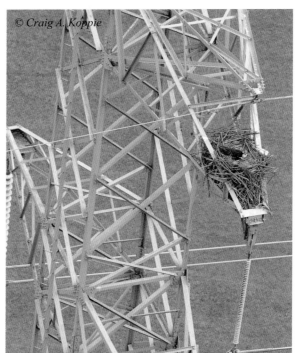

© Craig A. Koppie

© Teena Ruark Gorrow

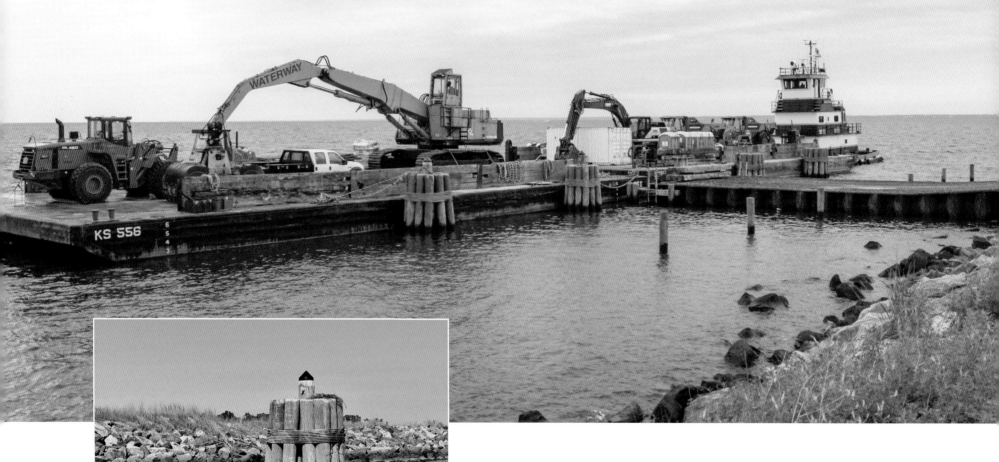

Barge activity at a mooring dock on Poplar Island in the Chesapeake Bay. *Courtesy of Alexa Boos*

WATERWAY

KS 556

Osprey nest on a dolphin, or piling structure. © *Craig A. Koppie*

From time to time, ospreys build nests on manmade structures erected for construction purposes. Human activity and the use of heavy equipment at these locations can create substantial disturbance to nesting birds and endanger their offspring.

This was the case when a newly mated osprey pair claimed a low-level piling on Poplar Island in the Chesapeake Bay. The structure was established to secure barges during the island's restoration project. However, the first-time nesters viewed it as a great place to live.

Each week during osprey nesting season, US Fish and Wildlife Service (USFWS) biologists from the Chesapeake Bay Field Office monitor Poplar Island osprey nests and collect data on eggs and young. In accordance with USFWS guidelines, the biologists concluded that the barge activity at the piling structure would disturb the ospreys' nesting season and removed the nest.

Nevertheless, when the team left the island, the resolute osprey couple returned to the structure and hastily rebuilt a smaller nest. The female osprey laid two eggs.

When the biologists returned to the project site and discovered that the osprey pair had reclaimed the piling, they identified another active nest nearby where the two eggs could be relocated. The ospreys at this foster nest were incubating two eggs of their own and readily accepted the additional two eggs.

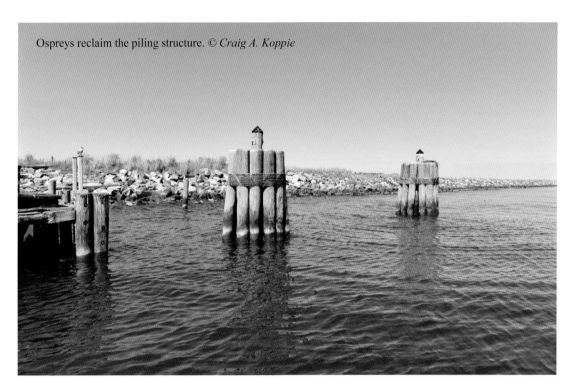

Ospreys reclaim the piling structure. © *Craig A. Koppie*

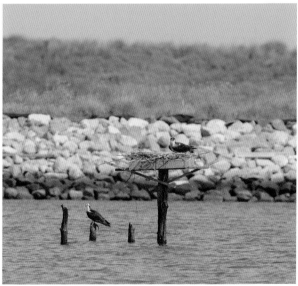

The mated ospreys observe as biologists approach their nest. © *Craig A. Koppie*

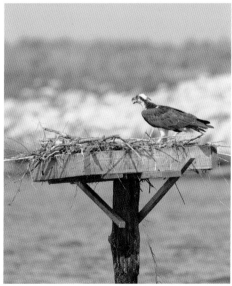

The female stands watch. © *Craig A. Koppie*

Meanwhile, in another area along the Eastern Shore of the Chesapeake Bay, two magnificent ospreys fly high in the early morning sky, gliding like mirror images. He flies in front and courts her by presenting the fish he grips in his talons. After performing an array of impressive aerial maneuvers, they separate and fly in circles as she chases him.

They are a newly mated pair. Her former mate did not return for nesting season. They have rebuilt the over-water platform nest she used last season and the couple is ready to create their first family together.

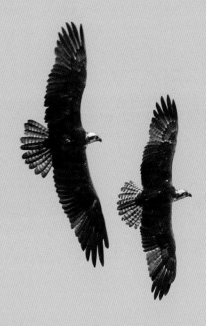

Mating begins with aerial maneuvers. *Photos © Teena Ruark Gorrow*







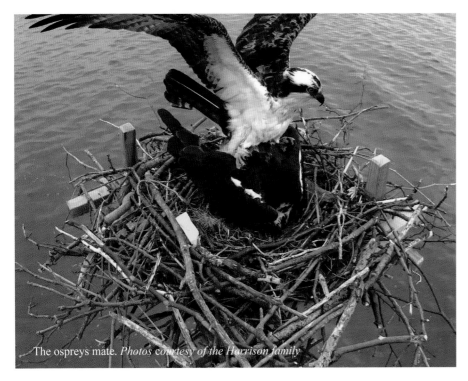

The ospreys mate. *Photos courtesy of the Harrison family*

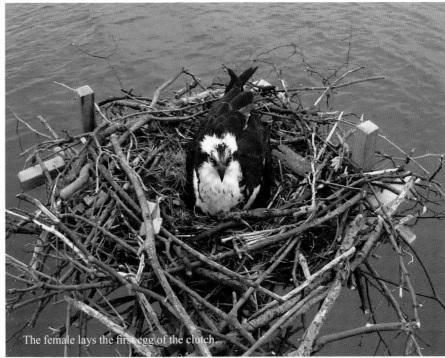

The female lays the first egg of the clutch.

They mate at the nest. Soon, the female lays her first egg in the egg cup. The oval egg is beige with shades of cinnamon, brown, and reddish-brown splotches. It appears slightly larger than a chicken egg. The female gently nudges the egg toward the center of the soft grasses that the pair collected to line the nest.

Both male and female incubate the egg to keep it warm, dry, and protected from aerial predators. To incubate, the adult carefully lowers its body down over the egg and gently rocks back and forth to settle into an incubating position. As the male and female prepare to switch places, they seemingly pause to admire the first egg produced together.

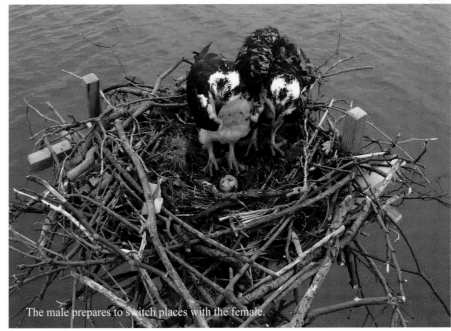

The male prepares to switch places with the female.

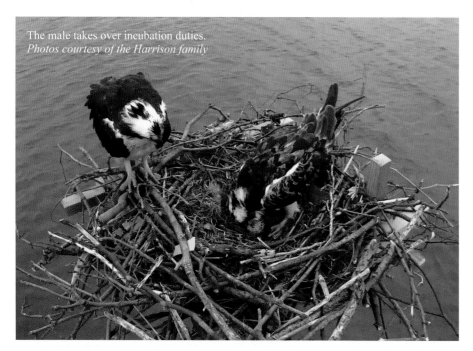

The male takes over incubation duties.
Photos courtesy of the Harrison family

The female stretches her legs, shakes her wings, fluffs her feathers, and perches on the side of the nest. The male, ready to assume the role of incubator, leans over the egg to conduct a physical assessment of the egg and nest lining. Using his beak, he slightly alters the egg's position in the egg cup, adjusts the location of a clump of grass, and tosses a branch off to the side of the nest. Apparently satisfied, he rests his body over the egg and rocks into incubating position. He reaches with his beak for a few twigs and sprigs of nest lining to tuck around his body like a blanket.

Once settled, the male visually monitors the environment by looking over the water in all directions. Still perched on the nest's edge, the female softly chirps as though sharing important information. He responds in kind.

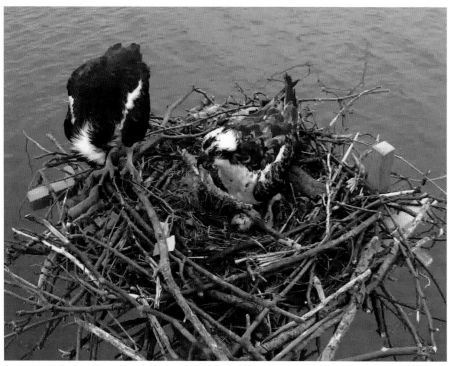

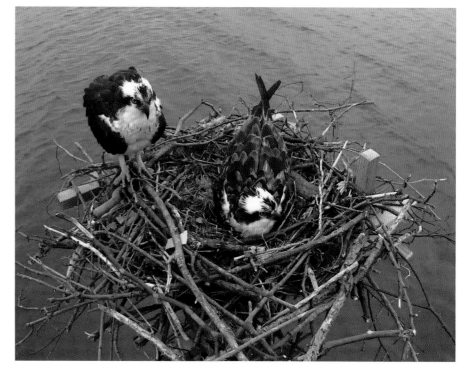

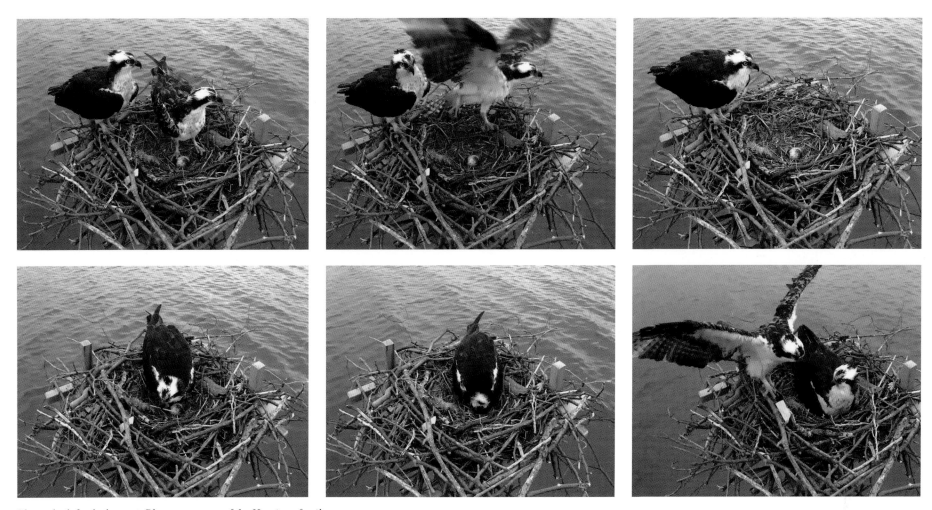

The male defends the nest. *Photos courtesy of the Harrison family*

Suddenly, the male stands. It is evident that both ospreys are concerned about something they are observing near their nest. Potential culprits could be another osprey or an American bald eagle close enough to pose a threat. Whatever the source of the intrusion, the male flies from the nest in the direction of the concern. The female stays behind, watching intently. Experienced female breeders assist the male in battle only if necessary, because leaving the nest unattended can jeopardize the egg.

Fortunately, the male must have control of the situation because the female quickly turns her attention to the egg. She carefully steps from the nest wall, positions her upper body over the egg, and adjusts a few twigs. With great precision, she slightly rolls the fragile egg toward her body with her beak and talons. This intentional egg-turning prevents the unborn chick from sticking to the inside of its shell and helps maintain an even temperature inside the egg. Because her beak and talons are sharp, the female takes great care not to puncture or otherwise harm the egg. Once settled over the egg, she seems especially guarded until her mate returns.

The ospreys are having an eventful first day as parents-to-be. Even so, they find time for home improvement. The male fetches sticks and grasses, which they arrange in the open spaces to further develop the nest.

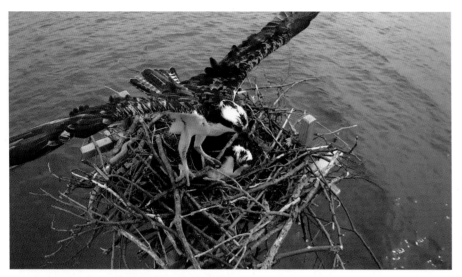
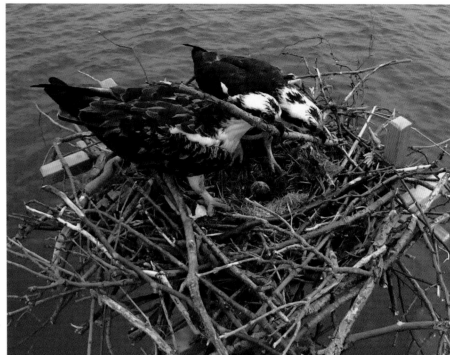
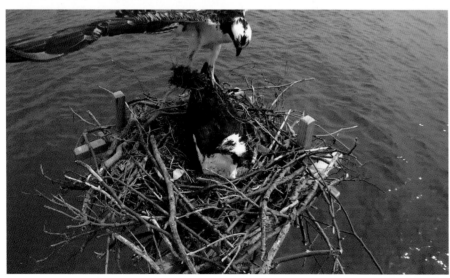
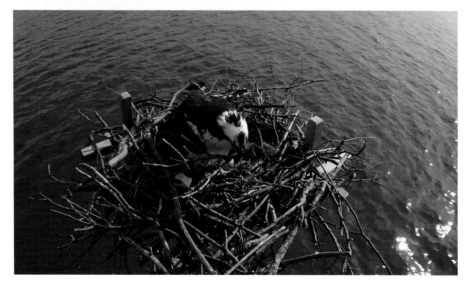

Photos courtesy of the Harrison family

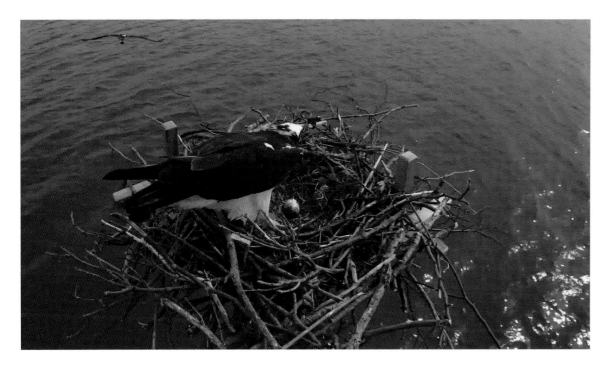

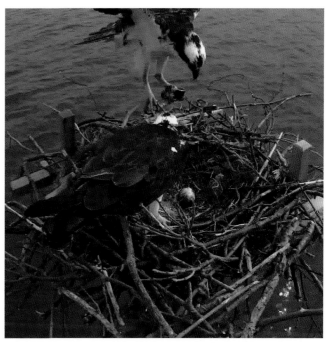

In addition to nest defense and repair, it is the male's responsibility to provide food for the female during incubation. The female communicates her desire to eat by uttering food-begging calls to her mate while he is away from the nest. A skilled angler, he plunges into the water and snatches a fish on his first attempt. The female watches as he flies to a nearby tree with the fish in tow. He makes quick work of removing the head and delivers it to the nest. She readily accepts his offering, takes a few big bites, and flies to a favorite perch to enjoy her meal. While she is away on break, the male resumes incubation.

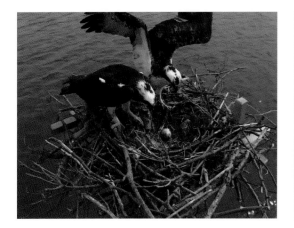

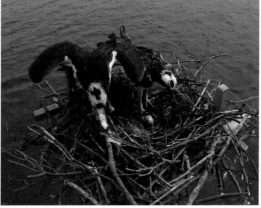

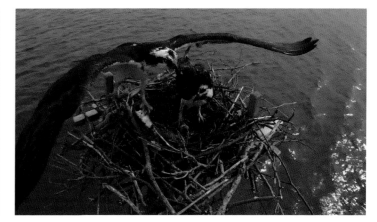

Photos courtesy of the Harrison family

They continue mating. On April 15, three days after the first egg is laid, the female lays a second egg. A third egg is laid six days later. The couple's clutch for this season is three eggs.

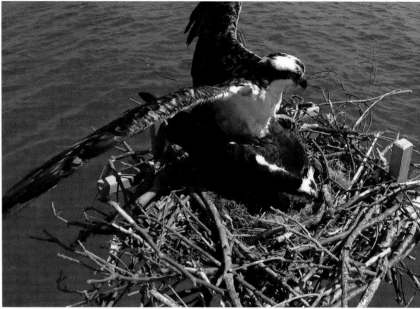

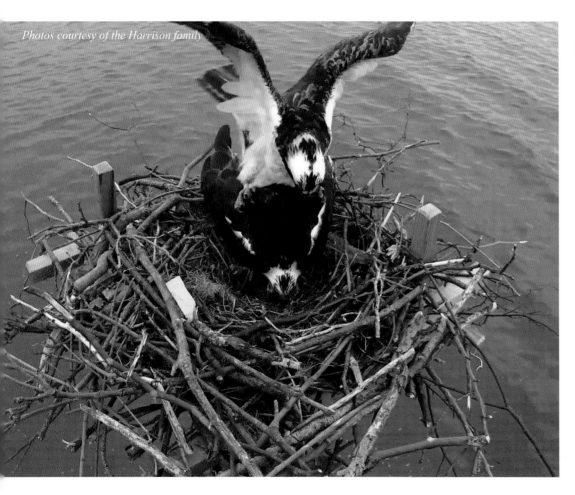

Photos courtesy of the Harrison family

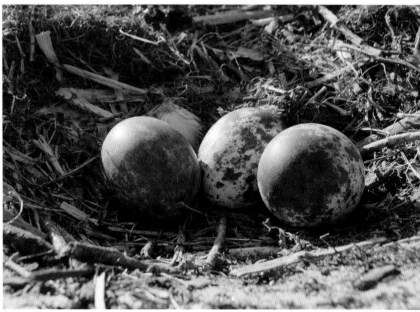

The clutch is set at three eggs. © *Craig A. Koppie*

Ospreys in the Chesapeake lay an average of three eggs, but clutch size varies between one to four eggs. Egg-laying and incubation usually take place from mid-April through late May, and ospreys generally incubate their eggs between five to six weeks. Hatching occurs as early as thirty-five days after the first egg is laid.

But, not all osprey nesting seasons are successful. Inclement weather events producing heavy wind and rain or ice; the age, maturity, and nesting experience of the mated ospreys; and human or predator disturbance causing the ospreys to flush from the nest site are all factors that can reduce the likelihood of successful hatching.

The osprey perches on a streetlight.
© *Teena Ruark Gorrow*

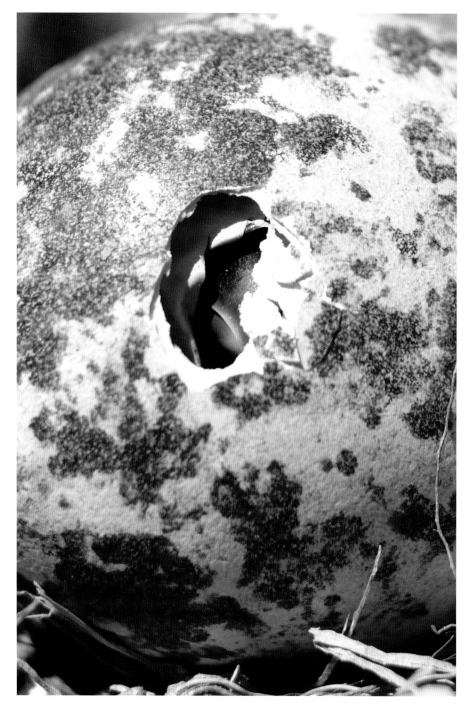

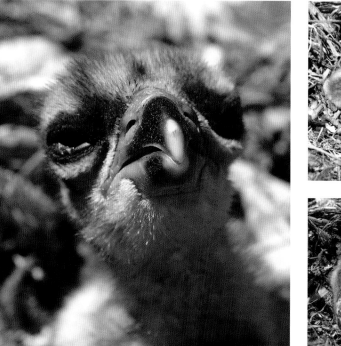

The osprey chick observes as its sibling initiates pipping.
Photos © Craig A. Koppie

When a clutch is comprised of more than one egg, hatching is usually staggered over a few days in the order the eggs were laid. To hatch, the chick shifts position inside the egg and pecks the shell using the egg tooth on the end of its beak. This tenacious pipping eventually chips a small hole in the shell. With continued tapping, the chick ultimately fractures the shell and breaks free. The tiny hatchling emerges, virtually helpless.

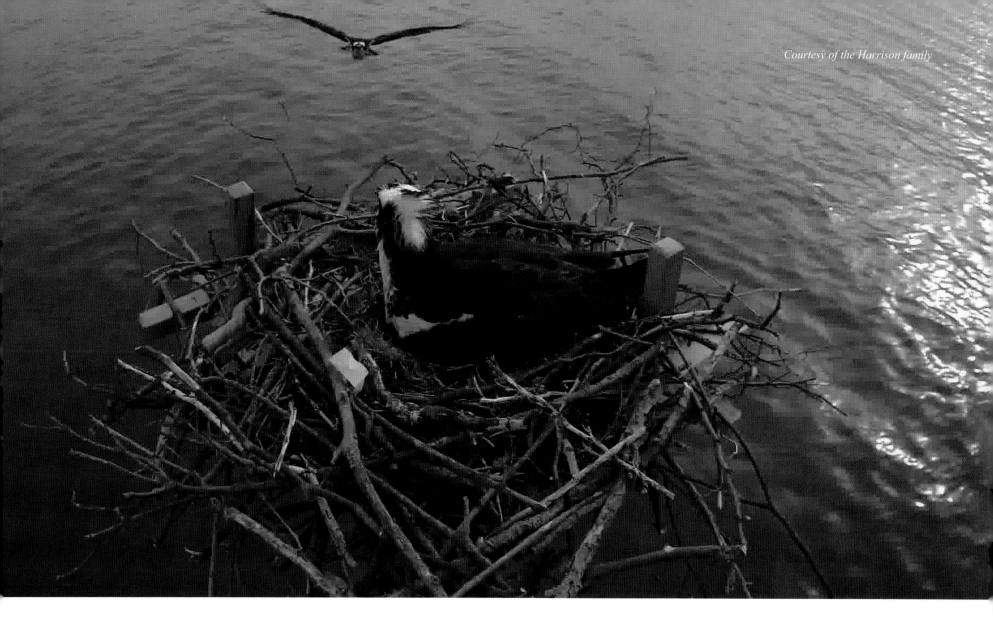

Day and night, the osprey mates perform their roles at the nest with dedication and skill. Now mid-June, there are still no hatchlings for this charming couple and no signs of pipping. Yet the ospreys have not lost hope. The persistent pair remains committed to each other, to incubating their eggs, and to maintaining their nest. They continue their efforts and they wait expectantly.

The ospreys are unaware of their fame, but this pair is known around the world as "the Chesapeake's favorite osprey couple" by their adoring fans. Their daily activities are being viewed by a million people visiting the Chesapeake Conservancy's osprey webcam pointed directly at the nest. A state-of-the-art camera, along with a rather sophisticated technology setup featuring video streaming, delivers live images and sound twenty-four hours a day.

This virtual connection to the osprey couple is provided courtesy of the Harrison family, private property owners along the Eastern Shore of the Chesapeake Bay. Each year, Mr. Harrison erects an over-water nest platform, with an attached arm for the camera, near the family's dock. Years ago, when he first mentioned installing a camera on the platform, Mrs. Harrison playfully nicknamed her husband the Crazy Osprey Man. However, she quickly became his helper and because of their continued effort, many people enjoy watching this nest each season.

Known as the Crazy Osprey Family, the Harrisons monitor the ospreys' daily activities in and around the nest. They inform the Chesapeake Conservancy, local raptor biologists, and the worldwide webcam audience about nest happenings. Through their *Crazy Osprey Family Blog*, Mrs. Harrison posts photographs, fun facts, and news about the ospreys. She also answers questions about the birds and the nest.

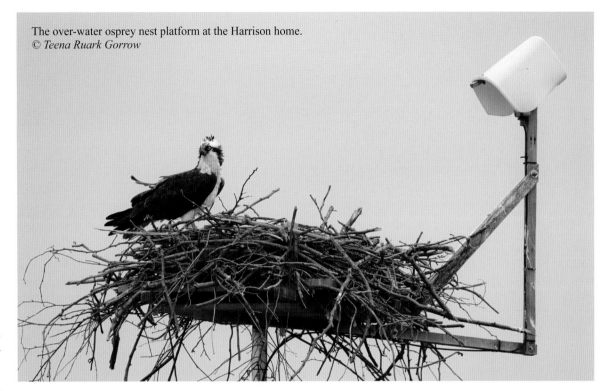

The over-water osprey nest platform at the Harrison home.
© *Teena Ruark Gorrow*

© *Craig A. Koppie*

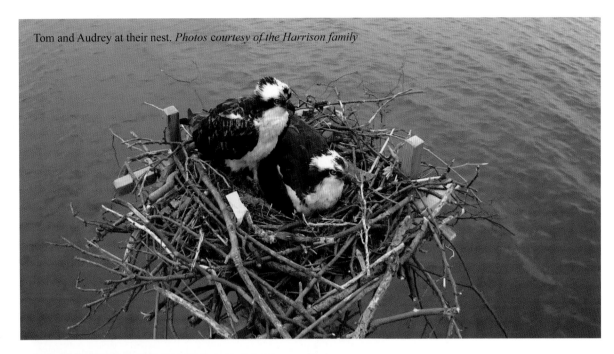

Tom and Audrey at their nest. *Photos courtesy of the Harrison family*

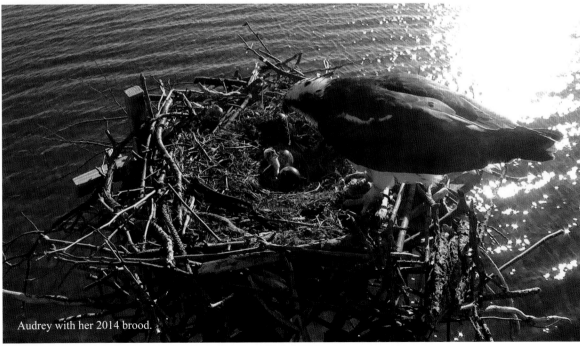

Audrey with her 2014 brood.

Years ago, the Harrisons affectionately named the nesting ospreys at their platform after dear family friends, Audrey and Tom. While Audrey returned to the platform again this season, sadly, Tom did not. Audrey soon found a new mate who received the name Calico Tom because of his uniquely mottled feathers.

As Audrey and Tom continued to incubate their eggs well past the gestation time line, the osprey pair's desire to parent a brood of chicks has been evident to viewers around the globe. Witnessing the nesters' perseverance, webcam viewers share in the disappointment now that the possibility of babies at this nest is lost.

The Harrisons discuss the ospreys' situation with Dr. Paul Spitzer, an ornithologist with more than thirty years of experience. Because ospreys possess exceptional parenting instincts and Audrey has successfully raised several broods of chicks, Dr. Spitzer suggests that this osprey couple would be excellent foster parents. The Harrisons pass the idea of a fostering event to the Chesapeake Conservancy. This leads to a consultation with the USFWS Chesapeake Bay Field Office raptor biologist, Craig Koppie. Conducting observations at the nest site and by webcam, Mr. Koppie concurs that this is an excellent fostering situation. He places Audrey and Tom on a waiting list should osprey eggs or chicks require relocation from an ill-fated nest.

USFWS biologists regularly monitor nests and, if warranted, relocate eggs from unsuccessful nests and rescue raptors trapped in perilous predicaments. They also relocate rehabilitated young from rescue centers to hand-picked foster nests whenever possible. They find that raptors are remarkably willing to adopt and care for young when added to their natural broods.

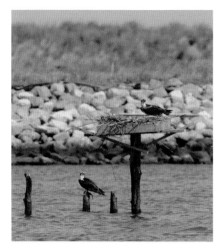

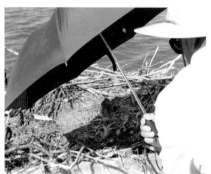

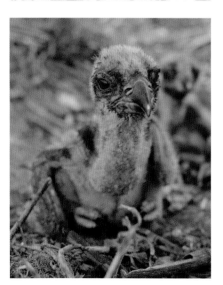

Meanwhile, USFWS biologists return to the Poplar Island osprey nest where two at-risk eggs were relocated from the construction site piling. Peter McGowan and Robbie Callahan see that the foster eggs and the pair's natural eggs have successfully hatched. The four nestlings are less than two weeks old, and their ages vary by four to six days. The biologists are immediately concerned about potential stress and survival at this nest. Chicks that hatch first are usually larger and more dominant than their younger siblings. When fish are scarce, the younger birds sometimes go without food. It takes a substantial amount of food to feed a family with four growing chicks. The smaller nestlings might perish if they don't get enough food.

Anticipating problems at this nest without human intervention, the biologists decide to relocate two of the chicks to a foster nest. Tom and Audrey, whose eggs are no longer viable, are at the top of the waiting list.

Biologists check on hatchlings at Poplar Island. *Photos © Craig A. Koppie*

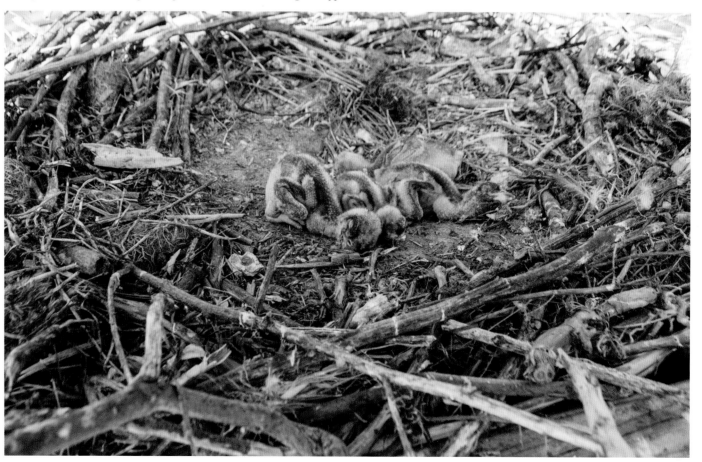

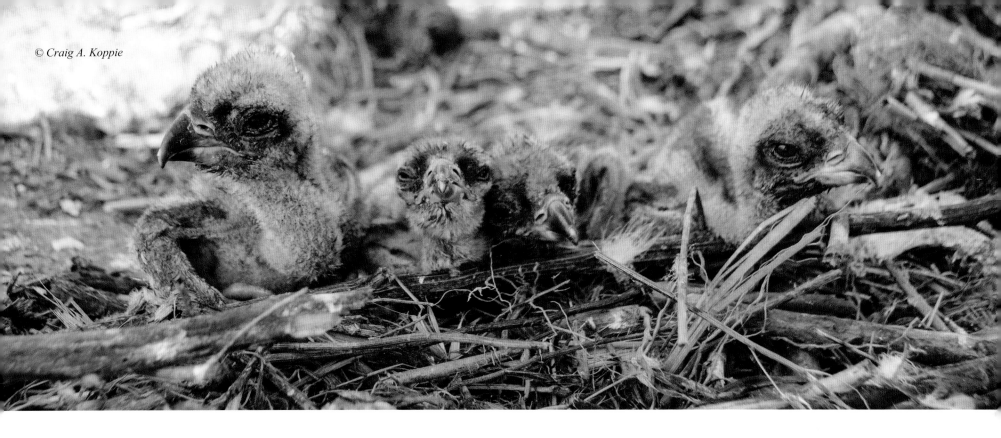

© Craig A. Koppie

Craig Koppie joins the team of biologists at Poplar Island to conduct the foster event. He selects the two most advanced nestlings with overall better body condition. These chicks' greater development will help ensure their survival during the transfer and initial period of acceptance once relocated to the foster nest with Audrey and Tom.

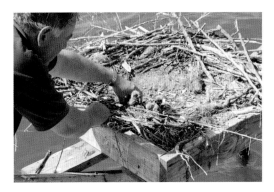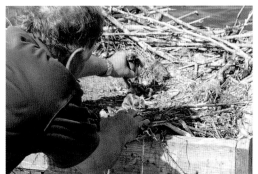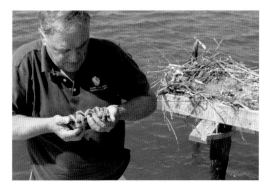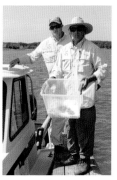

Photos courtesy of Peter C. McGowan/USFWS

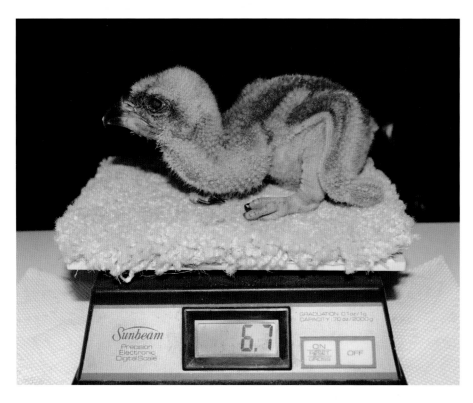

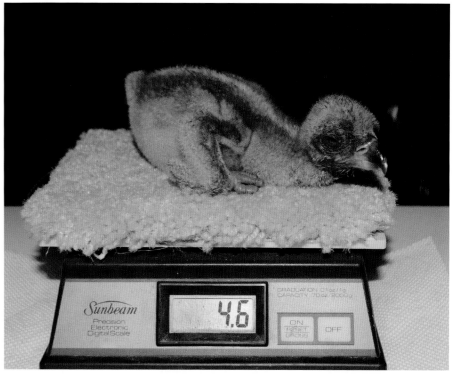

The larger of the two chicks weighs 6.7 ounces, while the smaller weighs 4.6 ounces. The remaining two siblings seem unconcerned about the activity at their nest and take a nap.

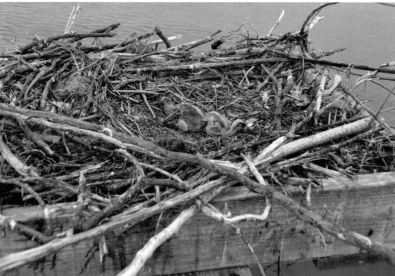

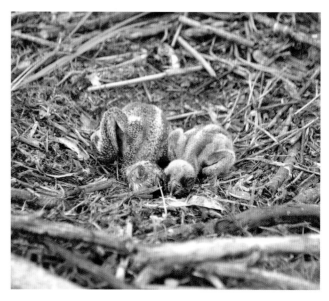

Photos © Craig A. Koppie

The osprey chicks are alert and doing well as they complete the journey to their new home. Soon, Mr. Koppie will deliver the tiny raptors to Audrey and Tom, who are still taking turns incubating their natural eggs at the nest. To prepare for the fostering event, Mr. Harrison has placed a ladder under the nest platform.

Meanwhile, Audrey patiently incubates her eggs. Tom has gone fishing.

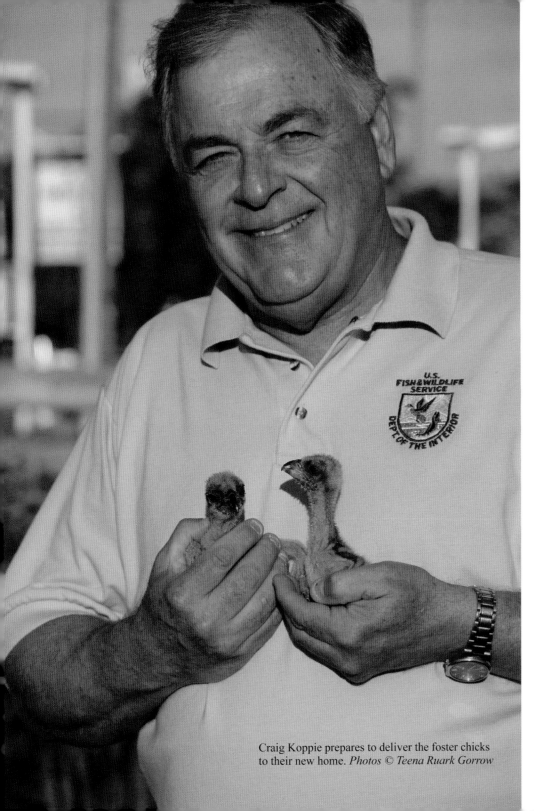

Craig Koppie prepares to deliver the foster chicks to their new home. *Photos © Teena Ruark Gorrow*

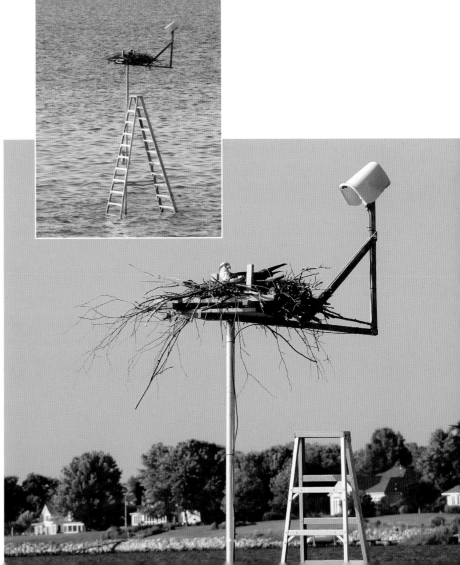

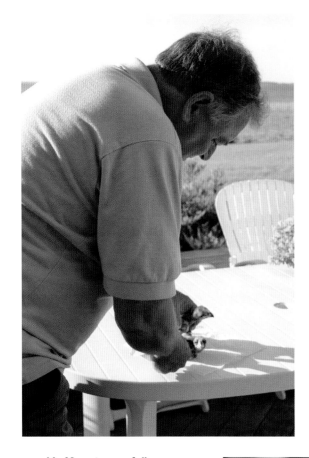

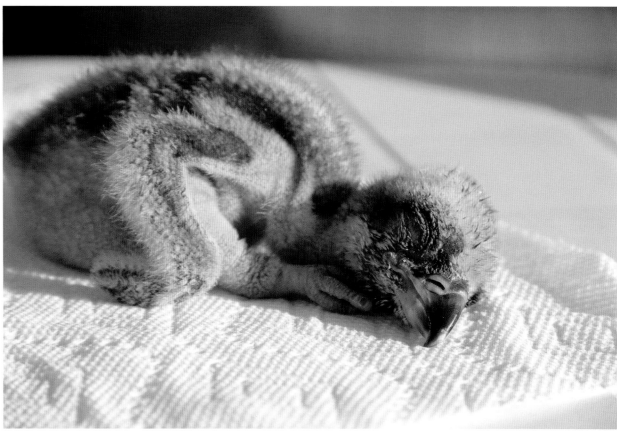

Mr. Koppie carefully removes the babies from the carrier. They doze while he finalizes plans with the Harrisons and chats with a national news reporter covering the story. Everyone with a camera captures the peaceful image of the sleeping babies.

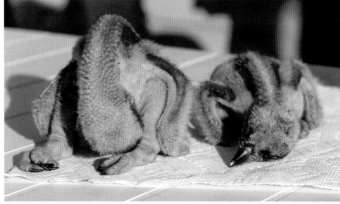

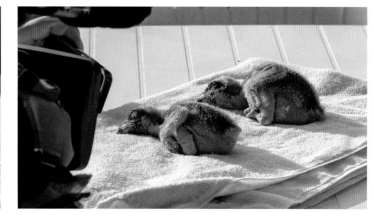

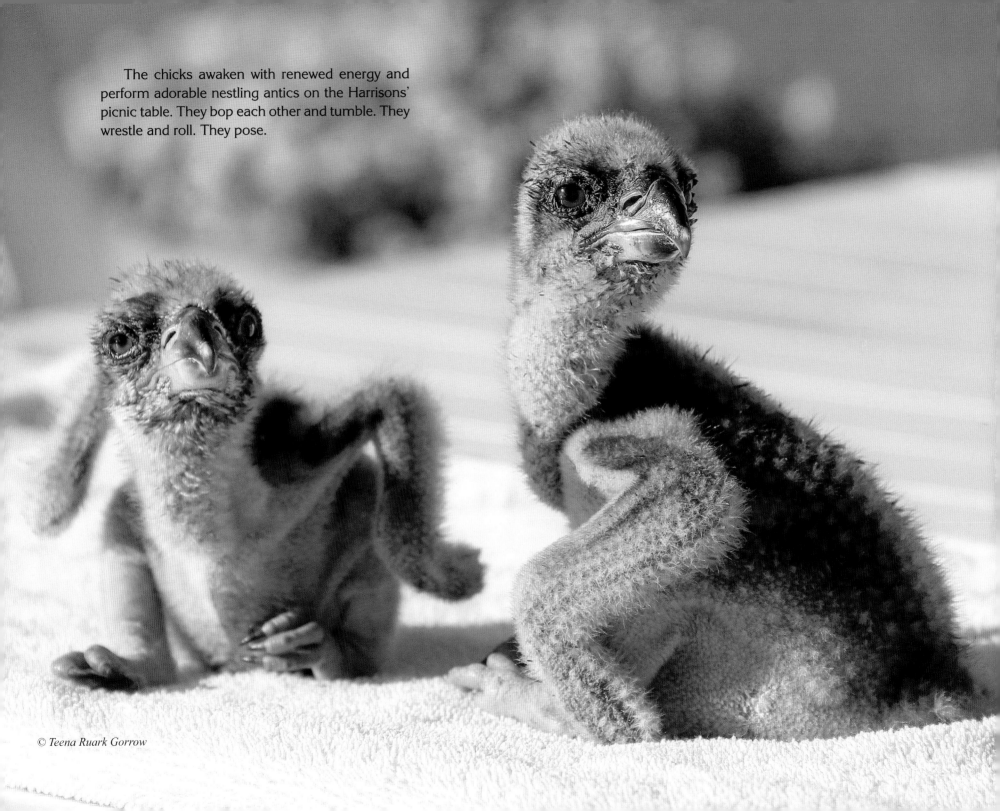

The chicks awaken with renewed energy and perform adorable nestling antics on the Harrisons' picnic table. They bop each other and tumble. They wrestle and roll. They pose.

© Teena Ruark Gorrow

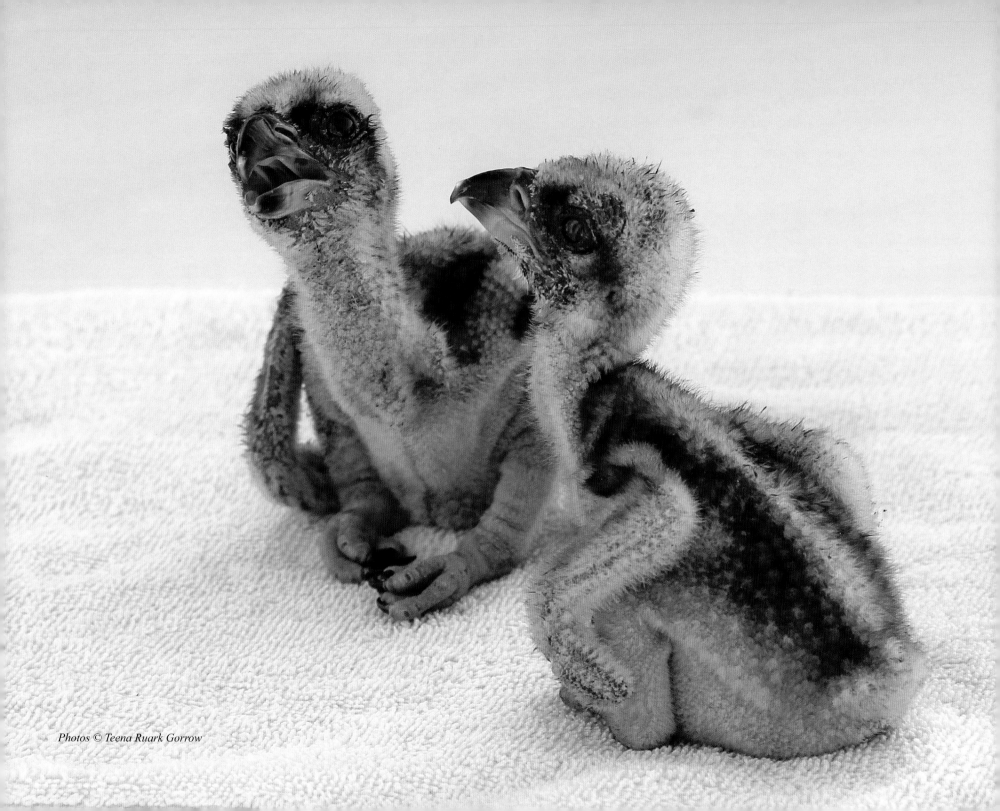

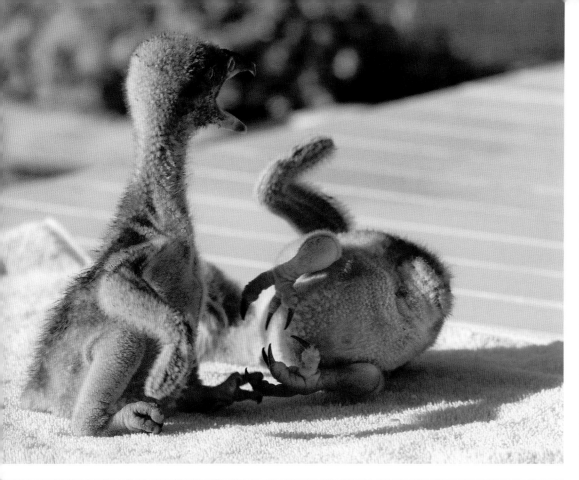
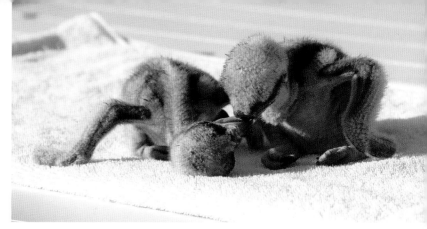

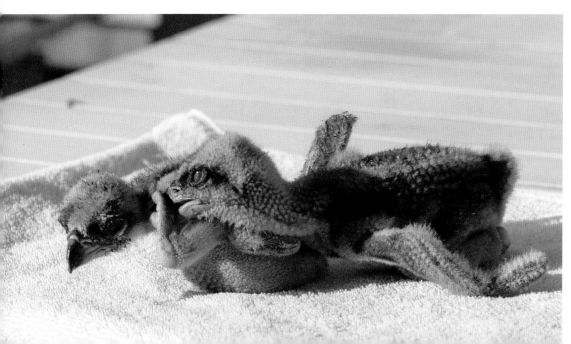

© Craig A. Koppie

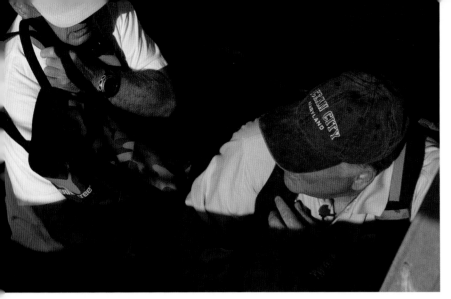

Mr. Koppie and Mr. Harrison carefully place the two chicks in an open canvas tote bag and wade toward the nest platform. As they approach, Audrey flushes from the nest, protests loudly, and circles the area.

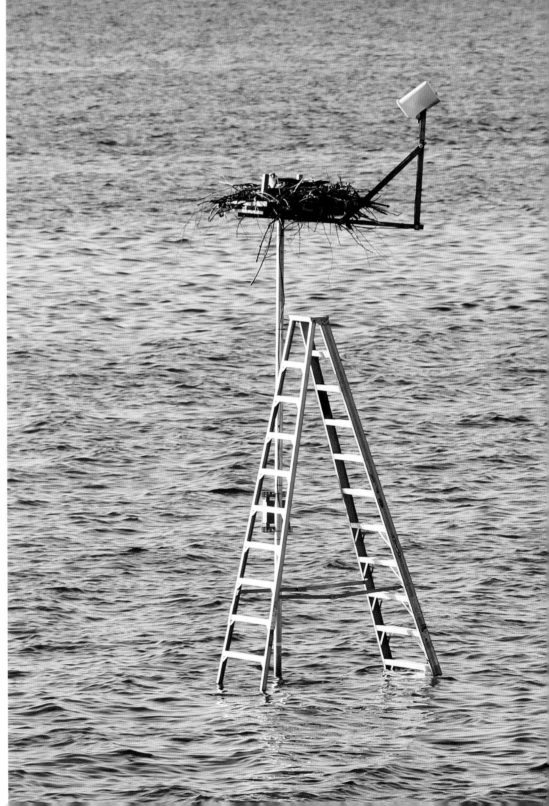

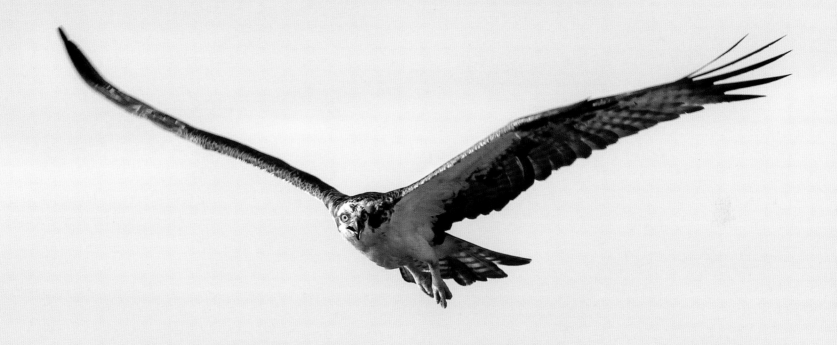

Audrey protests as the intruders approach the nest.
© *Teena Ruark Gorrow*

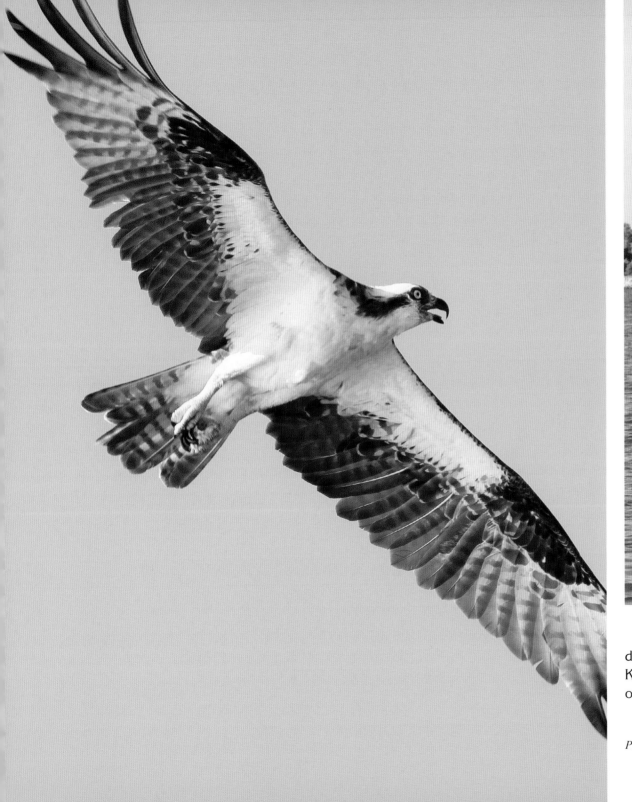

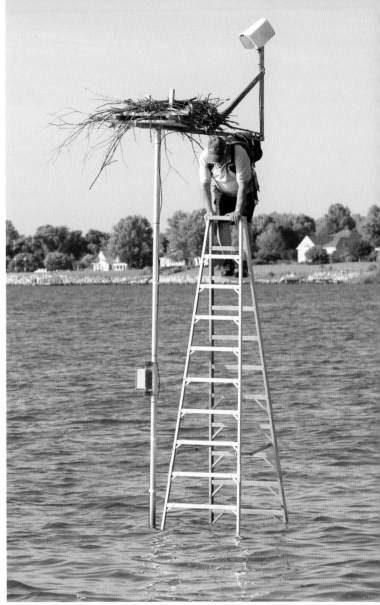

Audrey's defensive flight display and alarm calls demonstrate her displeasure with the disturbance. Mr. Koppie climbs the ladder and looks inside the nest at the ospreys' three eggs.

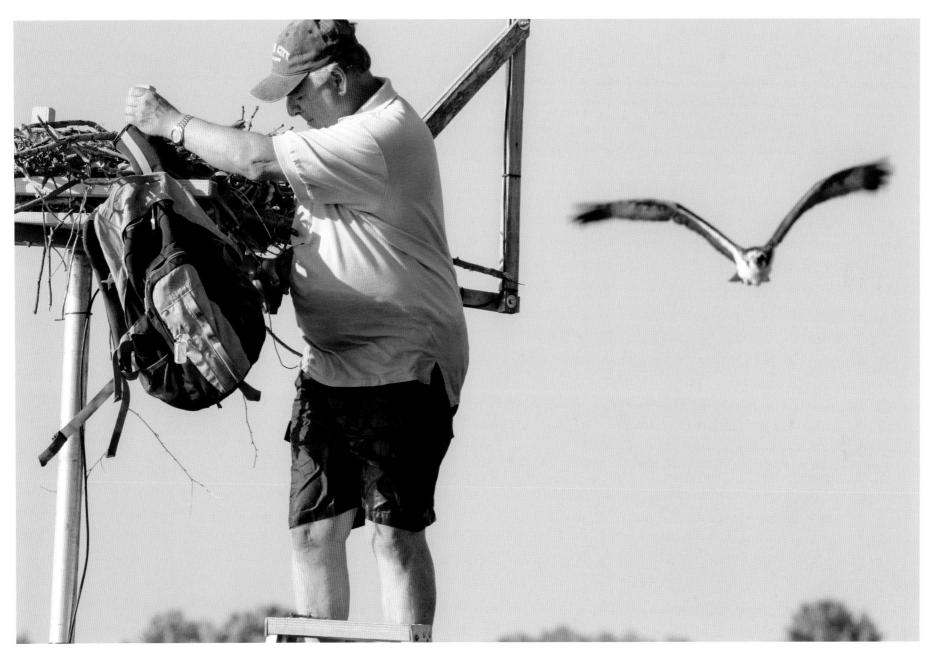

Audrey continues protesting as Craig Koppie prepares for the foster event at the nest.
© *Teena Ruark Gorrow*

46

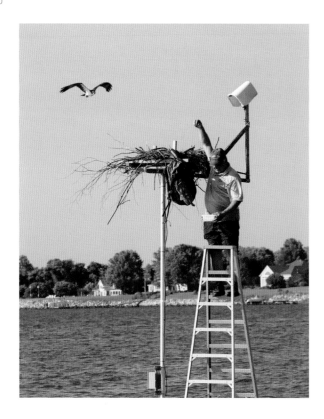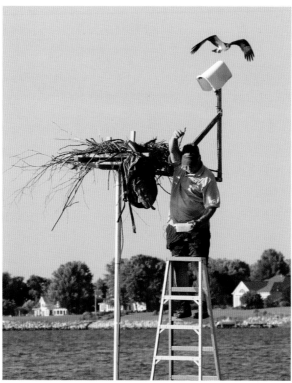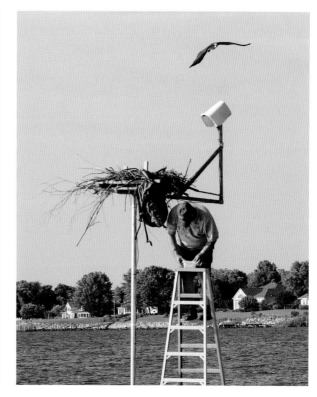

He removes two of the three eggs and carefully places them in a container inside his backpack for later examination. He intentionally leaves one egg in the nest for Audrey and Tom to see. The egg's presence might encourage the new foster parents to return to their nest for incubating, even if they do not immediately accept the chicks as their own. If so, the egg incubation will keep the parents close to the nestlings and create an opportunity to bond.

While the eggs are being collected, Audrey maintains her defensive posture above the nest. Tom is not in view.

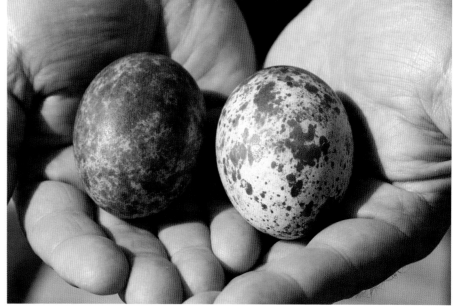

Two of the three eggs are being removed from the nest.
Photos © Teena Ruark Gorrow

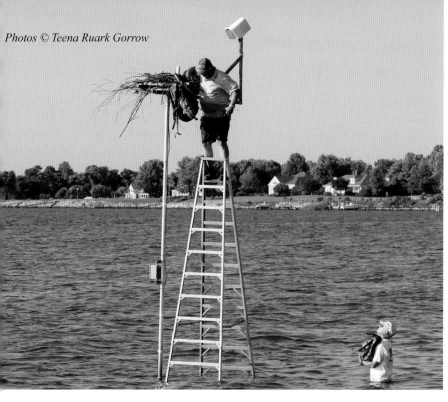

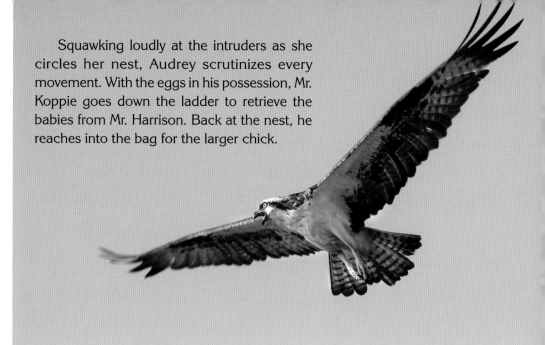

Squawking loudly at the intruders as she circles her nest, Audrey scrutinizes every movement. With the eggs in his possession, Mr. Koppie goes down the ladder to retrieve the babies from Mr. Harrison. Back at the nest, he reaches into the bag for the larger chick.

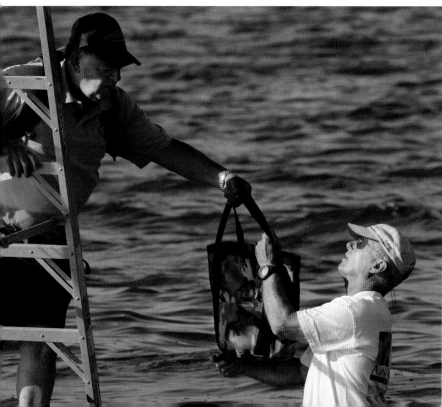

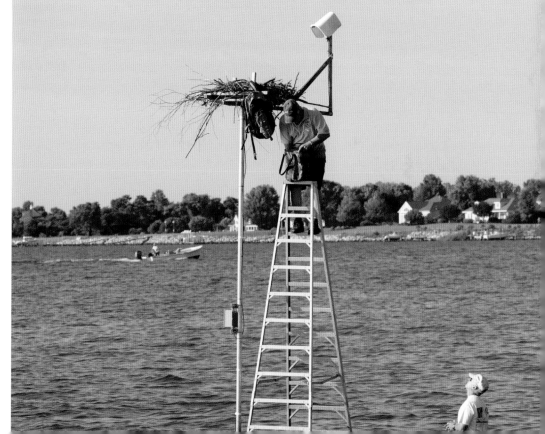

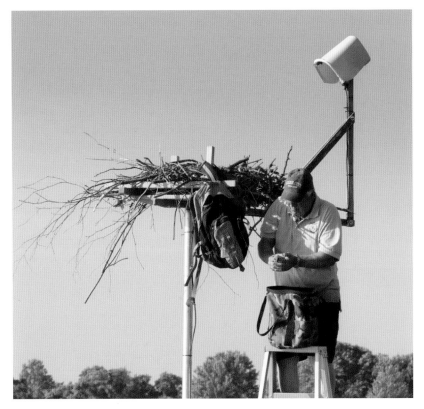 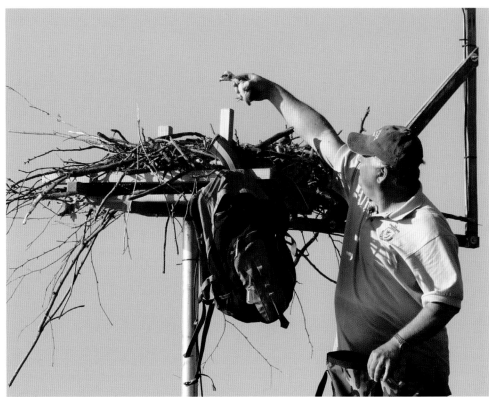

He gently places the first chick on the soft grasses beside the remaining egg. Then he reaches into the bag for the second chick and places it alongside its sibling.

Safely relocated to their new home, the siblings look at each other and the nest. They stretch their necks and bob their heads to catch a glimpse of the adult osprey coming their way. Audrey is vocalizing and her new babies are listening.

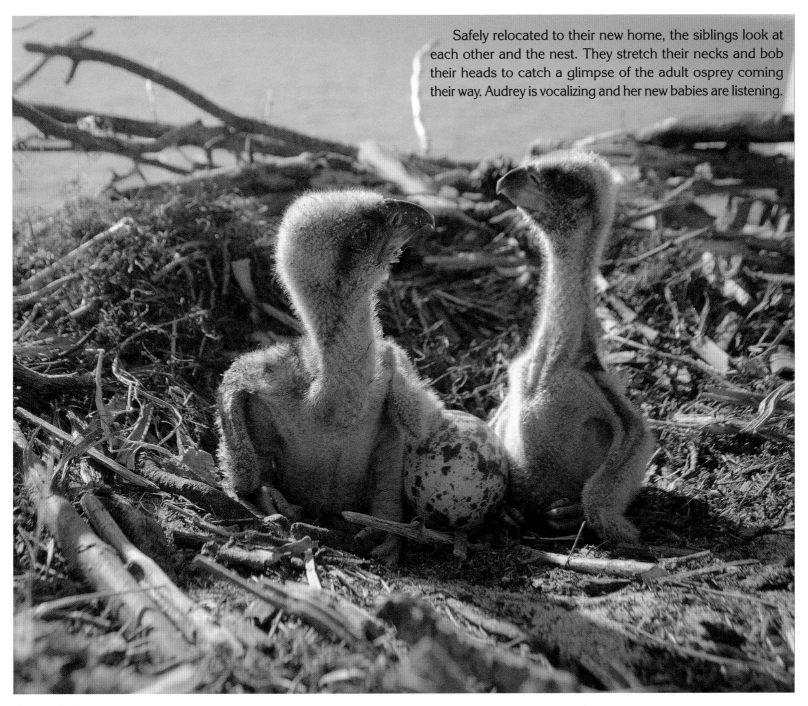

© Craig A. Koppie

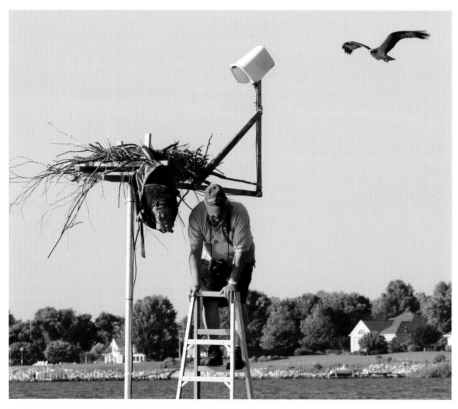

Audrey wants to see inside her nest before Mr. Koppie can get down the ladder. © *Teena Ruark Gorrow*

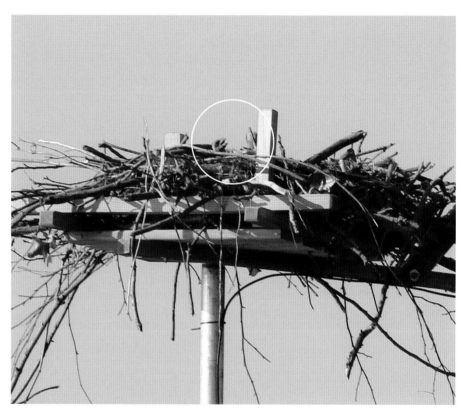

From the nearby dock, two tiny heads can be seen facing skyward above the branches as Audrey makes her approach. (A circle was added to show the birds.) © *Teena Ruark Gorrow*

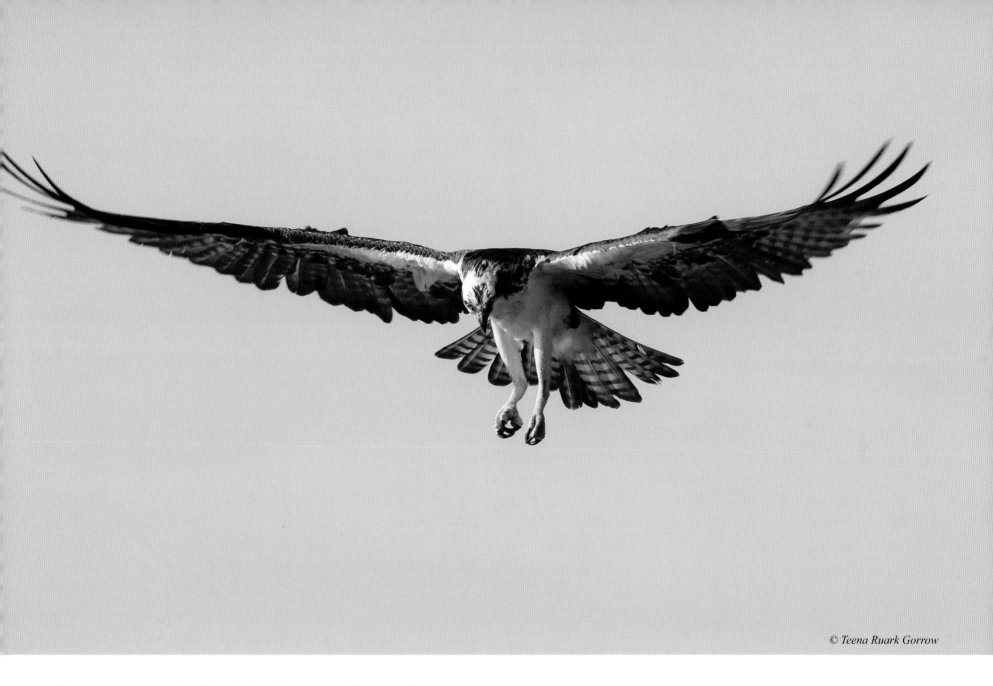

© Teena Ruark Gorrow

Time seems to stand still as Audrey hovers over her nest. In apparent disbelief, she stares down at the nestlings leaning on her remaining egg. She looks first at one chick and then the other.

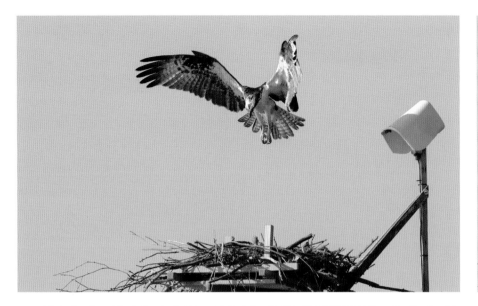

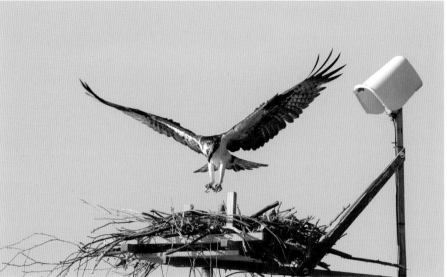

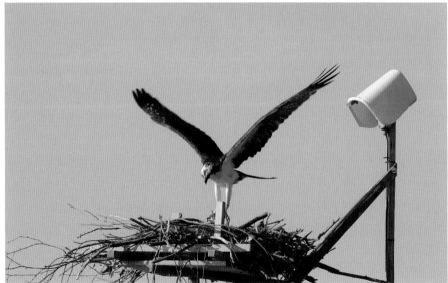

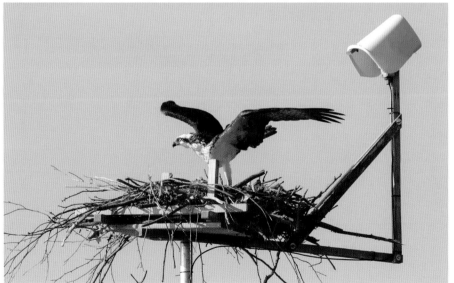

Photos © Teena Ruark Gorrow

Audrey lowers her body toward the nest as if to land. Instead, she lifts higher and resumes hovering. Keenly focused on the chicks, perhaps Audrey is wondering about the nest intruders, the babies now chirping at her, or her two missing eggs. Gingerly, she lands inside the nest.

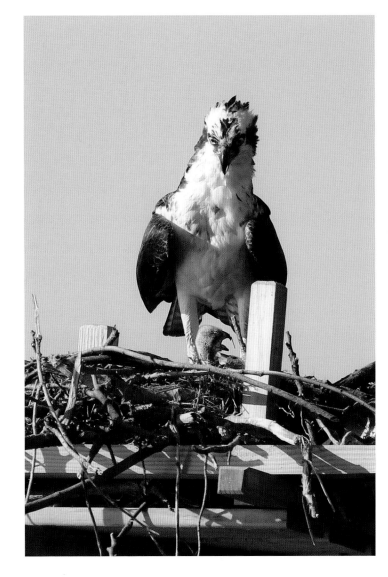

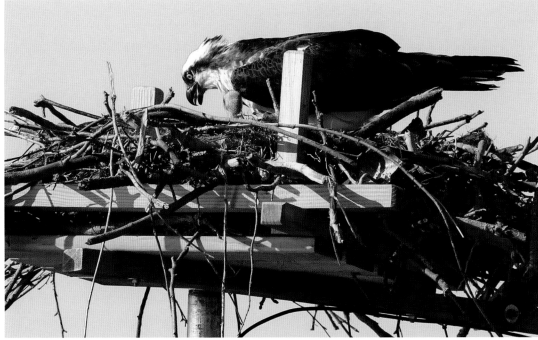

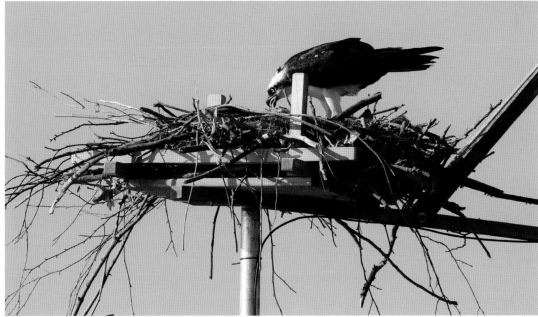

Audrey immediately engages with the chicks. She examines the tiny nestlings and chirps softly toward them. With heads bopping, they chirp and squawk back at their new mother.

Photos © Teena Ruark Gorrow

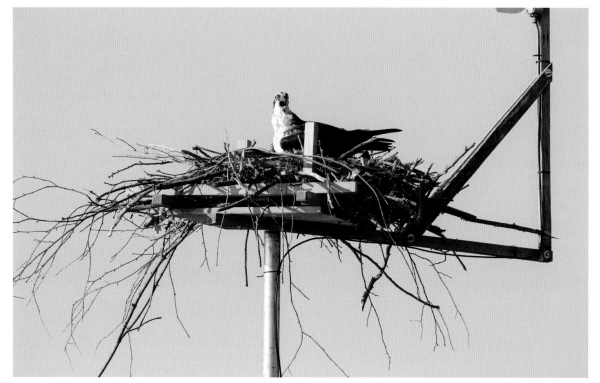

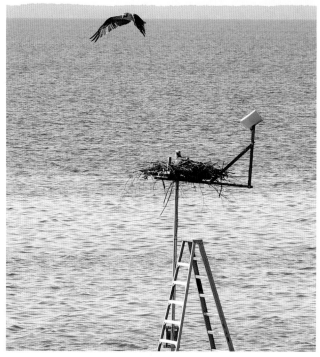

While the new mom and babies are getting acquainted at the nest, Mr. Koppie is back on shore and being interviewed by Sally Kidd, a national correspondent for Hearst Television's Washington, DC News Bureau. The story of this foster event will be released by television, radio, newspaper, online news, and social media outlets.

At the nest, Audrey calls for her mate. Tom flies near but does not land.

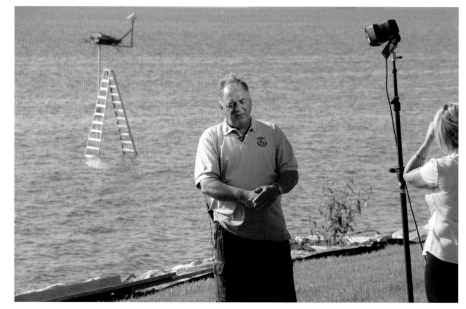

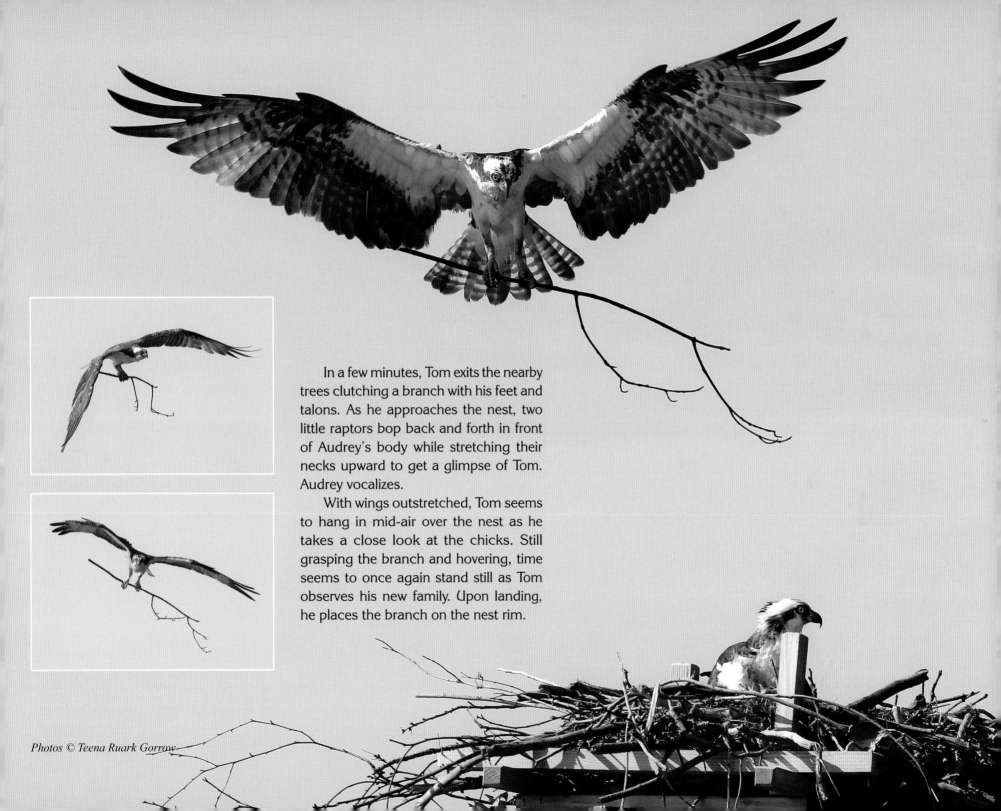

In a few minutes, Tom exits the nearby trees clutching a branch with his feet and talons. As he approaches the nest, two little raptors bop back and forth in front of Audrey's body while stretching their necks upward to get a glimpse of Tom. Audrey vocalizes.

With wings outstretched, Tom seems to hang in mid-air over the nest as he takes a close look at the chicks. Still grasping the branch and hovering, time seems to once again stand still as Tom observes his new family. Upon landing, he places the branch on the nest rim.

Photos © Teena Ruark Gorrow

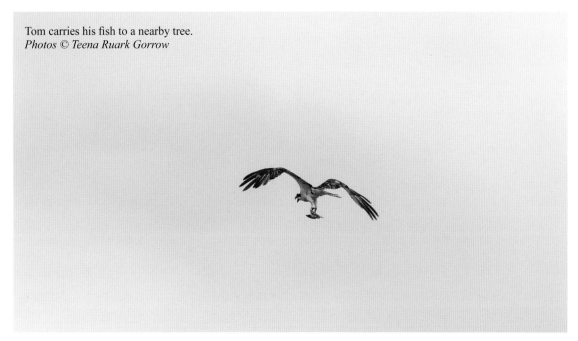

Tom carries his fish to a nearby tree.
Photos © Teena Ruark Gorrow

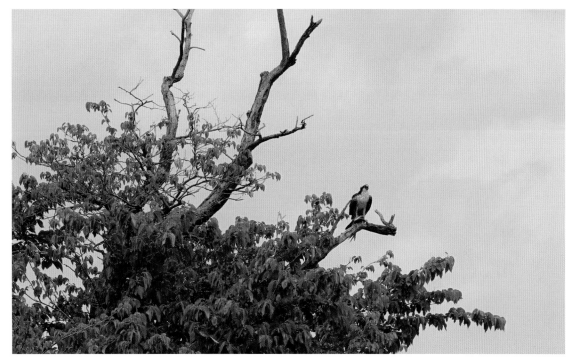

After a few minutes at home, Tom flies out of the nest to go fishing and carries his catch to a nearby tree. He glances overhead as a pair of Osprey military helicopters travel across the sky. Audrey calls Tom, but he does not respond.

Perhaps Tom is confused about the events that transpired or pondering whether to be a foster dad. Whatever he's thinking, Tom is in no hurry to return to the nest. He remains perched on the branch for a few hours, slowly removing the head of the fish and observing the nest area.

Audrey stays in the nest with the chicks while Tom perches on the branch with the fish. It appears that Audrey and the babies are bonding. Sometimes the new foster mom leans close to the nestlings as if engaged in conversation or to provide shade on this hot, sunny afternoon. Occasionally, she stands to stretch her legs and call Tom.

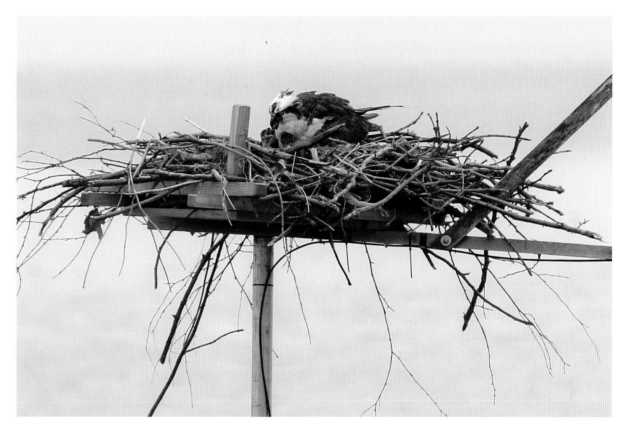

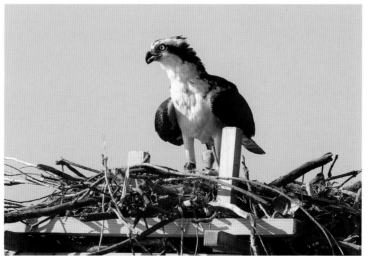 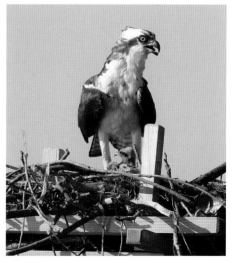

Photos © Teena Ruark Gorrow

It takes a while, but Tom eventually flies toward the nest carrying the headless fish caught earlier in the day. Although eager to feed the chicks, Audrey refuses the decaying meal and requests a fresh catch for the babes. Tom glides back out over the water and immediately returns with a fresh fish.

Audrey grips the fish with her sharp talons and uses her beak to tear meat away from bone. She leans over the chicks and offers morsels of the fresh food. Stretching their little bodies toward Audrey's beak, the hungry siblings readily accept the meal until their crops are full.

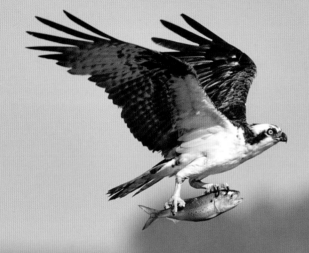

Tom returns to the nest. © *Craig A. Koppie*

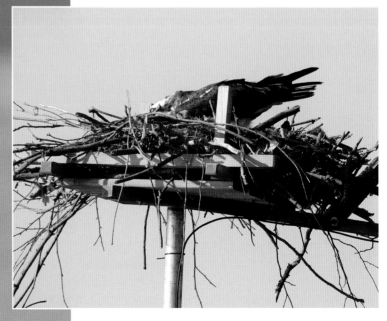

© *Teena Ruark Gorrow*

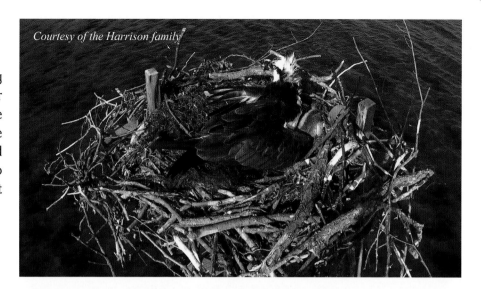

Courtesy of the Harrison family

The sun sets over the Chesapeake watershed. It has been an exciting day for Audrey and Tom and the two tiny ospreys sleeping peacefully in their cozy nest. Just this morning, these persistent and dedicated parents-to-be were waiting expectantly for their unviable eggs to hatch. Now, their home is filled with new life and it appears that the attentive parents have accepted the young as their own. As darkness approaches, Audrey draws the two chicks close to her body and continues to incubate the remaining egg that Mr. Koppie left in the nest.

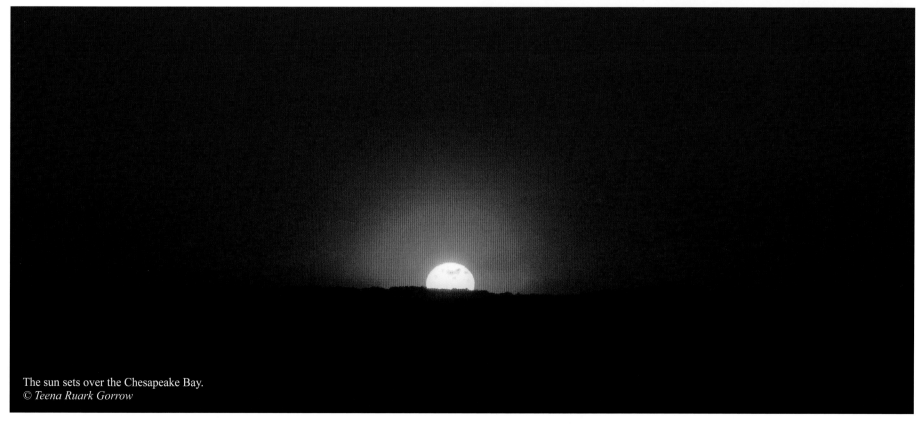

The sun sets over the Chesapeake Bay.
© *Teena Ruark Gorrow*

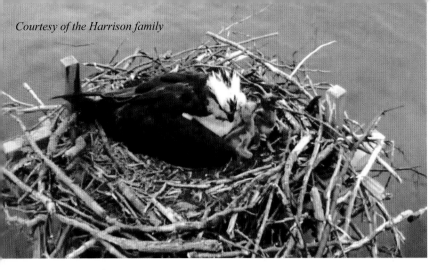

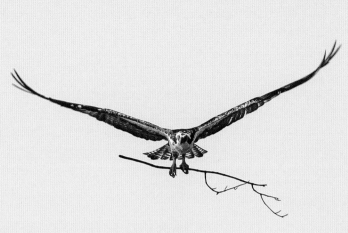

All goes well during the night for the osprey family. Tom delivers a branch and forages fresh fish for breakfast. The siblings are alert and ready to devour the tasty morsels from Audrey's beak.

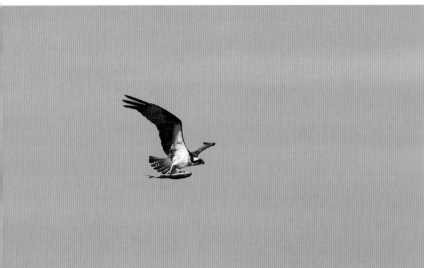

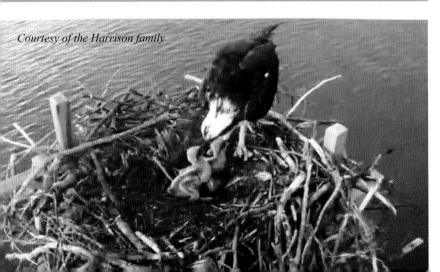

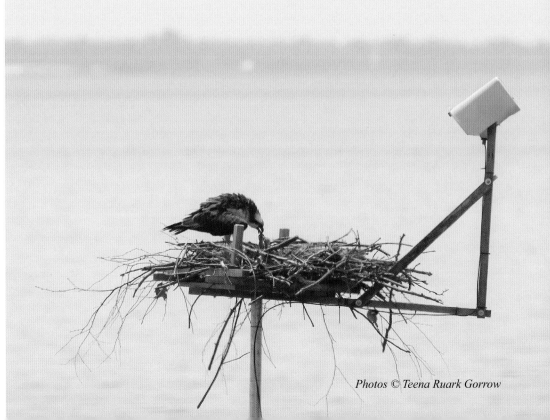

Tom and Audrey parent the chicks.
© *Teena Ruark Gorrow*

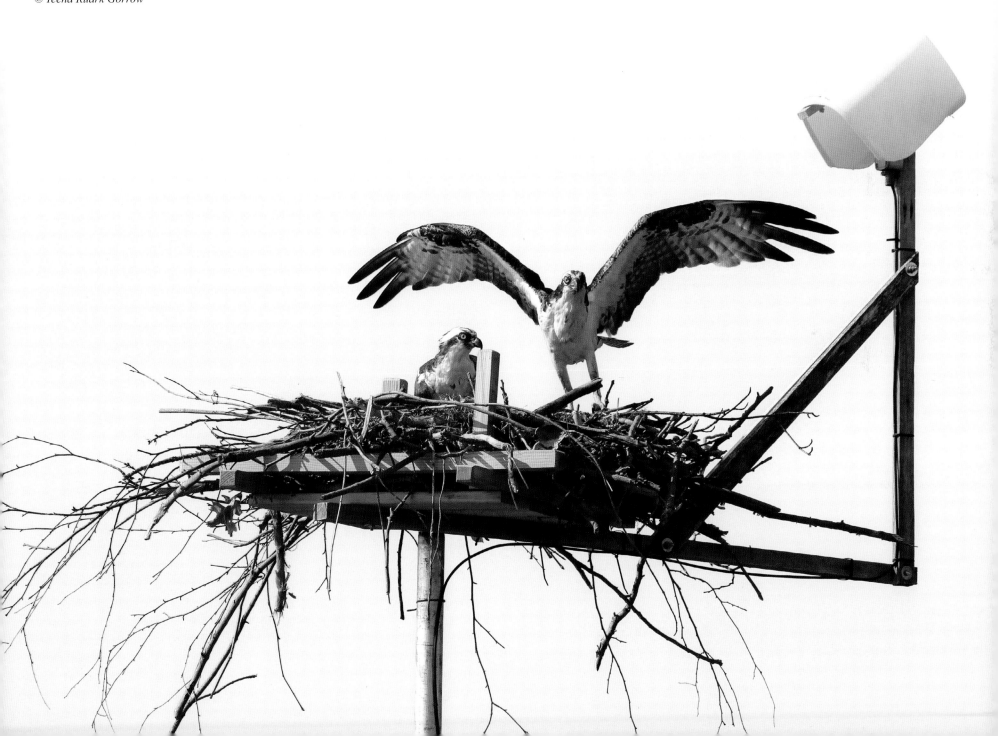

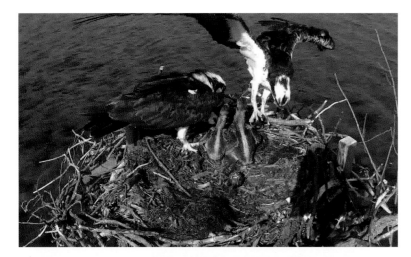

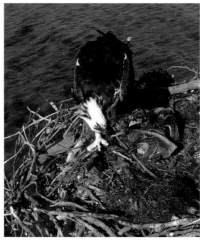

Tom and Audrey settle into a routine of feeding, protecting, and caring for their young. Audrey spends most of her time in the nest with the chicks, while Tom watches over the family and serves as their provider. Growing and getting stronger each day, the siblings sometimes scoot to the nest wall when they see their dad approach with a meal.

The new family settles into a routine.
Photos courtesy of the Harrison family

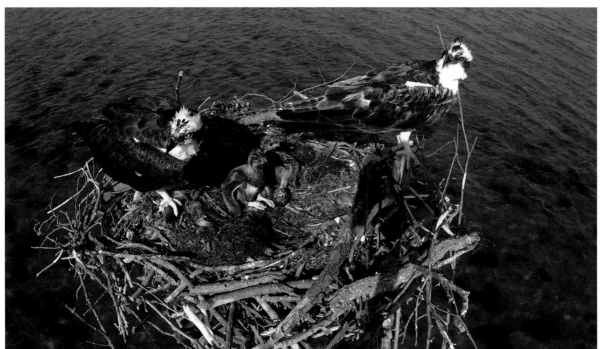

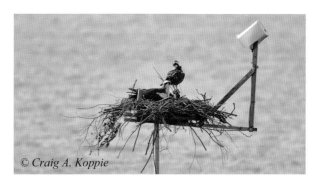

© Craig A. Koppie

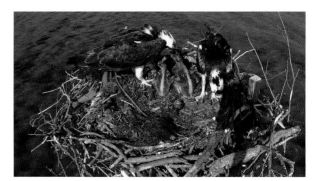

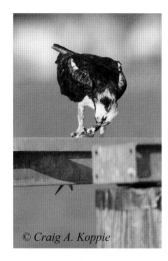

© Craig A. Koppie

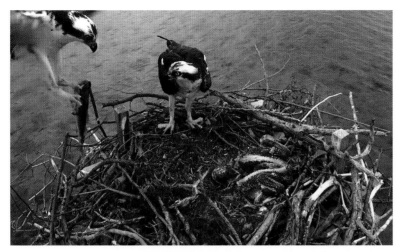

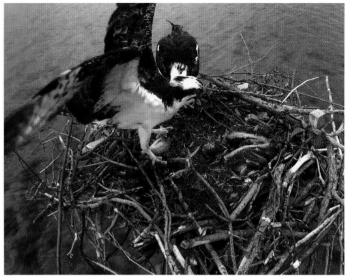

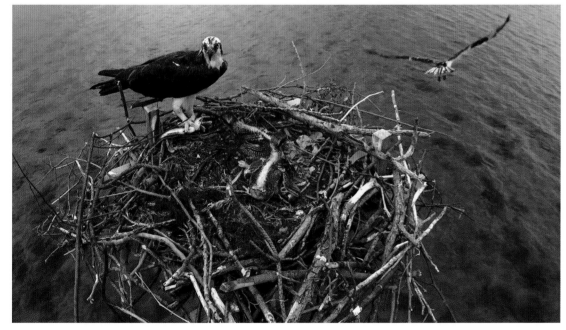

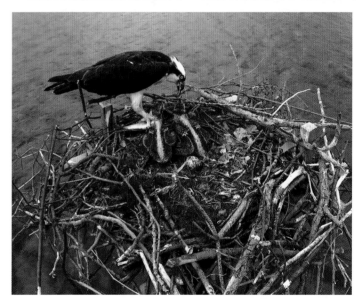

Photos courtesy of the Harrison family

A capable fisherman, Tom brings fish to the family several times daily. He sometimes consumes portions of the fish on a nearby tree or dock before delivery but often brings the entire fish to the nest. He occasionally stays with the family. Other times, he drops the fish at the nest and flies away when Audrey begins feeding the chicks.

The family has been together just ten days when the National Weather Service issues a tornado watch along the Chesapeake Bay watershed. Strong winds rock the ospreys' over-water platform nest, rough surf crashes against their platform pole, and pounding rain soaks the inside of the nest.

With her wings slightly extended in tent-like fashion, Audrey keeps her body hunkered down in a brooding position over the chicks. She faces the fluctuating winds and occasionally lifts her head to glance over the nest wall. One gust of wind knocks Audrey off balance and temporarily lifts her body to briefly expose the chicks she is masterfully shielding from the storm's elements. However, in seconds, the determined mother regains her protective stance over the nestlings.

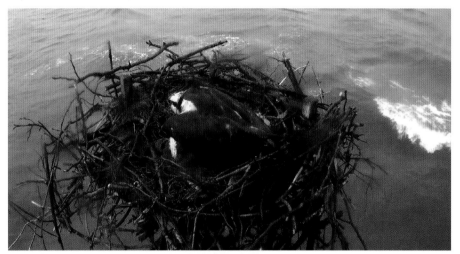
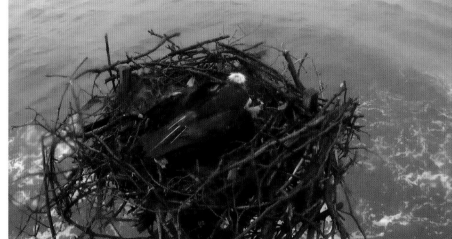

The family endures dangerous weather at the nest.
Photos courtesy of the Harrison family

Osprey nests are often exposed to strong winds and soaking rains because they are usually constructed in the open on tall structures. Sadly, chicks can be lost and nests sometimes fall during these severe weather events. Even with a sturdy platform and quality nest construction, it takes perseverance and commitment for the parents to protect themselves and their young.

Audrey is an experienced mother. Her slightly oily feathers repel rainwater, and she knows how to position her body to keep her chicks warm and dry.

The osprey family survives the storm with the nest intact. Pleasant summer weather returns the next day and the parents resume their regular activities.

The ospreys fluff their feathers, dry out, and resume normal activities following the storm.

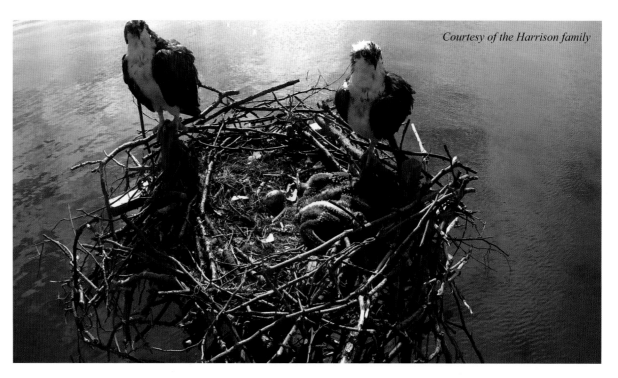

Courtesy of the Harrison family

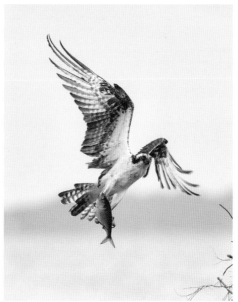

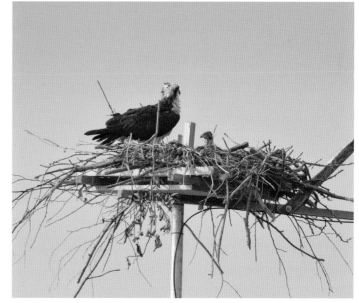

Photos © Craig A. Koppie

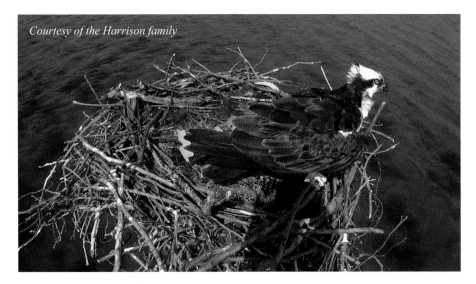

Courtesy of the Harrison family

Besides dangerous storms, the Chesapeake Bay area endures sweltering heat and humidity during the summer, with temperatures frequently reaching the nineties or higher. Audrey uses her body and feathers to provide shade for the young on these oppressive days. During these acts of kindness, Mrs. Harrison astutely refers to Audrey as Mombrella.

This wise mother also locates submerged aquatic vegetation or bay grasses to help cool the chicks. She grabs the wet mass with her talons and places it beside the chicks in the nest. Afterward, Audrey glides just above the water and skims her feet, splashing cool water onto her feathers. She submerges her body to thoroughly wet her head and body feathers.

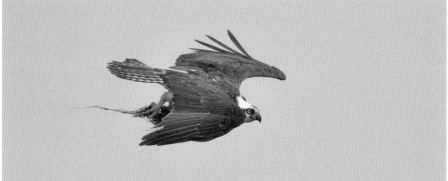

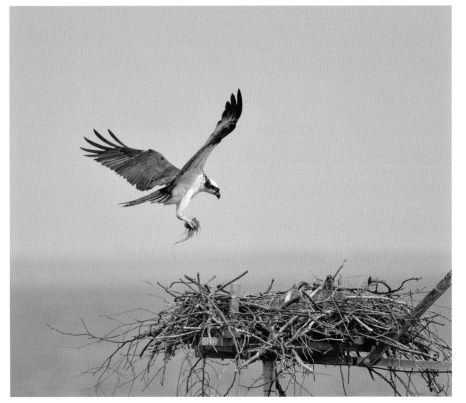

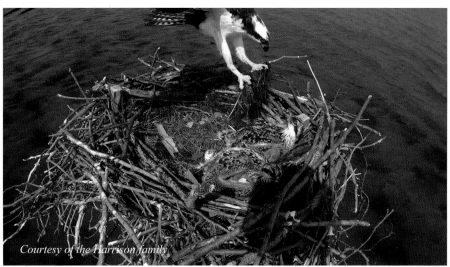

Courtesy of the Harrison family

Photos © Craig A. Koppie

As the calendar rolls over to July, more food is required to feed the growing ospreys. Tom delivers a variety of fish as many as eight times a day. While ospreys sometimes eat small aquatic animals or rodents, fish is the main food item being delivered to the nest.

By all appearances, these chicks are eating well and growing. Their tail feathers now protrude and resemble the ends of a paintbrush. The ospreys politely expel their waste away from the nest.

The ospreys' nest is also home to a family of sparrows. They dart around the ospreys and perch on branches. They sometimes reach over the rim of the nest to claim twigs and down for the interior nest they have created inside the ospreys' nest.

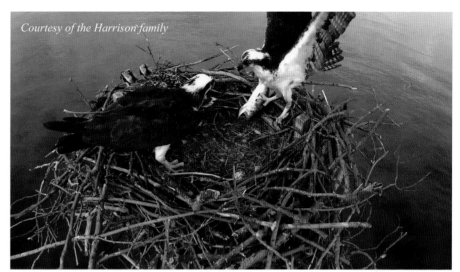

Courtesy of the Harrison family

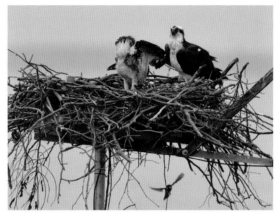

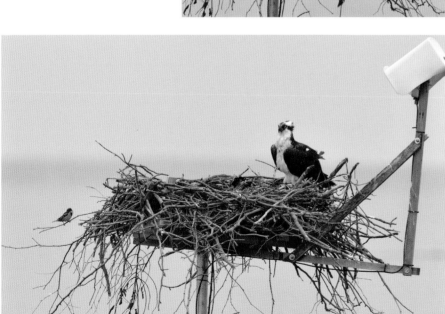

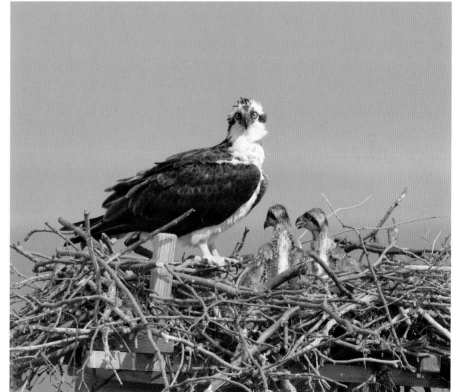

Photos © Craig A. Koppie

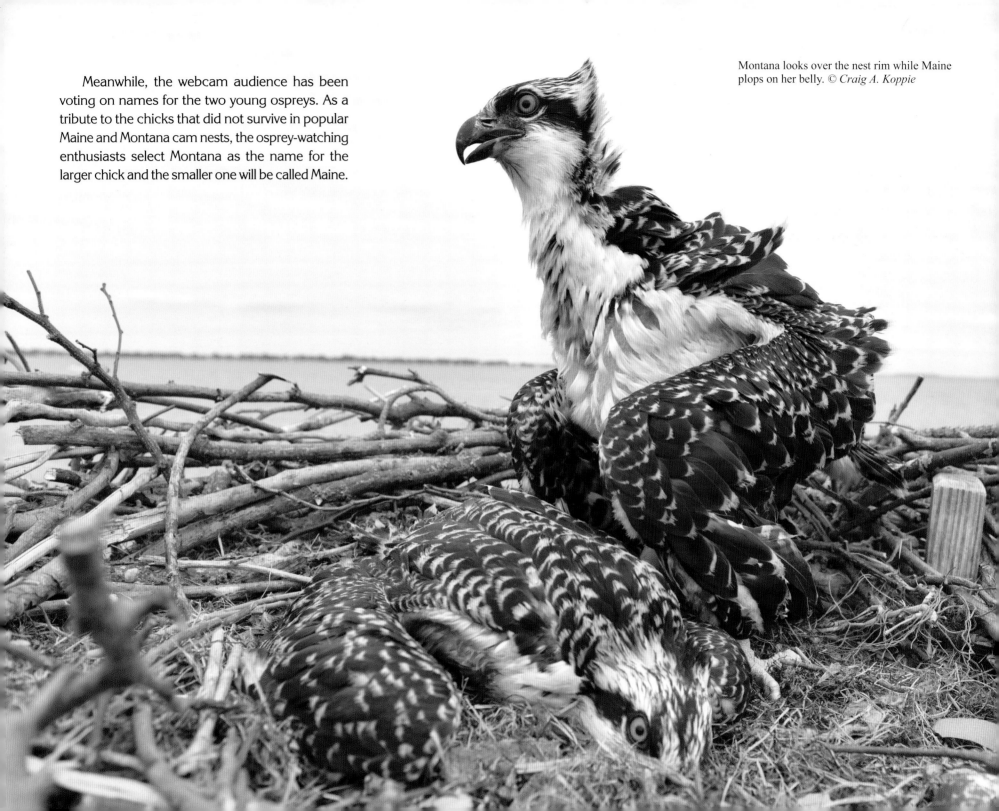

Meanwhile, the webcam audience has been voting on names for the two young ospreys. As a tribute to the chicks that did not survive in popular Maine and Montana cam nests, the osprey-watching enthusiasts select Montana as the name for the larger chick and the smaller one will be called Maine.

Montana looks over the nest rim while Maine plops on her belly. © *Craig A. Koppie*

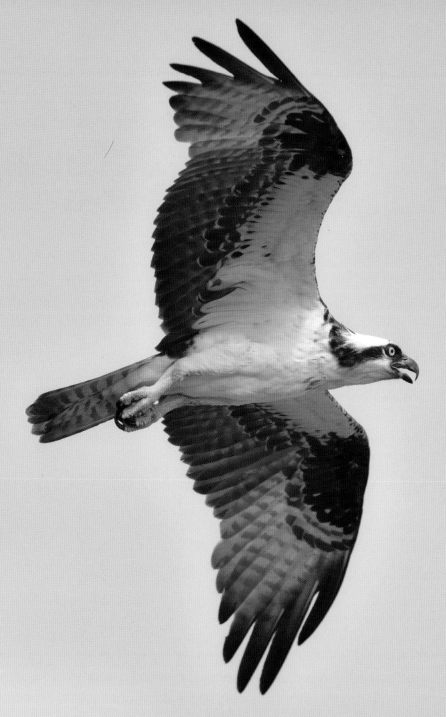

Audrey. © *Craig A. Koppie*

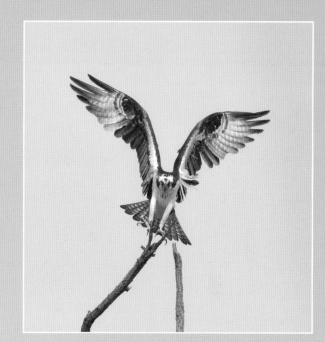

Tom. © *Craig A. Koppie*

One warm morning in mid-July, Audrey and Tom create a stunning visual display as they fly across the nest sky. Tom is quite the showman as he lands on a nearby perch.

Audrey is the larger of the two birds. She has bright yellow eyes and a dark necklace of feathers across her white breast, which is characteristic of females. Tom, like other males, is a bit smaller than his mate. He has a light brown patch on the nape of his neck and deep, golden eyes. Both adults have dark brown plumage above and white undersides. Their wings are five to six feet long and have a distinctive crook in the middle common to ospreys.

Today seems like just another summer day. But the ospreys are about to receive visitors.

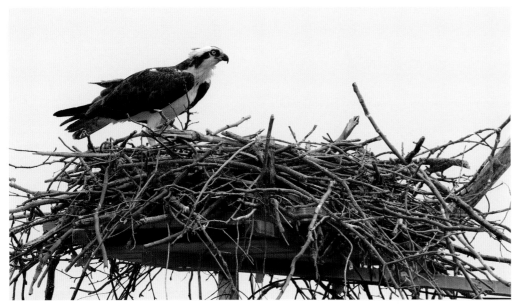

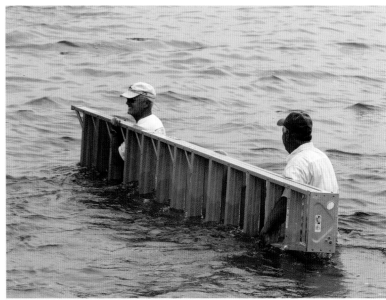

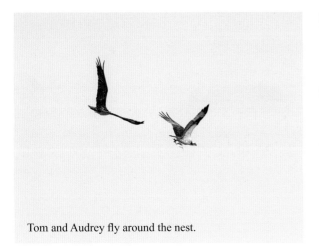

Tom and Audrey fly around the nest.

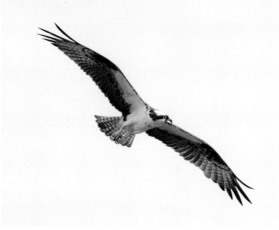

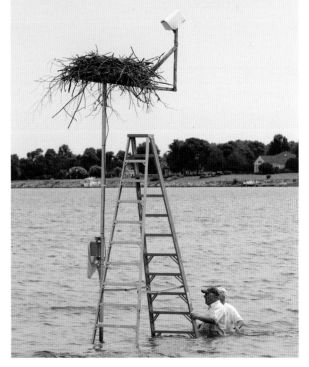

Tom has gone fishing and Audrey is perched on the nest wall watching Montana and Maine. The Harrison family, Chesapeake Conservancy staff, and Craig Koppie have decided that today is the day to conduct health checks and band the chicks.

As Mr. Koppie and Mr. Harrison wade toward the nest platform carrying the ladder, Audrey protests loudly. She flies out of the nest to join Tom, now on his way to deliver breakfast. The pair flies side by side for a few moments before Audrey begins circling the nest. Gazing at the approaching intruders, she maintains a defensive posture in the sky while making loud squawking noises. Perhaps she is warning the chicks or the intruders, or both.

Mr. Harrison and Mr. Koppie stabilize the ladder at the nest platform. *Photos © Teena Ruark Gorrow*

With Audrey patrolling overhead, Mr. Koppie climbs the ladder to access the nest. He removes Maine and delivers the chick down the ladder to Mr. Harrison for safekeeping.

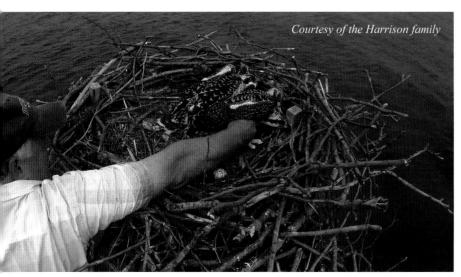

Audrey is alarmed by the intruders at her nest. *Photos © Teena Ruark Gorrow*

Courtesy of the Harrison family

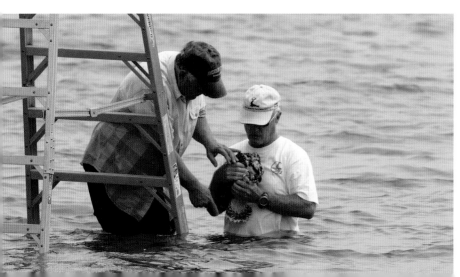

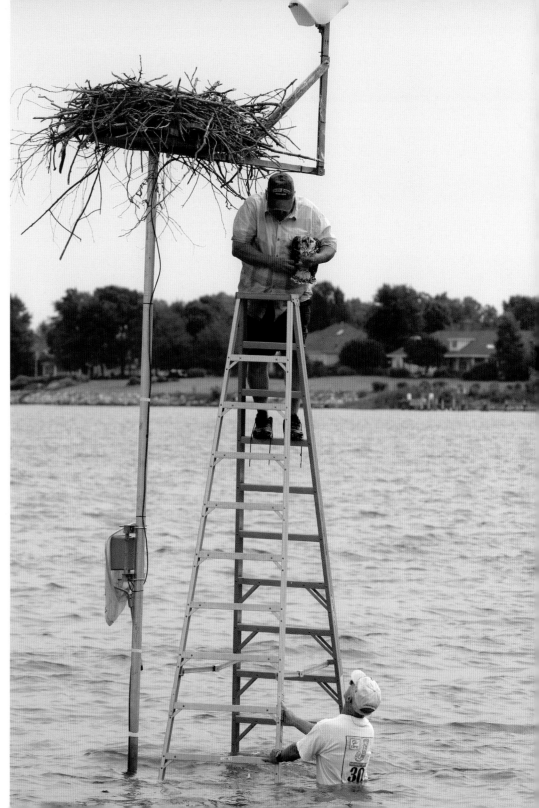

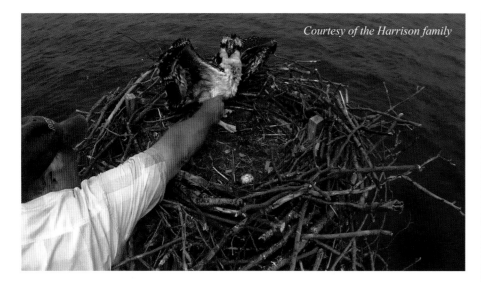

Courtesy of the Harrison family

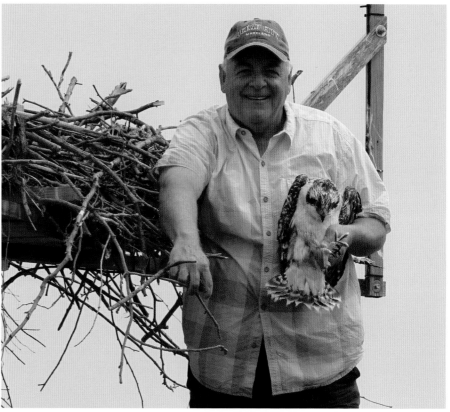

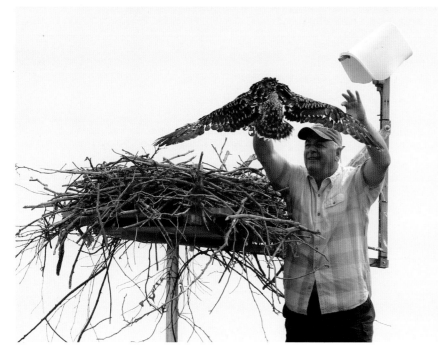

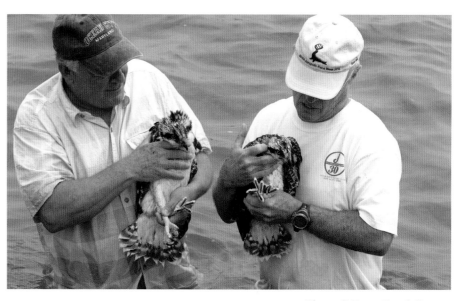

Next, he carefully lifts Montana from the nest. Then, Mr. Koppie and Mr. Harrison head back to the dock with the precious cargo. Audrey squawks and continues circling the nest in protest.

Photos © Teena Ruark Gorrow

73

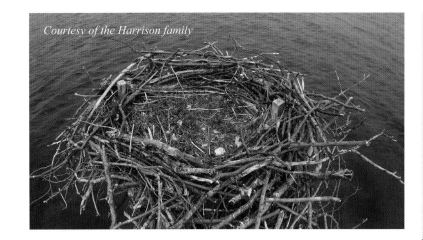

Courtesy of the Harrison family

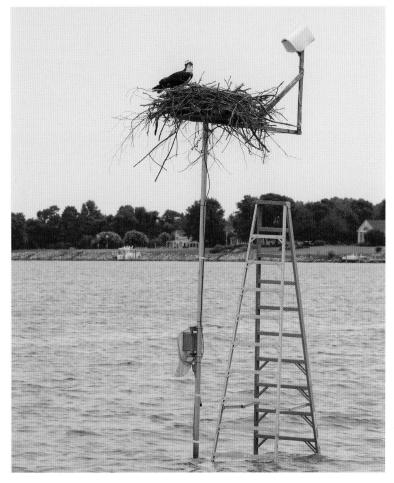

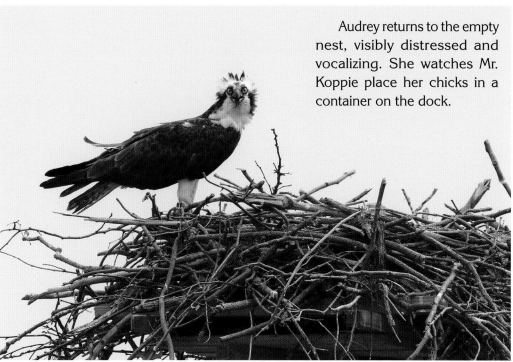

Audrey returns to the empty nest, visibly distressed and vocalizing. She watches Mr. Koppie place her chicks in a container on the dock.

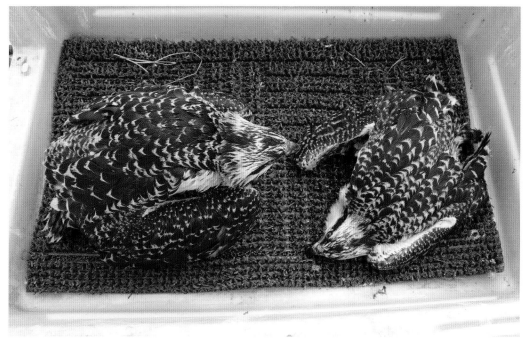

Photos © Teena Ruark Gorrow

Montana. *Photos © Teena Ruark Gorrow*

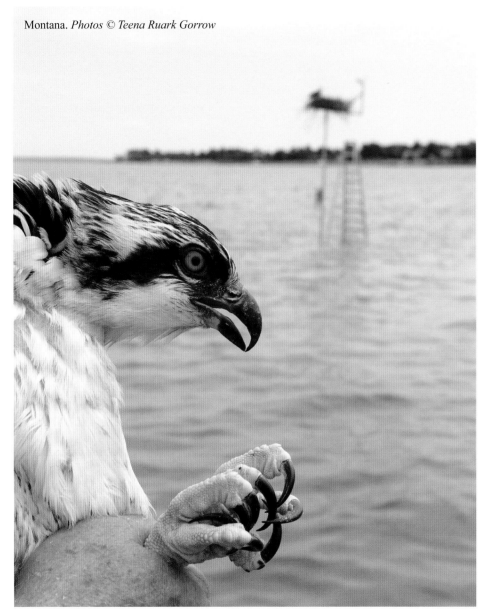

Montana watches her mother.

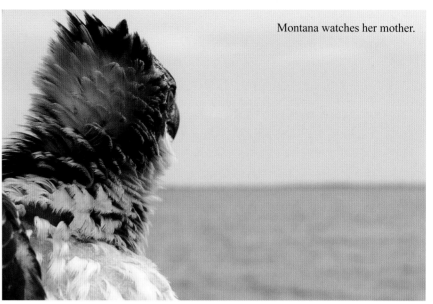

Maine.

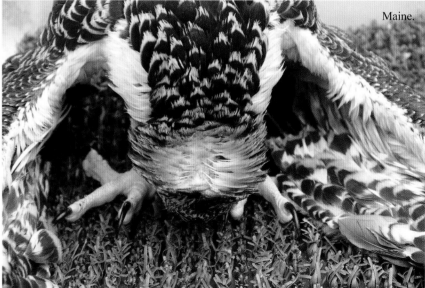

He lifts Montana from the container. While using one hand to securely hold the tarsus area of each foot, he positions the young osprey so it is leaning against his chest. Able now to see each other, Montana looks toward the nest as Audrey calls. At the same time, Maine drops her head, hides her face, and seems to be playing dead. Mom just might be providing survival instructions to the kids.

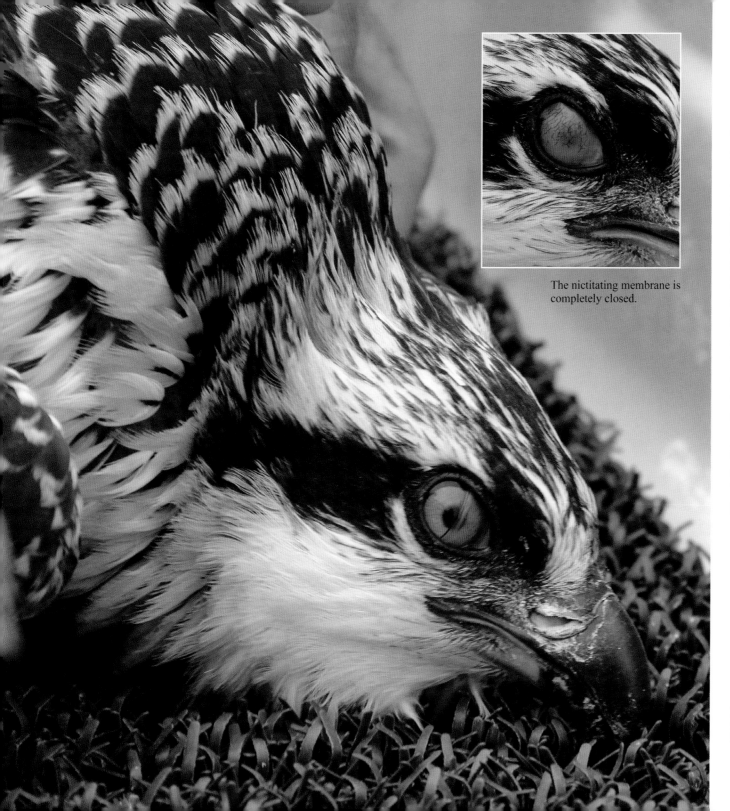

The nictitating membrane is completely closed.

The chick starts to close her nictitating membrane as she is about to be handled.
Photos © *Teena Ruark Gorrow*

Mr. Koppie checks the overall appearance and condition of each chick. He is looking for indicators that the little raptors are developing normally and on schedule.

The ospreys' deep-orange eyes look clear, and characteristic malar stripes create the illusion that the birds are wearing glasses. While being examined, both chicks instinctively close their nictitating membranes—a clear film that protects the eye. Their nares—nostrils on the upper beak—appear healthy with no discharge. In a couple of months, when the young ospreys can fly and dive underwater for fish, they will close their nostrils before plunging under the water's surface.

The sharply hooked, black beak looks well-developed on each bird and the egg tooth has been absorbed. There are no obstructions around the beak area.

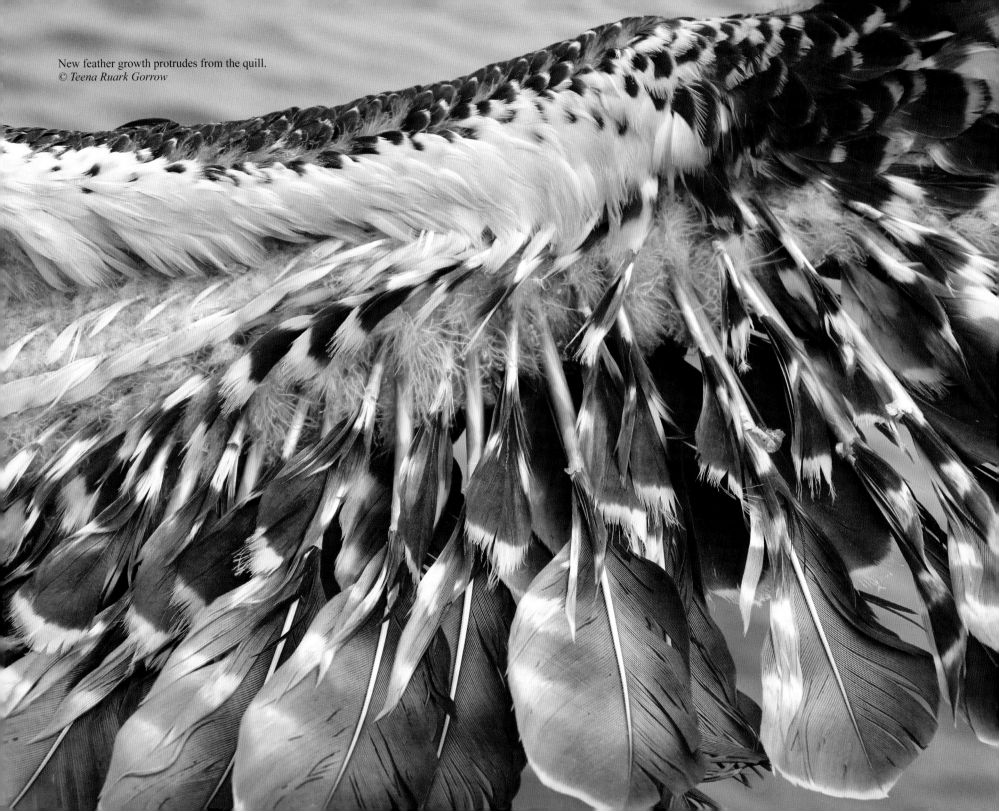

New feather growth protrudes from the quill.
© *Teena Ruark Gorrow*

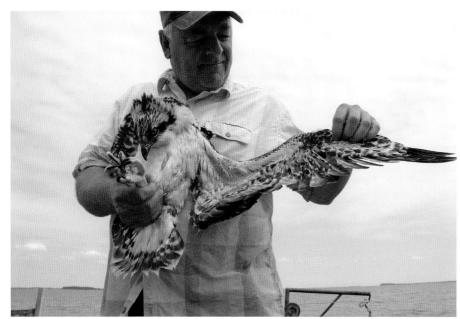

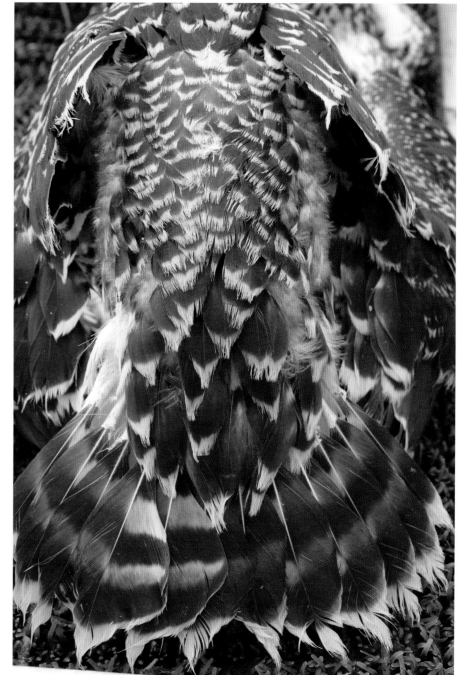

The chicks are also examined for bone and feather development. Mr. Koppie extends each wing and determines that both chicks seem to be developing on schedule. There are no signs of parasites.

Within a few weeks, the osprey chicks will have fully grown juvenile feathers and will be ready to fly, but their adult plumage will not be achieved until around eighteen months. Their buff-tipped feathers present a somewhat speckled appearance, making it easy to distinguish the chicks from their adult parents. Other distinctive features include a black and white barred tail; a streaked crest with white, beige, and black feathers; and a beige and white chest.

Photos © Teena Ruark Gorrow

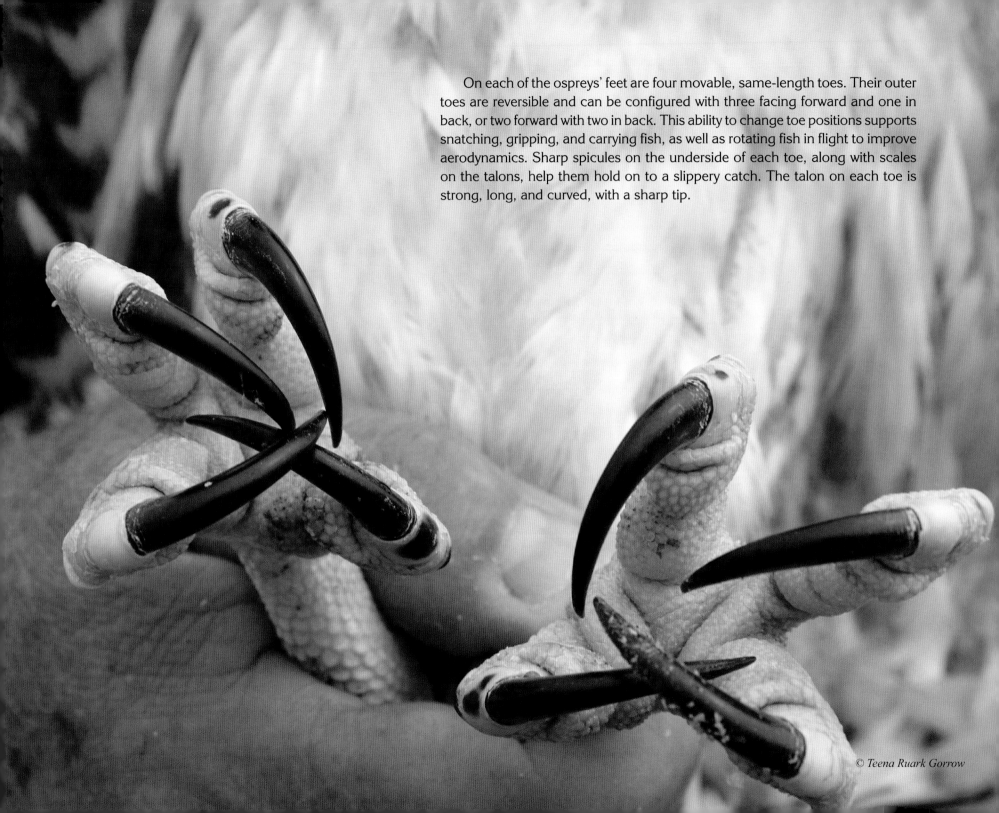

On each of the ospreys' feet are four movable, same-length toes. Their outer toes are reversible and can be configured with three facing forward and one in back, or two forward with two in back. This ability to change toe positions supports snatching, gripping, and carrying fish, as well as rotating fish in flight to improve aerodynamics. Sharp spicules on the underside of each toe, along with scales on the talons, help them hold on to a slippery catch. The talon on each toe is strong, long, and curved, with a sharp tip.

© Teena Ruark Gorrow

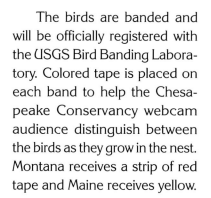

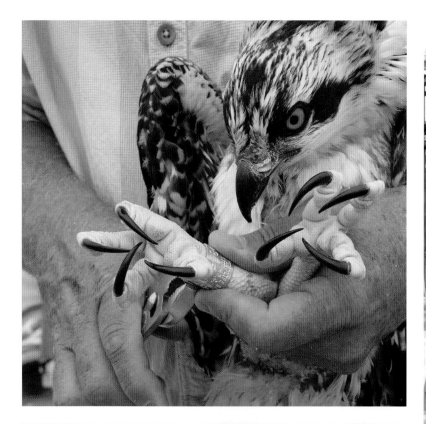

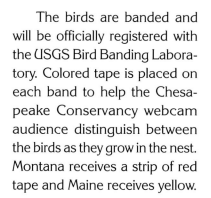

The birds are banded and will be officially registered with the USGS Bird Banding Laboratory. Colored tape is placed on each band to help the Chesapeake Conservancy webcam audience distinguish between the birds as they grow in the nest. Montana receives a strip of red tape and Maine receives yellow.

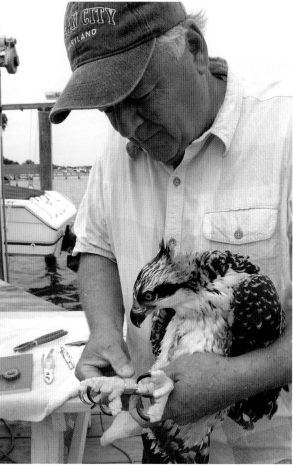

Both chicks receive migratory bird bands.
Photos © Teena Ruark Gorrow

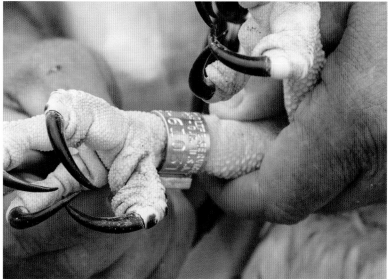

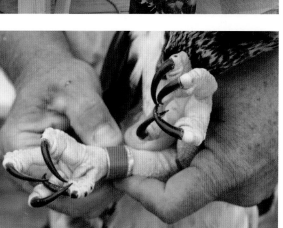

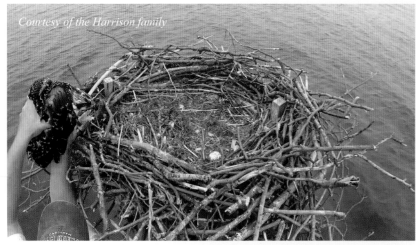

Courtesy of the Harrison family

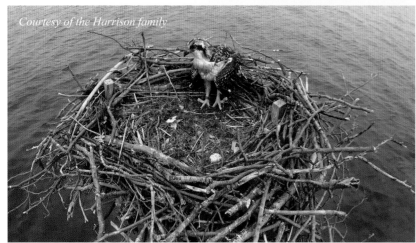

Courtesy of the Harrison family

With the health checks and banding completed, Mr. Koppie and Mr. Harrison start wading toward the nest platform to return the chicks. Audrey flushes from the nest, briefly meets Tom in the air, and defensively circles the area.

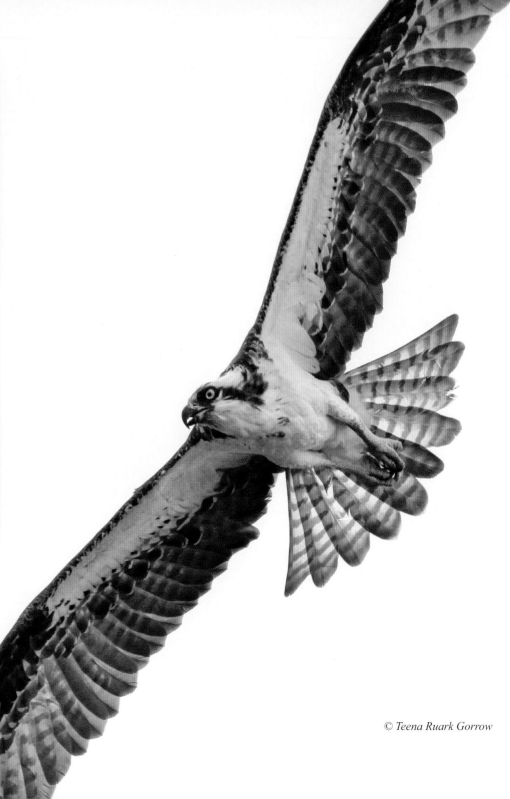

© *Teena Ruark Gorrow*

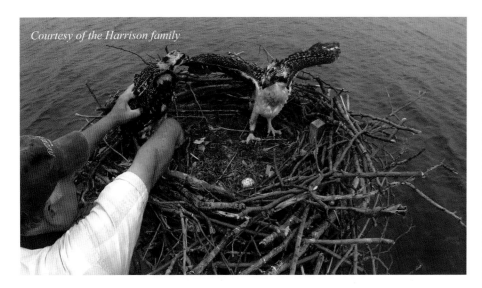

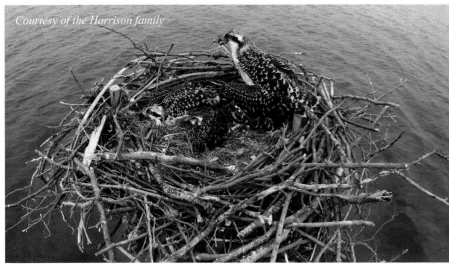

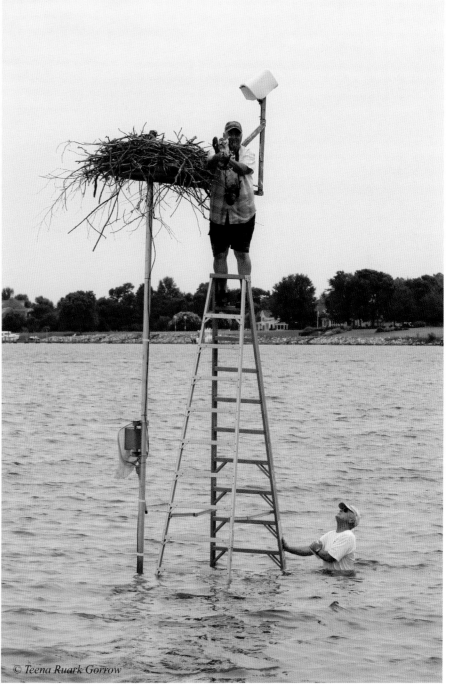

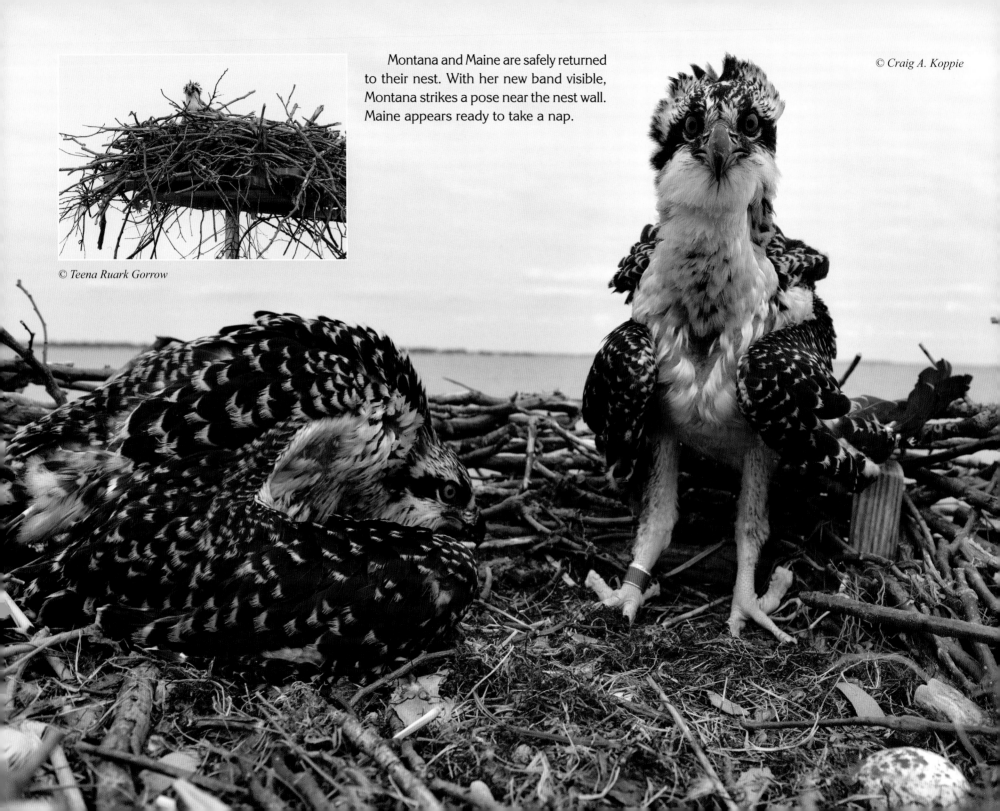

Montana and Maine are safely returned to their nest. With her new band visible, Montana strikes a pose near the nest wall. Maine appears ready to take a nap.

© Craig A. Koppie

© Teena Ruark Gorrow

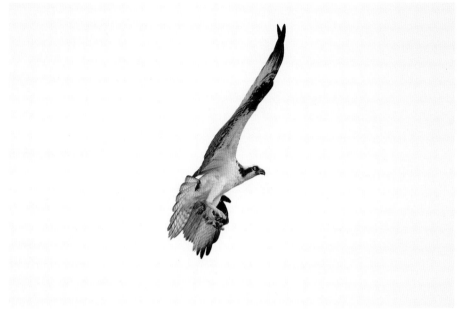

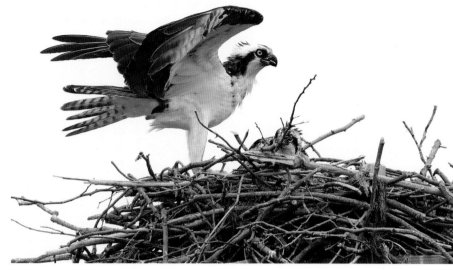

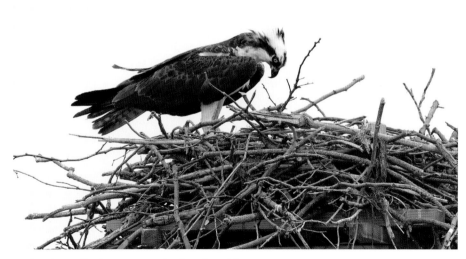

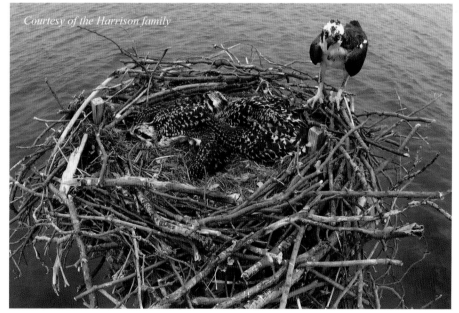

Courtesy of the Harrison family

Audrey immediately returns to check on her girls.
Photos © Teena Ruark Gorrow

Two days after the health checks and banding, a fledgling from a neighboring nest makes a surprise visit and lands beside the siblings. It is unclear why the intruder selected this spot as a resting place. Perhaps the young bird was lost or confused. Maybe the osprey experienced a problem while taking its first flight or there was trouble in its home nest. While fledglings do sometimes visit nearby nests, this has not happened in the twenty years the Harrisons have had a platform nest on their property.

The siblings do not appear apprehensive about their guest and stay plopped on their bellies. However, that is not the case with their mother. In seconds, Audrey lands on the nest rim to handle the intrusion.

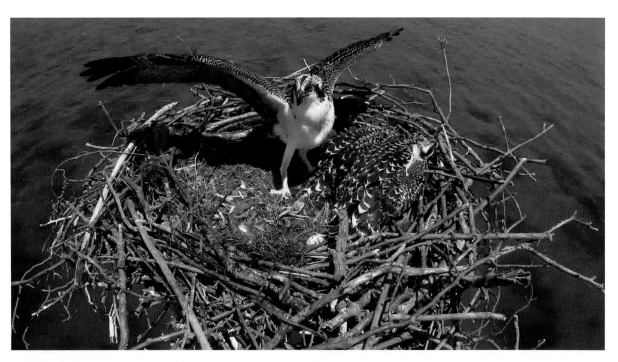

An intruder arrives at the nest.
Photos courtesy of the Harrison family

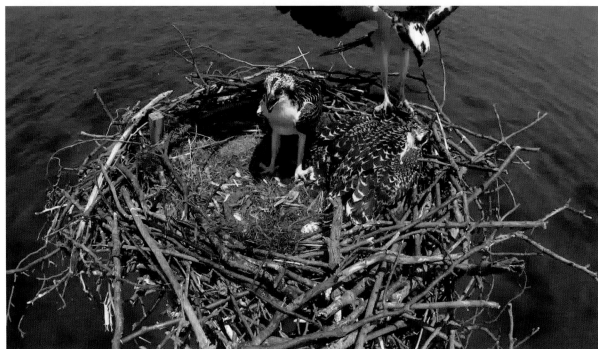

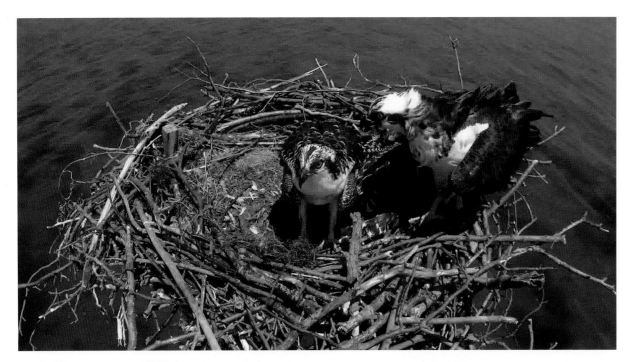

Seeing that the siblings are undisturbed, Audrey moves closer to the fledgling. The young bird cheeps in a high tone that resembles whining. Scrutinizing her visitor, Audrey vocalizes, aggressively flaps her wings, and pecks the fledgling on the head. Looking around the nest area, the younger osprey continues to cry and demonstrates food-begging behaviors. Audrey is not accepting company at this time, but the fledgling does not heed her warning.

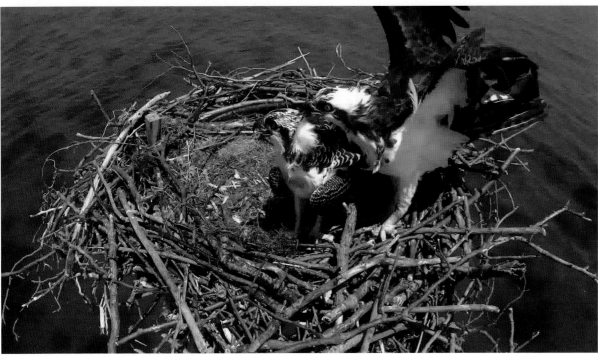

The fledgling's vocalizations are constant and piercing. Even so, Audrey maintains her defensive posture and surrounds the uninvited guest with her wings. She relentlessly pecks and shoves the interloper.

Landing on the nest wall with a fish gripped in his talons, Tom interrupts the standoff. He has removed the head from the fish and the meal is ready to eat. The fledgling is eyeing the fish.

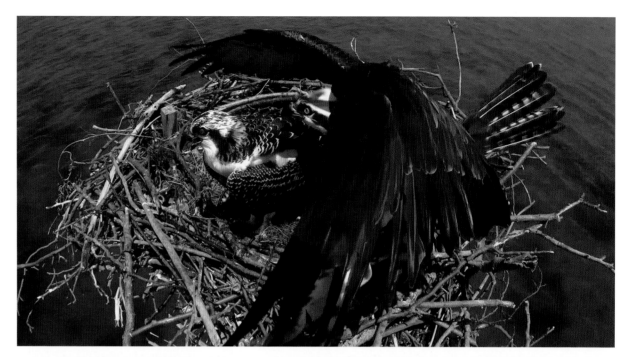

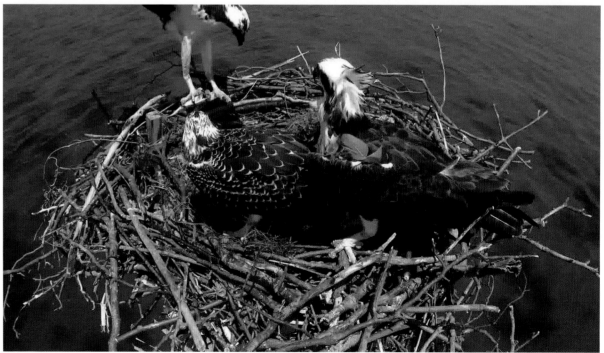

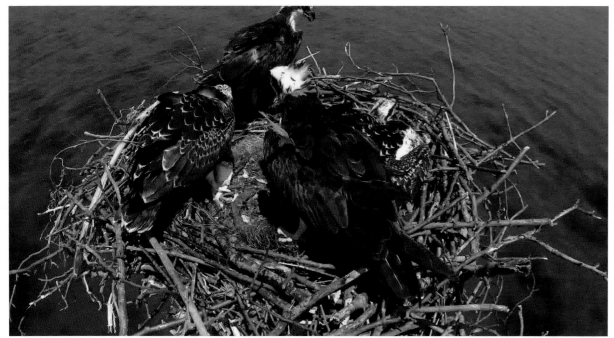

In seconds, the hungry visitor grabs the fish from Tom, briefly mantles the food, and tears away a piece of the meat. The fledgling quickly swallows the strip of flesh and returns for another bite. Audrey's disapproval is evident as she maintains her defensive posturing. Indifferent to Audrey's concerns, Tom perches on the nest wall and looks out over the water. Audrey and the fledgling somehow come to an understanding.

A few hours later, Audrey brings a fish to the nest and offers dinner to her girls. The cautious fledgling warily moves toward Audrey. Without hesitation, the caring mother offers a generous serving of meat to the fledgling and continues to feed the bird. Then, there were three.

Photos courtesy of the Harrison family

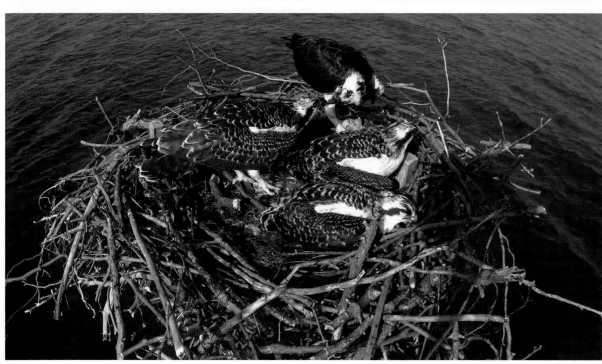

The nest guest takes flight but soon returns. The reason this fledgling decided to live with Tom, Audrey, and the siblings will remain a mystery. Seeing that the young osprey has been accepted as a member of the family, Mrs. Harrison offers E.T. as the name for the third foster chick. The Chesapeake Conservancy webcam audience agrees.

Considering E.T.'s overall appearance, size, and ability to fly, the fledgling is thought to be a male and approximately two to three weeks older than his new siblings. He comes and goes with no protests from his foster parents. If E.T. is away from the nest when a fish is delivered, he arrives on the scene in a hurry to share the meal. He also flies to the nest and calls to Tom when he is ready to eat.

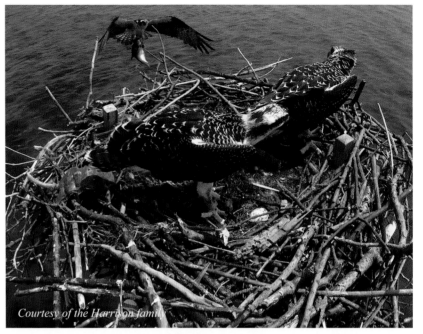

Courtesy of the Harrison family

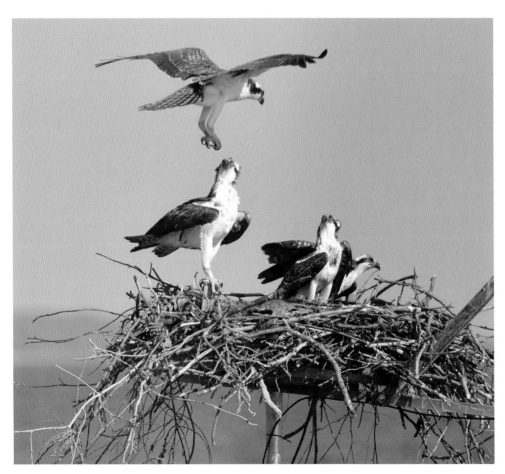

Tom and Audrey now have three chicks.
© *Craig A. Koppie*

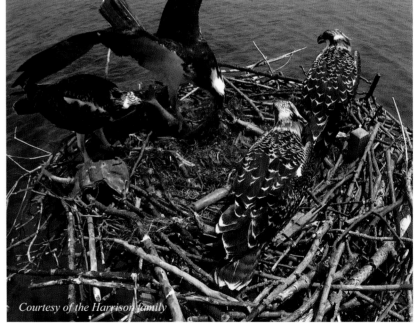

Courtesy of the Harrison family

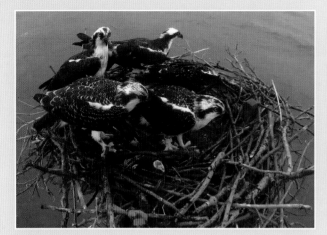

Courtesy of the Harrison family

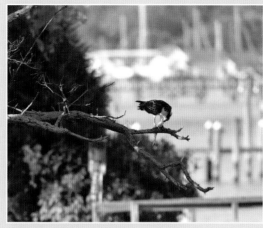

E.T. sometimes takes his fish to a favorite perch at mealtime. © Craig A. Koppie

Over the next few days, E.T. gets comfortable in his new home. With another mouth to feed, Tom delivers extra fish to ensure that there is no sibling rivalry or food competition. In fact, Tom sometimes supplies his family with six or more fish in a ninety-minute period.

E.T. boldly accepts Tom's catch and often claims the first fish delivered. He usually perches on the nest wall when consuming the fresh meat. From time to time, E.T. takes the meal from the nest to a favorite perching spot, perhaps to practice his fish-carrying skills.

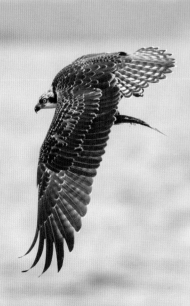

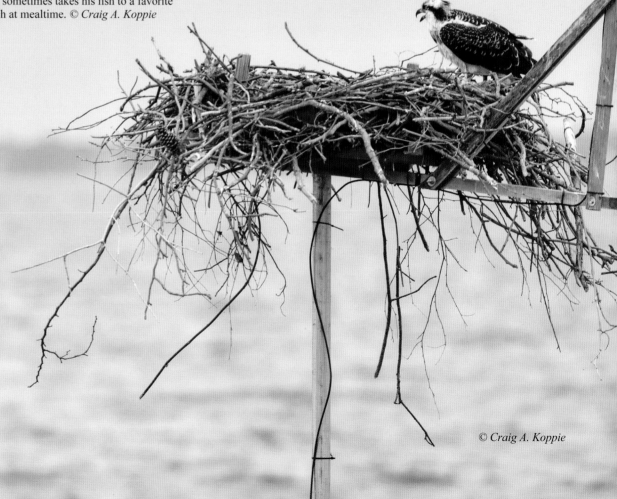

© Craig A. Koppie

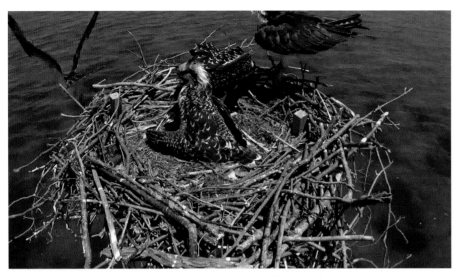

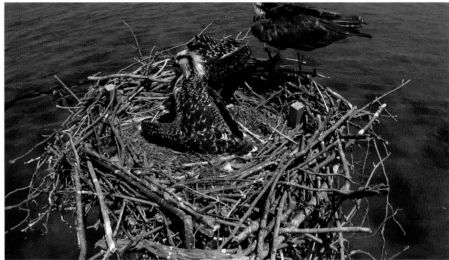

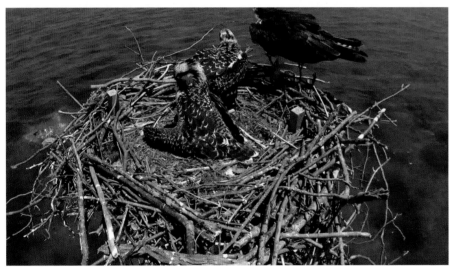

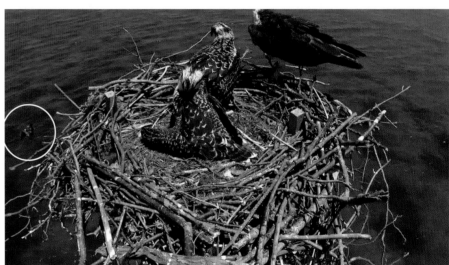

E.T. takes a bath. (Circles were added to show E.T. in the water.) *Photos courtesy of the Harrison family*

One hot July day, the siblings are busy preening their feathers as Audrey watches the nest skies. While the girls are grooming, E.T. suddenly dives from his perched position on the nest wall and plunges into the water below the nest. He flaps his wings and splashes water around his body. At times, he submerges his head and briefly disappears underwater. E.T. is bathing.

E.T. lifts out of the water, shakes the excess droplets from his wings, and flies back to the nest. Having landed, he extends his wings out over the nest to dry. He then heads back into the water for more fun. The family stops to watch E.T. splashing in the water below the nest.

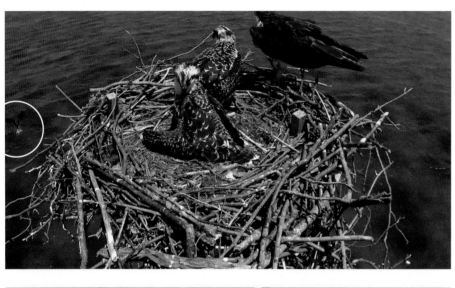

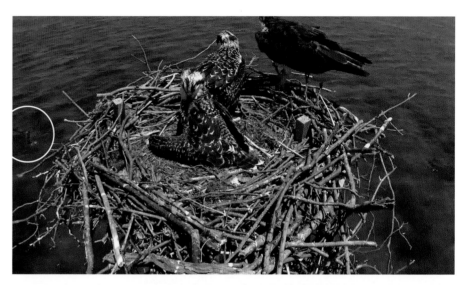

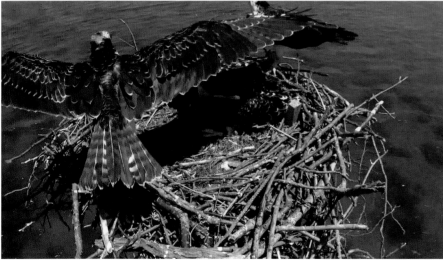

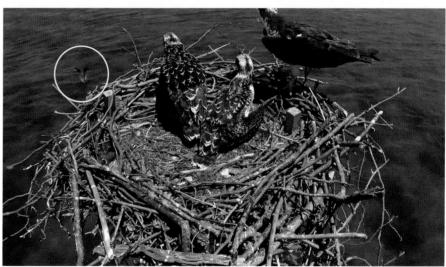

Photos courtesy of the Harrison family

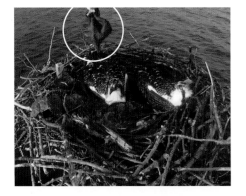

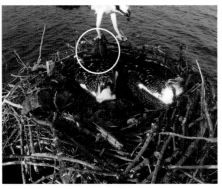

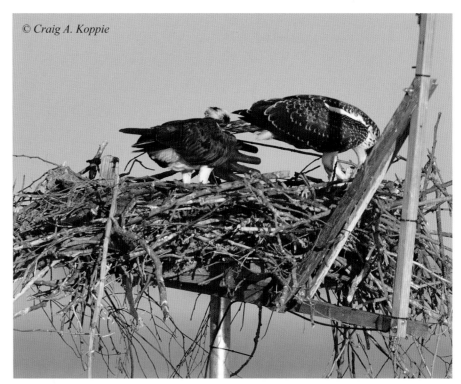

© Craig A. Koppie

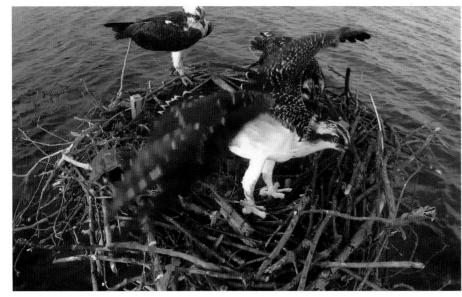

There is great excitement when Tom arrives with a black rubber glove—a new source of entertainment for the entire family! The ospreys lift, bite, and drag it across the nest. Ospreys are known to bring shells, like the horseshoe crab delivered earlier, to their nests, along with other decorative items including toys and stuffed animals. Maine is particularly fond of the glove and uses it as a pillow.

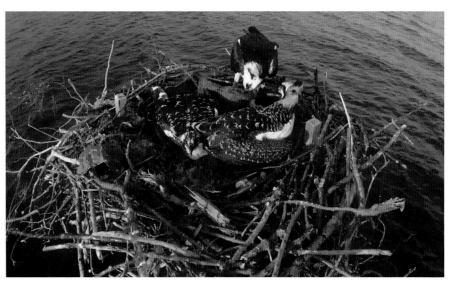

Tom brings a black rubber glove to the nest. (Circles were added to show the glove.) *Photos courtesy of the Harrison family*

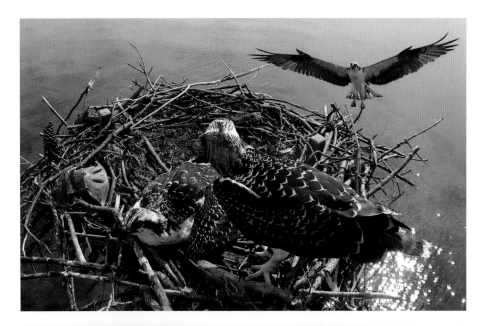

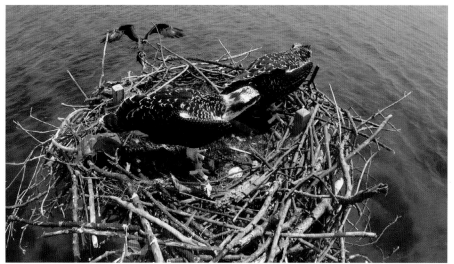

Now August, the almost adult-sized siblings are alert and active. They observe their parents and other movement beyond the nest.

In addition to playing with the glove and toying with nest materials, the sisters stretch, flap their wings, and hop around the nest. These exercises help develop wing and leg muscles as the siblings prepare to fledge.

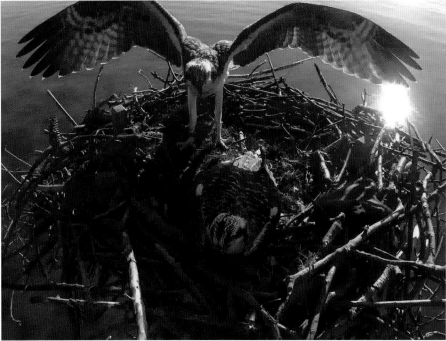

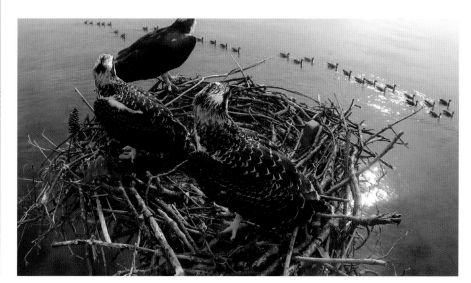

Photos courtesy of the Harrison family

It takes more and more food to feed the growing and active young ospreys. In addition to the array of menhaden and bluefish Tom already delivered to the nest on this particular afternoon, he fetches an Atlantic needlefish for the family. He battles the fish into position.

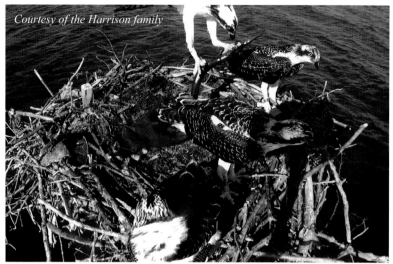

Courtesy of the Harrison family

Tom is an experienced angler and handles Atlantic needlefish with skill. *Photos © Craig A. Koppie*

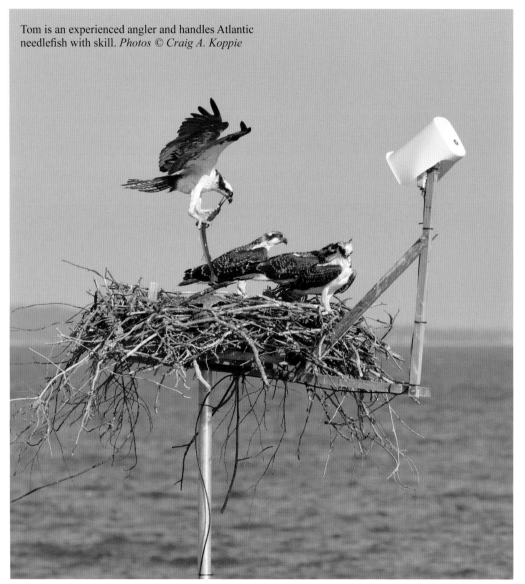

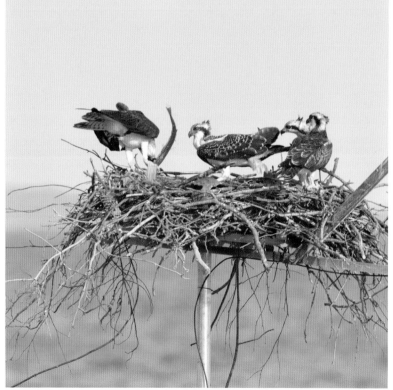

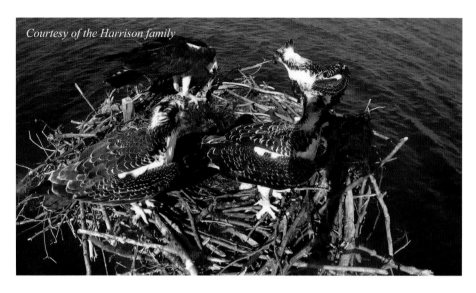

Courtesy of the Harrison family

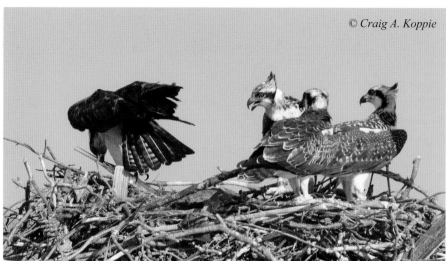

© Craig A. Koppie

Given the fish's long, narrow body and toothy jaws, it takes effort to prepare this meal for the family. The first step is to carefully break into the head area. The needlefish is devoured and all three chicks turn away, filled.

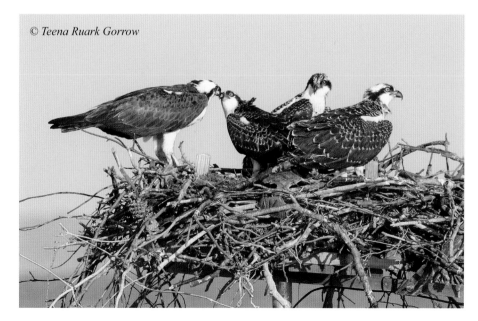

© Teena Ruark Gorrow

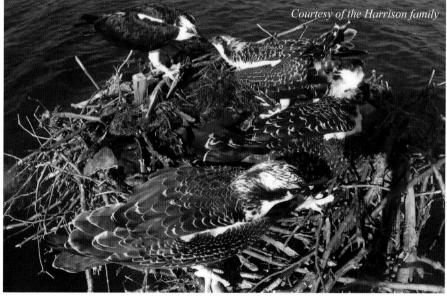

Courtesy of the Harrison family

96

Later that evening, Montana and Maine are alone inside the nest. Both siblings have been hopping and flapping their wings to prepare for fledging. Maine has plopped on her belly to rest after the fish feast she enjoyed during the afternoon.

Montana, on the other hand, faces the light breeze and performs an array of wing-flapping exercises. She lifts her wings, powers upward, and briefly hovers over the nest before dropping her feet back onto the sticks.

Montana exercises while Maine is plopped on her belly. *Photos © Teena Ruark Gorrow*

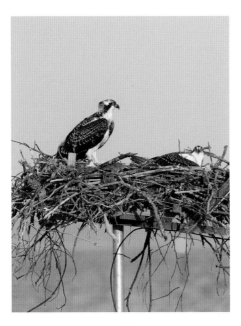
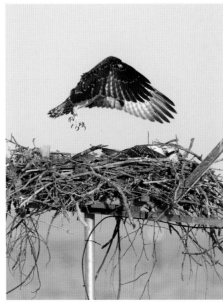
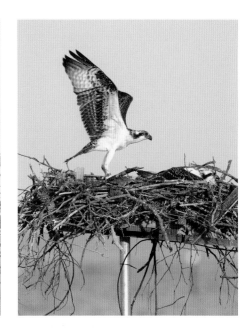

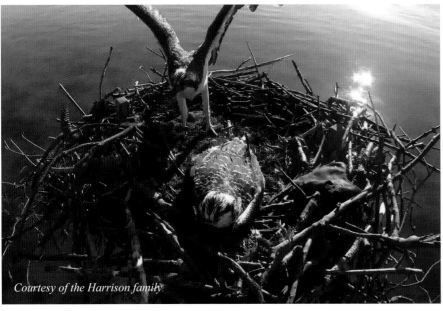
Courtesy of the Harrison family

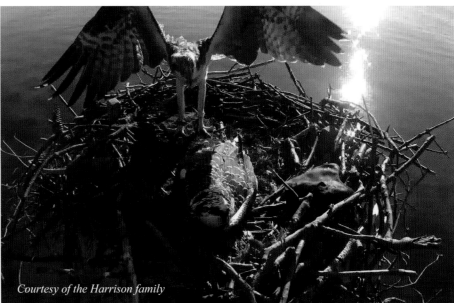
Courtesy of the Harrison family

Later that evening, Montana and Maine are alone inside the nest. Both siblings have been hopping and flapping their wings to prepare for fledging. Maine has plopped on her belly to rest after the fish feast she enjoyed during the afternoon.

Montana, on the other hand, faces the light breeze and performs an array of wing-flapping exercises. She lifts her wings, powers upward, and briefly hovers over the nest before dropping her feet back onto the sticks.

Montana is learning about control as she tests her wings in the wind. *Photos © Craig A. Koppie*

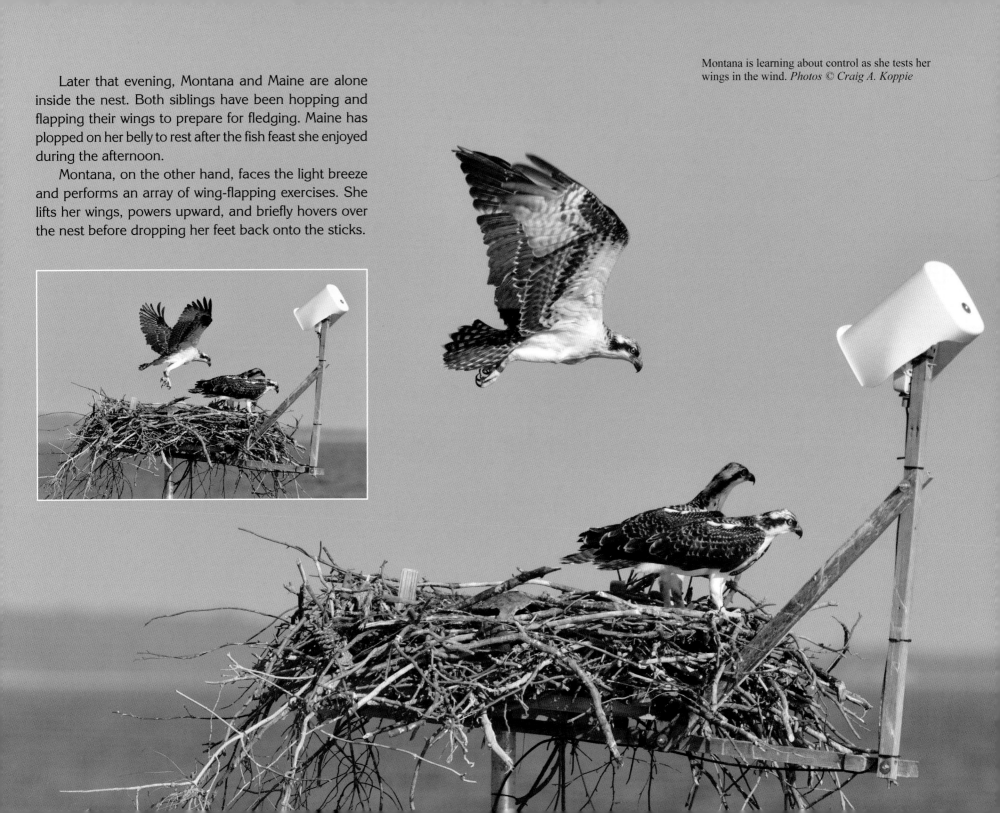

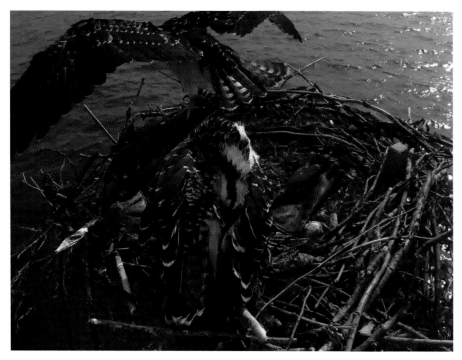
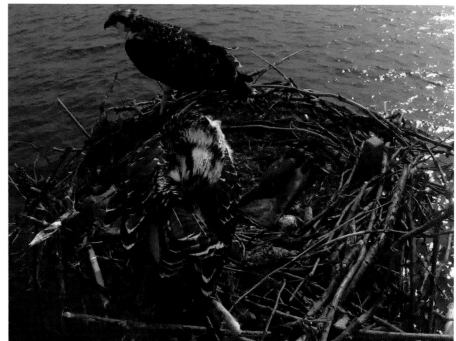

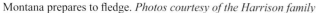
Montana prepares to fledge. *Photos courtesy of the Harrison family*

There is a sense of anticipation as Montana hops onto the rim of the nest and tightly grasps the branches with her talons. Facing the breeze, she spreads her wings and leans into the wind. Not quite ready to release the nest material from her grip, she quickly retracts her wings and folds them close to her body.

Bobbing her head back and forth, Montana intently observes the area directly in front of her. She opens her wings a second time but folds them back into place.

The young osprey adjusts her position on the nest's rim and robustly flaps her wings. Although still holding on to the nest wall, Montana fully extends her wings and tail feathers. The nest platform begins to shake as Montana vigorously pumps her wings and rapidly hops along the nest wall. Busy preening on the opposite side of the nest, Maine pauses to observe her sister's activity.

Suddenly, Montana lifts off the nest and remains airborne. With the wind beneath her wings, the elder sibling takes her first flight. She is now a fledgling.

Maine observes as her sister glides above her head and around the nest area. Her eyes follow Montana's every movement.

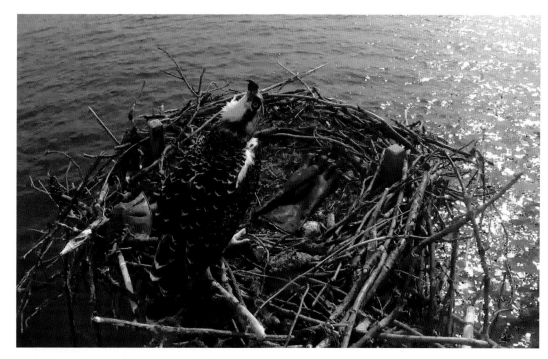

Montana is a fledgling. *Photos courtesy of the Harrison family*

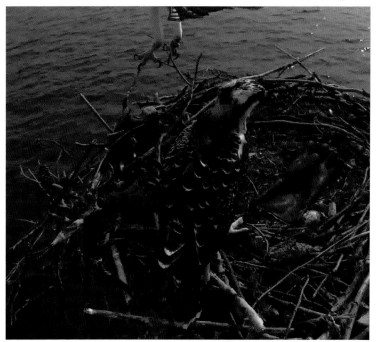

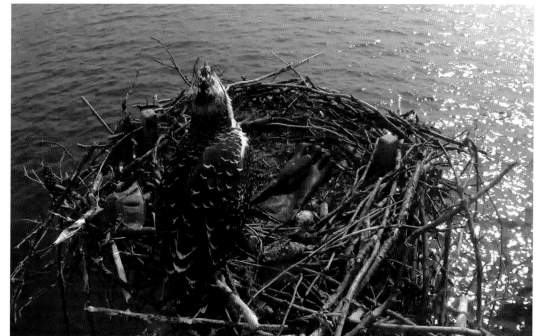

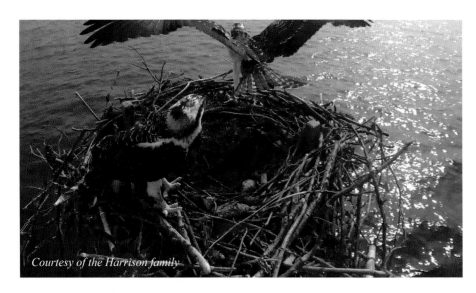

Montana's first flight lasts just under two minutes and she lands successfully inside the nest. As if this monumental achievement were an ordinary event, the girls perch on opposite sides of the nest to preen.

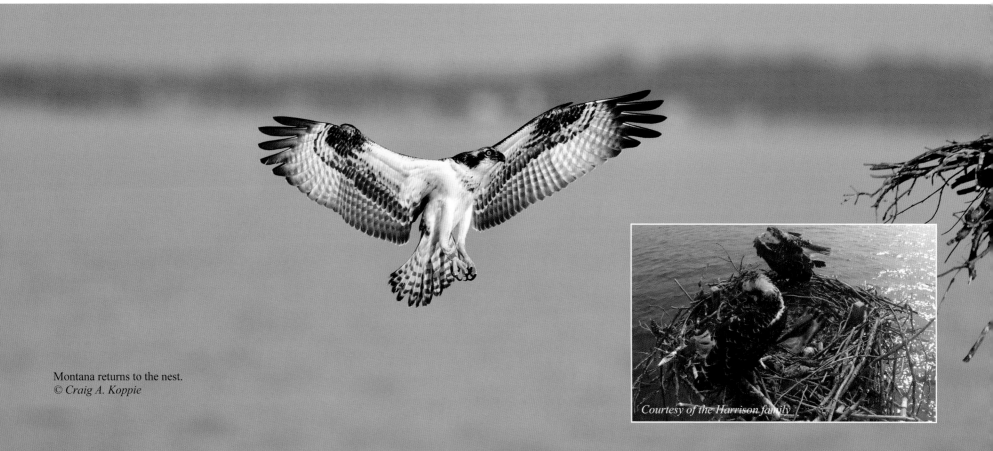

Montana returns to the nest.
© Craig A. Koppie

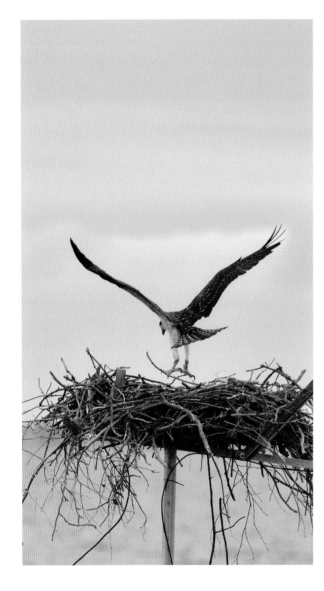
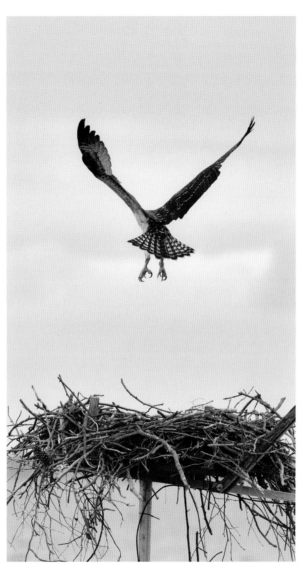
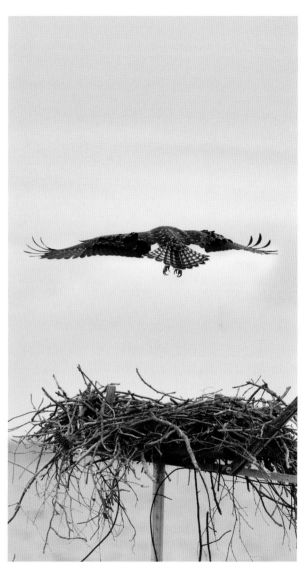

Photos © Craig A. Koppie

Maine is also training for flight. She exercises her wings, powers upward, and hovers over the nest before lowering her body back onto the sticks. Like her sister, this young osprey will soon fledge.

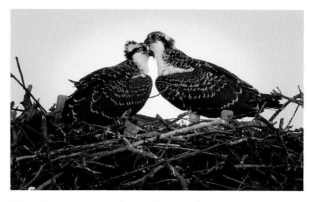 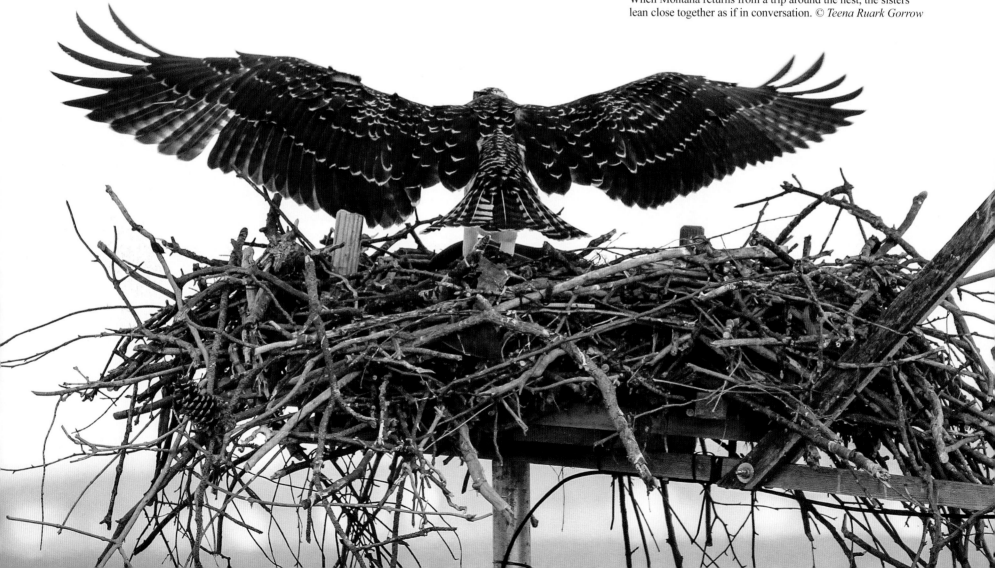

Maine takes advantage of the roomy nest to wing-ercise. © *Teena Ruark Gorrow*

When Montana returns from a trip around the nest, the sisters lean close together as if in conversation. © *Teena Ruark Gorrow*

102

While Maine is napping, a blast of wind under her right wing and tail unexpectedly lifts her from behind. She flips over onto her head but quickly regains her footing.

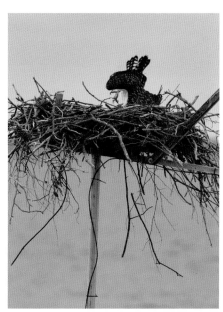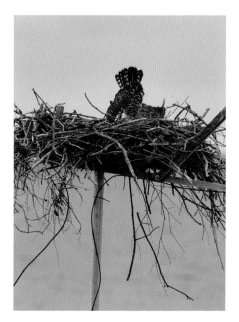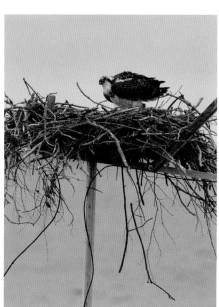

Photos © Craig A. Koppie

On this beautiful August morning, two days after Montana fledged, Maine is flapping her wings and hopping along the nest wall while vocalizing. She is watching the dock area where Tom and her siblings sometimes perch. Maine wants to fly.

Tentatively, she approaches the rim and spreads her wings. But, the apprehensive nestling hesitates and decides she is not ready to glide into the breeze.

Seconds later, Maine hops to the opposite side of the nest. This time, the young raptor's movements demonstrate determination and control. She gracefully spreads her tail feathers and lifts her fully extended wings while releasing the nest rim. Catching the wind, Maine rises into the air.

The youngest nestling is now a fledgling. Maine is flying.

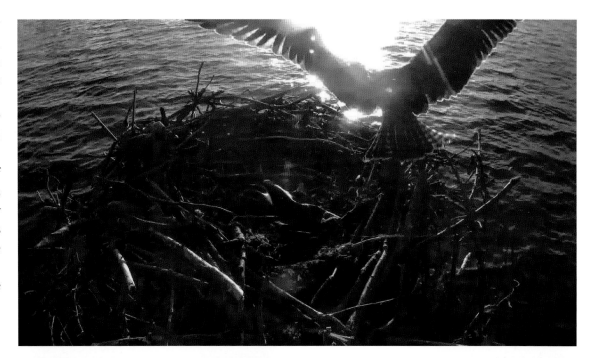

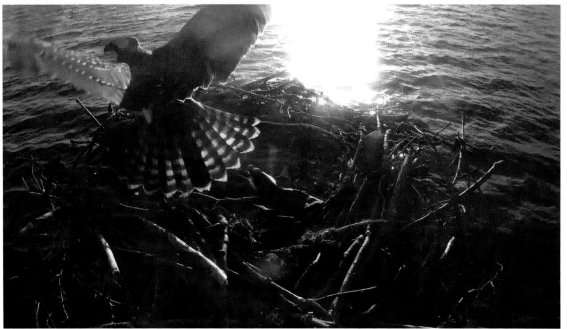

Photos courtesy of the Harrison family

Maine has fledged.
© Craig A. Koppie

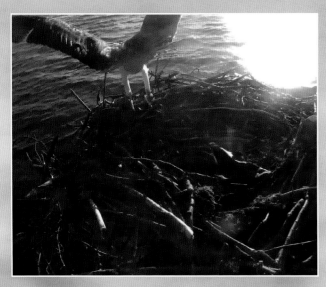

A successful landing for Maine. *Courtesy of the Harrison family*

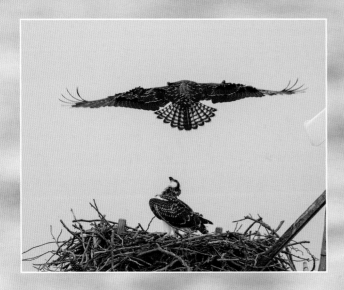

Photos © Teena Ruark Gorrow

Maine's first flight lasts approximately three minutes and concludes with a successful landing on the nest rim, where she perches to preen. During the day, both fledglings practice wing-flapping and hopping around the nest.

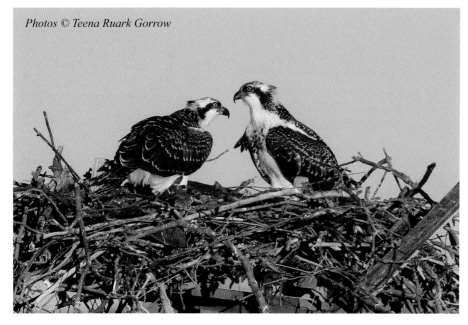

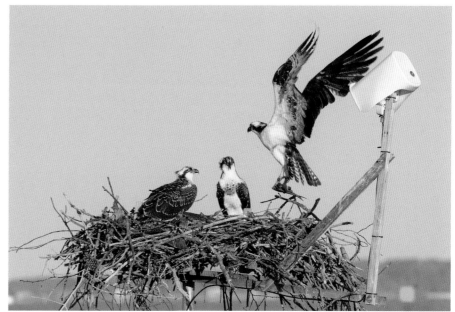

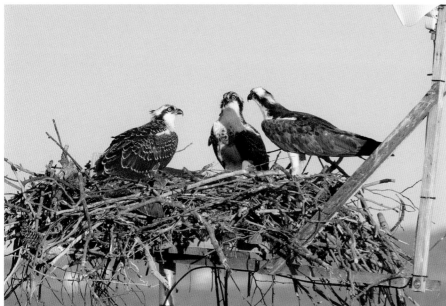

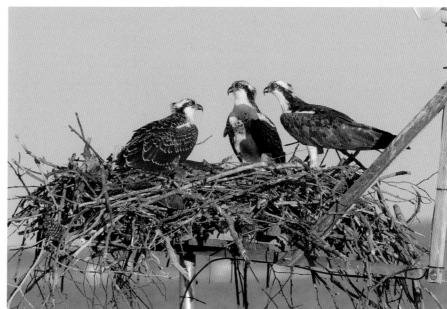

Photos © Teena Ruark Gorrow

As sundown approaches, Montana and Maine are perched inside the nest. Tom arrives with a fresh fish, but neither fledgling appears interested in having a meal. Tom seems to communicate with each daughter before heading toward the neighbor's dock to consume the fresh catch.

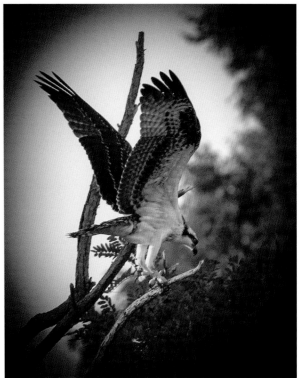

Maine lands on a snag near the nest.
© *Teena Ruark Gorrow*

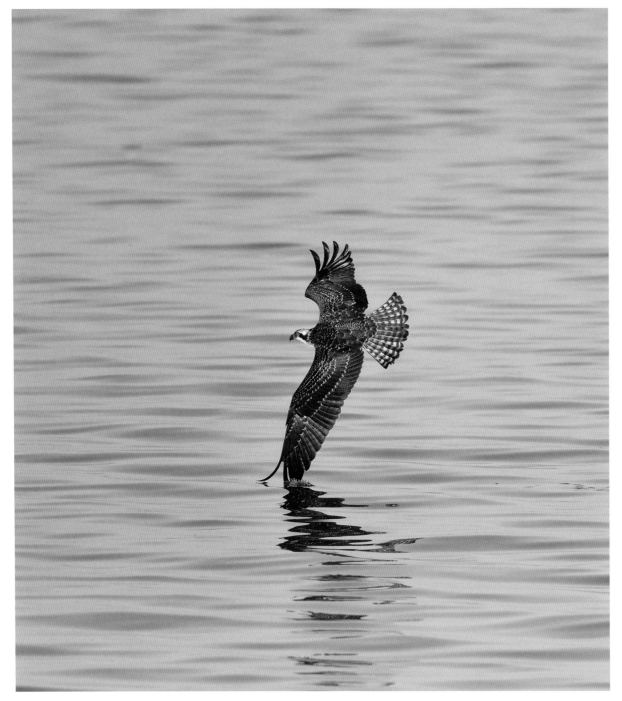

Montana glides over the water and dips her wing.
© *Craig A. Koppie*

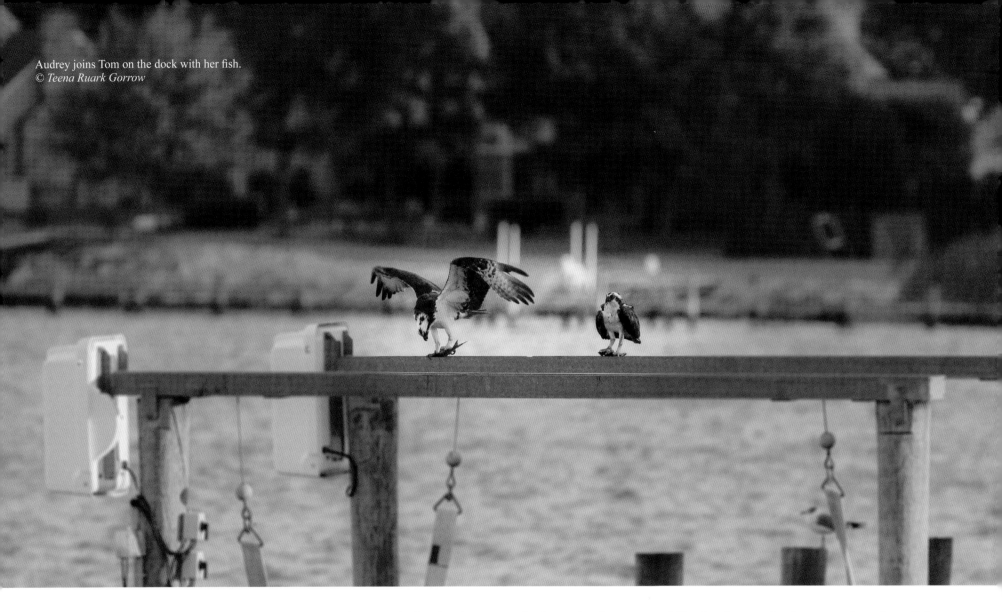

Audrey joins Tom on the dock with her fish.
© *Teena Ruark Gorrow*

Montana soon flies out of the nest and glides over the water before landing in a nearby tree. Within minutes, Maine leaves the nest and repeatedly circles the nest area before heading to the tree where she has often watched her father perch. She carefully lands on a snag and rubs her beak on the branch.

Shortly thereafter, Audrey arrives at the nest to offer a second dinner opportunity. She calls her young family to gather round. Still, the fledglings express no interest in food.

Audrey exits the nest and flies by the patch of trees at the edge of the nest area where Maine is perched. Satisfied that all is well with her family, Audrey circles the nest area and joins Tom at the dock.

After a few bites of fish, something catches her attention and Audrey begins to watch Maine. The protective mother quickly grips the fish and flies toward the trees. In seconds, Audrey lands on a branch just below Maine and perches with her youngest daughter.

Now that they can fly, Maine, Montana, and E.T. spend less time at home. They explore trees, docks, boats, and other items of interest along the shoreline. From their perching posts, these young birds of prey watch the shadows of fish swimming just beneath the surface.

Although the fledglings will come and go during the next few weeks until migration, the nest platform will remain a central gathering place for the family. Tom and Audrey will continue to drop off food for the fledglings while they learn to fish.

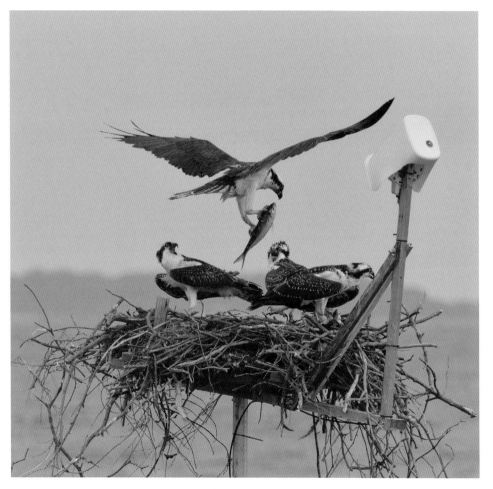

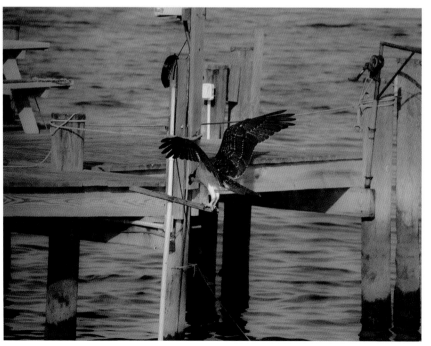

Photos © Craig A. Koppie

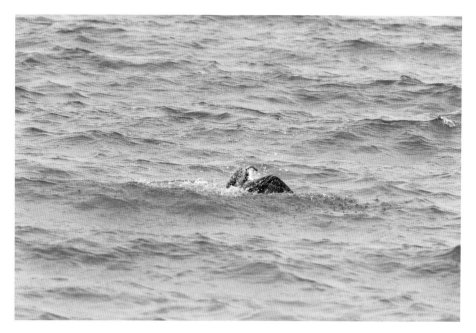
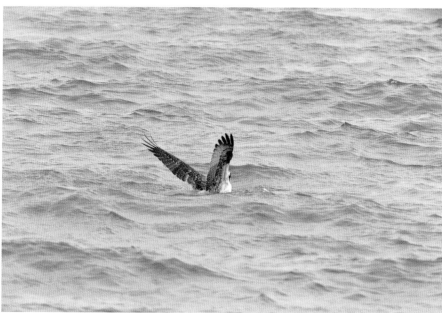

Scanning the water from her perch on a nearby tree, Montana spots a fish near the surface. She glides over the water, splashes down, and makes her first attempt. After the plunge, she comes up empty-footed. With practice, the young osprey will become a proficient angler, but, not today.

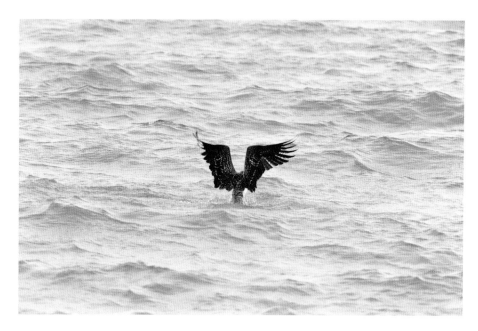
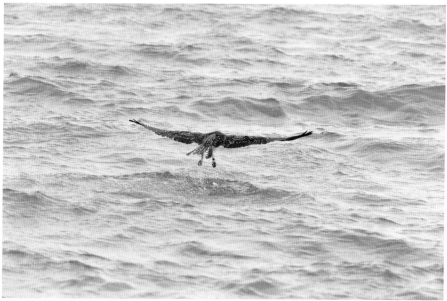

Photos © Craig A. Koppie

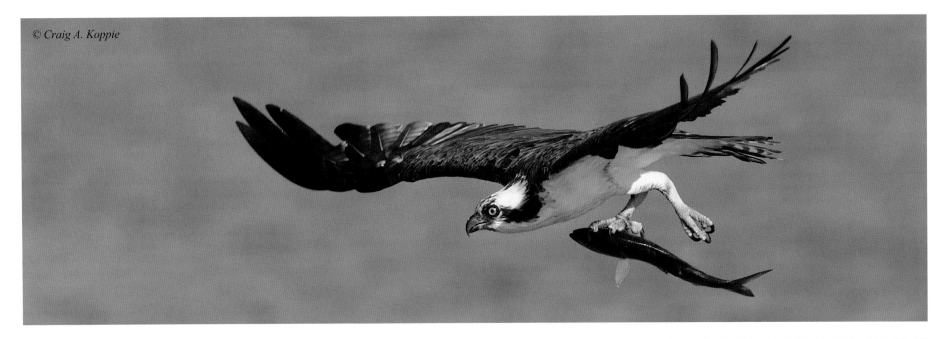

© Craig A. Koppie

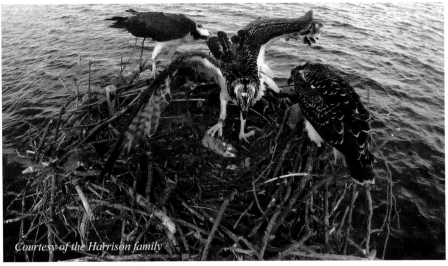

Courtesy of the Harrison family

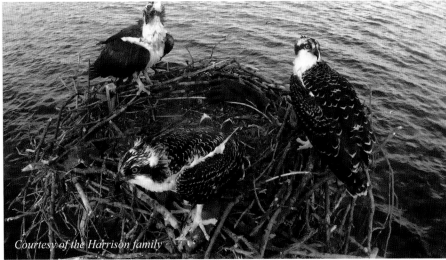

Courtesy of the Harrison family

Montana knows that she will not go hungry. Back at the nest, she eagerly accepts a fish delivery. With her feet and talons, she masterfully handles the fish while maintaining her footing in the nest and on the wall. She has learned her parents' technique of consuming the fish from head to tail, starting with the head.

The girls have eaten, but E.T. returns to the nest hungry. He perches on the wall and calls for his father to bring a fish.

Perhaps displaying gratitude, E.T. flaps his wings, hops around the nest, and chirps when he sees Tom approaching with a large fish. Tom arrives with an impressive meal for his son. E.T. enthusiastically accepts the fish and drags it to the center of the nest.

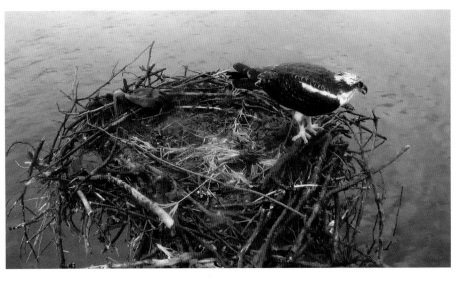

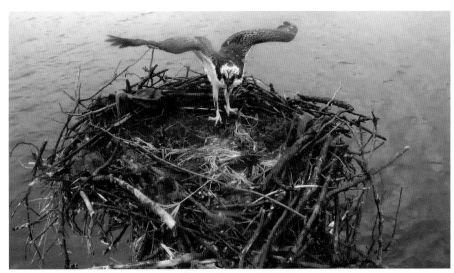

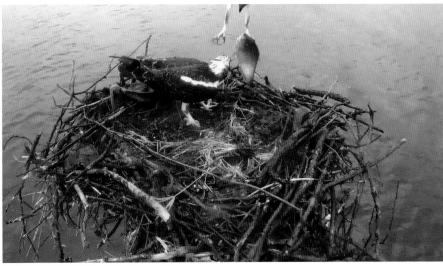

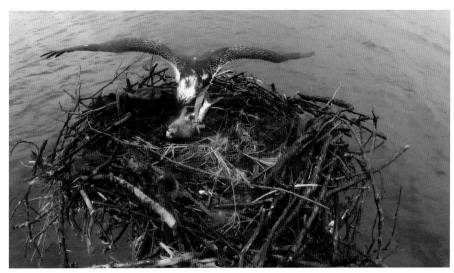

E.T. calls for a fish delivery. *Photos courtesy of the Harrison family*

114

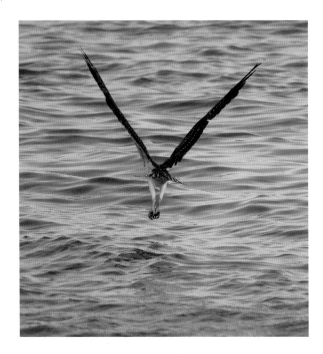

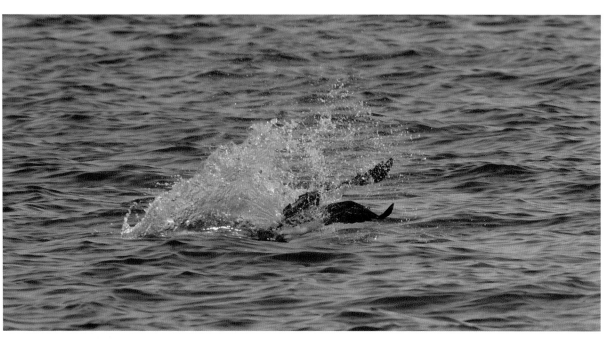

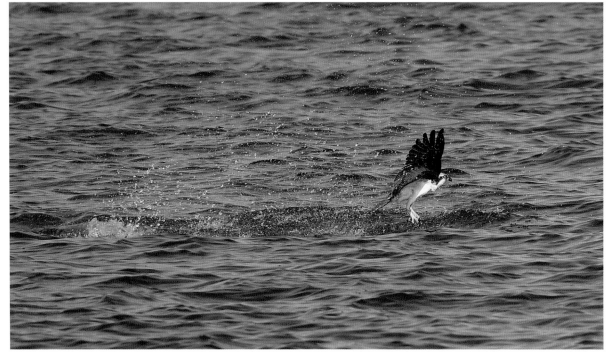

On her way to pick up a clump of wet grass for the nest, Audrey takes a detour. She skips across the water and plunges in headfirst to bathe.

Photos © Craig A. Koppie

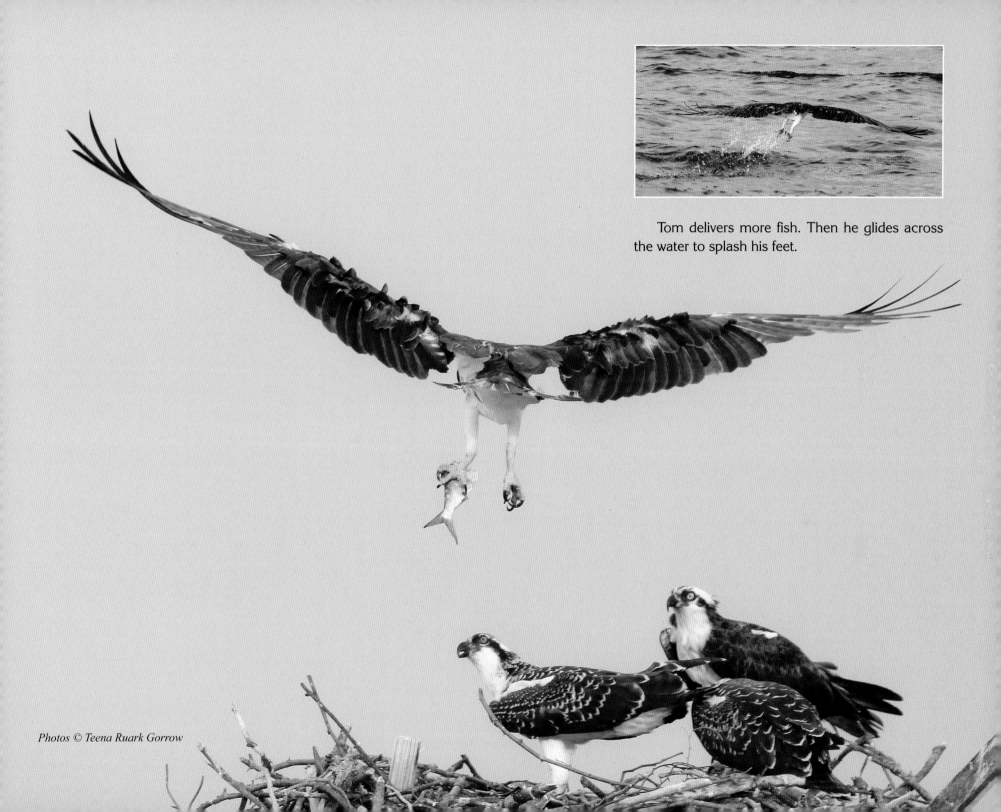

Tom delivers more fish. Then he glides across the water to splash his feet.

Photos © Teena Ruark Gorrow

Audrey and Tom have been faithful companions throughout nesting season. Together they built a cozy home on the over-water nest platform provided by the Harrison family. The dedicated parents-to-be laid a clutch of three eggs, which they incubated well past the eggs' viability time line. When their eggs didn't hatch, the pair willingly accepted two foster chicks rescued from an overcrowded nest. Shortly thereafter, they also accepted an intruder fledgling in need of help. With commitment and dedication, the caring parents successfully raised their brood of three foster chicks with a worldwide audience viewing their every action through the Chesapeake Conservancy's osprey webcam.

As nesting season comes to a close, the Chesapeake's favorite osprey couple and their young will soon depart for warmer regions. If they follow typical osprey migration routes, these beloved raptors will journey to Central or South America. With September just around the corner, any day could be the last to see these magnificent raptors in the Chesapeake Bay—until next season.

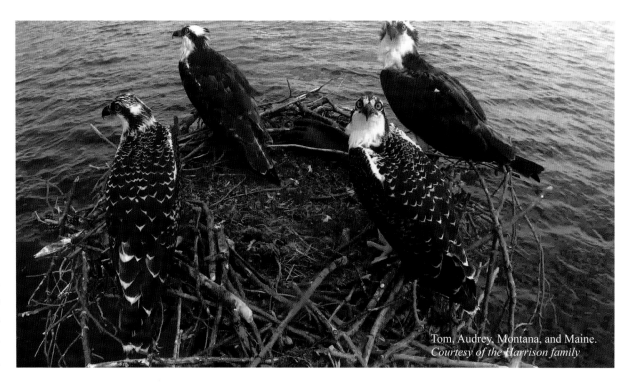

Tom, Audrey, Montana, and Maine.
Courtesy of the Harrison family

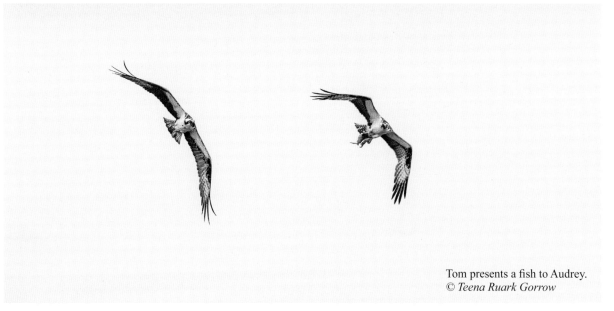

Tom presents a fish to Audrey.
© *Teena Ruark Gorrow*

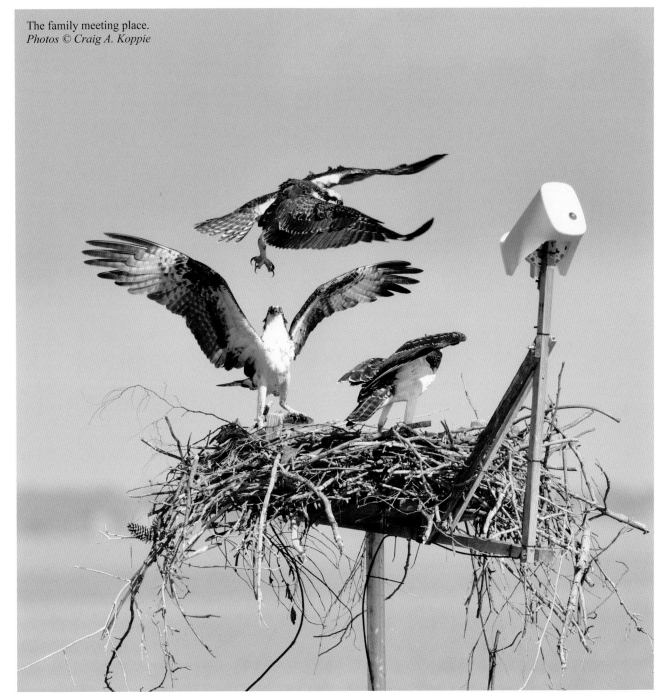

The family meeting place.
Photos © Craig A. Koppie

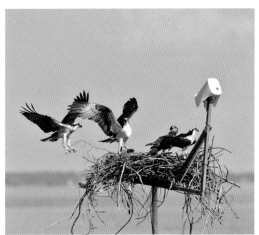

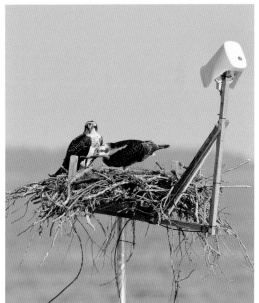

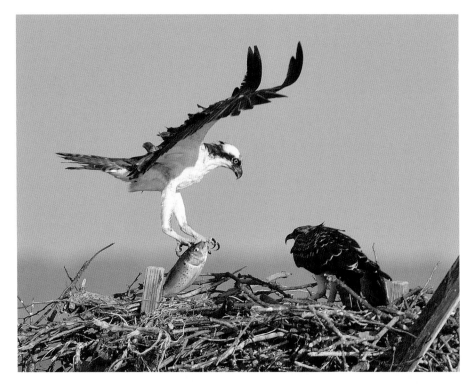

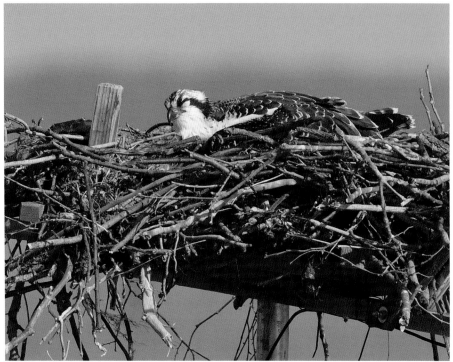

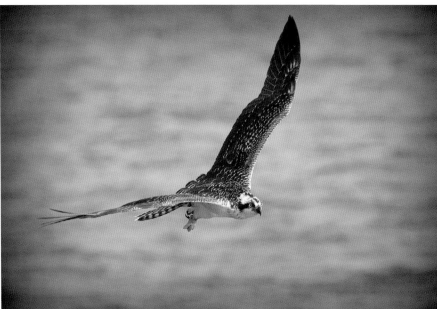

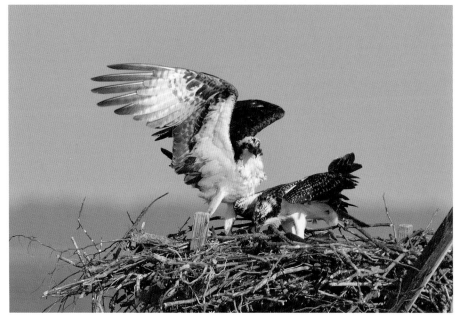

They eat, sleep, and fly. *Photos © Craig A. Koppie*

Full house. *Photos © Craig A. Koppie*

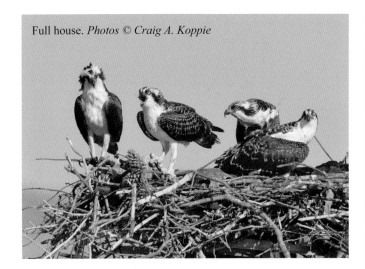

Powerhouse.

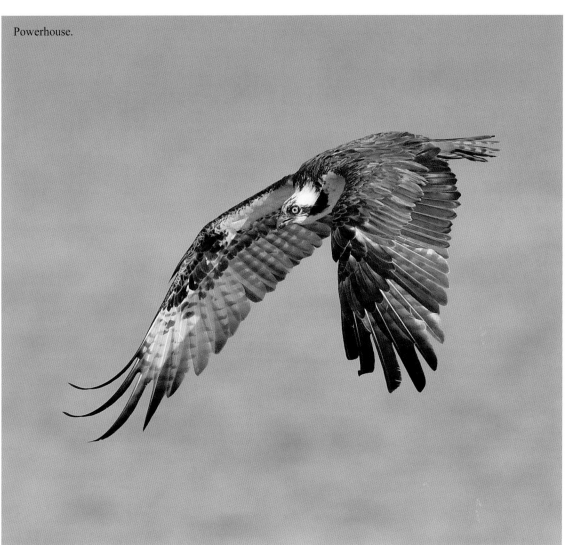

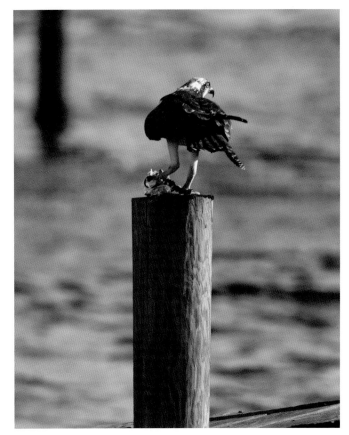

Perched on a Chesapeake Bay dock.

120

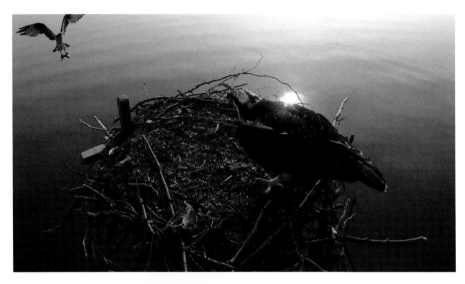

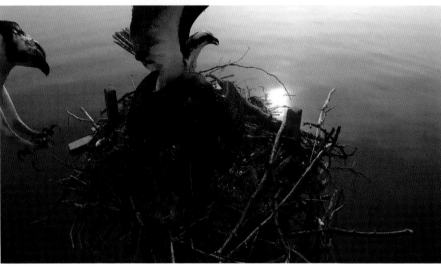

Audrey and Montana are no longer seen around the nest area. They have started their southward journey. However, Tom still watches over the nest and brings fish to Maine and E.T.

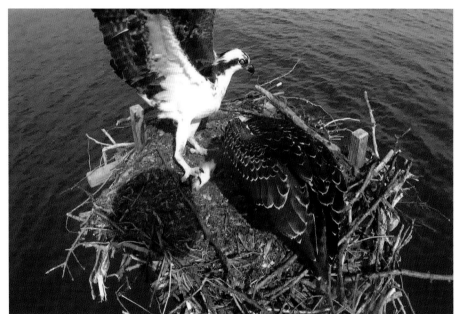

Photos courtesy of the Harrison family

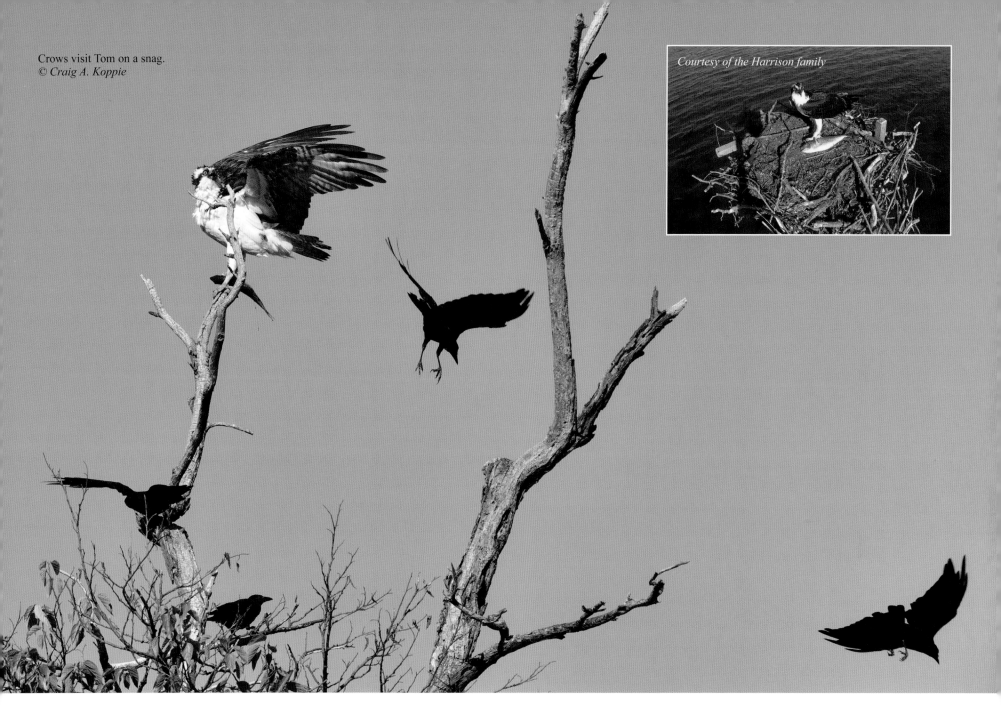

Crows visit Tom on a snag.
© Craig A. Koppie

Now mid-September, Maine has also migrated. Tom and E.T. are still around and occasionally land in the nest. E.T. has learned to fish.

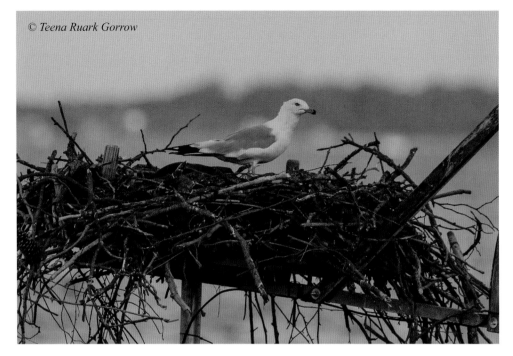

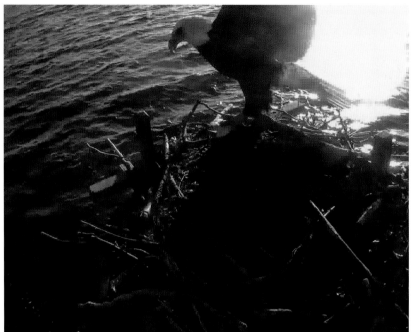

Because the nest is vacant most of the time, other birds sometimes stop by the nest to look for food or devour their catch. American bald eagles, crows, herons, and gulls are among the platform guests.

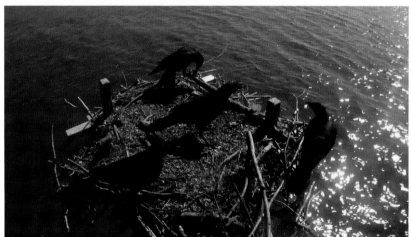

Photos courtesy of the Harrison family

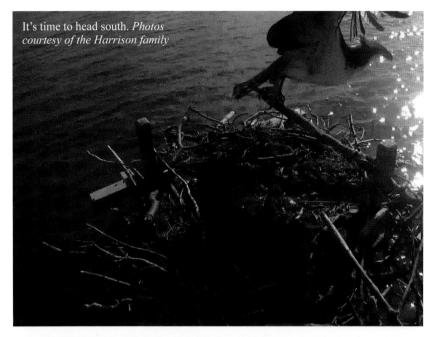

It's time to head south. *Photos courtesy of the Harrison family*

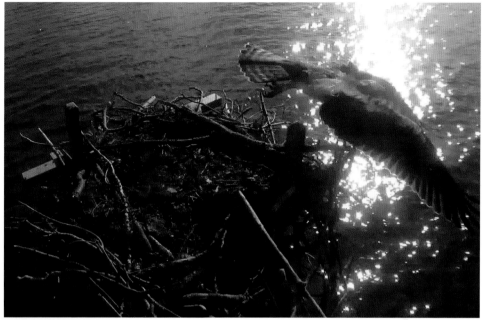

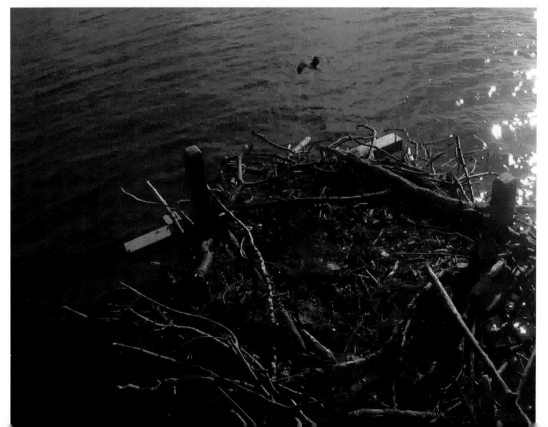

E.T. visits the nest one last time and then departs. He is the last member of the family to migrate. Like his siblings, the juvenile now begins his life away from home and starts the long journey south.

Osprey nesting season comes to a close on the
Chesapeake Bay. © *Teena Ruark Gorrow*

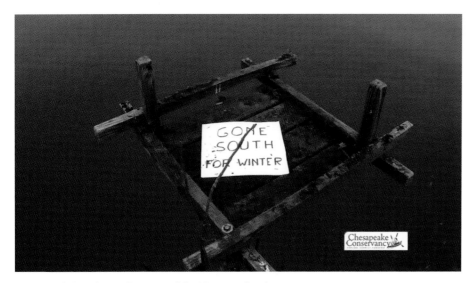

Gone south for winter. *Courtesy of the Harrison family*

With word of a potential hurricane traveling up the East Coast and confident that Audrey, Tom, and the kids have migrated, Mr. Harrison removes the nest and camera from the over-water platform. Mr. Koppie stops by to lend a hand.

The ospreys have vacated the Chesapeake Bay and the US Fish and Wildlife Service telemetry data shows that some members of this local population have already reached Central America. Nevertheless, it will soon be time for nesting season to begin once again. Between Valentine's Day and the wearing of the green, Mr. Harrison will wade out into the water to prepare the platform for Audrey and Tom. Hopefully, the magnificent osprey pair will return on schedule, build a nest, mate, and lay a clutch of eggs.

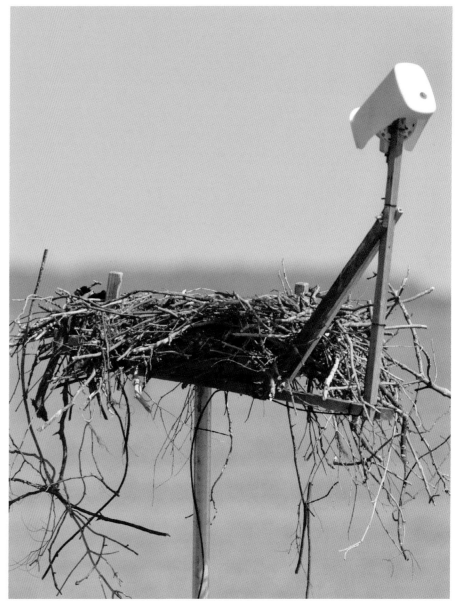

© *Craig A. Koppie*

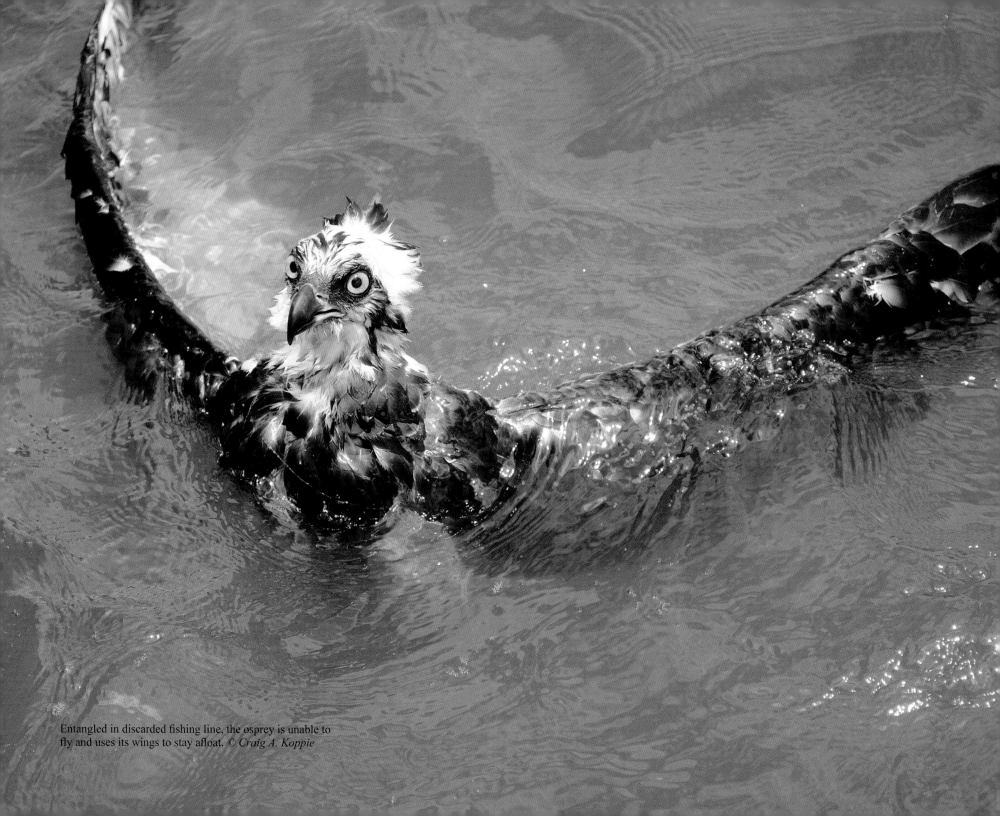

Entangled in discarded fishing line, the osprey is unable to
fly and uses its wings to stay afloat. © *Craig A. Koppie*

APPENDIX A: THE PLIGHT OF THE OSPREY

Since DDT was banned in 1972, osprey populations in the Chesapeake Bay and other areas of the US have made a remarkable comeback. The number of breeding pairs in the Chesapeake Bay, home to the largest nesting population in the world, is currently estimated to be around 10,000 pairs. However, ospreys continue to face threats caused by humans, including habitat destruction, water pollution, and noise disturbance.

Another threat is discarded fishing line. In the early 2000s, biologists from the US Geological Survey and US Fish and Wildlife Service studied ospreys nesting in the Chesapeake Bay. They observed that many of the nests contained fishing line, kite string, balloon ribbon, and a host of other cordage materials. These materials can result in entanglement, often causing slow death or severe injuries such as limb amputation by constricting blood flow to the wings and leg. More recent surveys show a similar pattern. On several occasions, dead ospreys were entangled in fishing line or other cordage material, along with young chicks that had to be cut free.

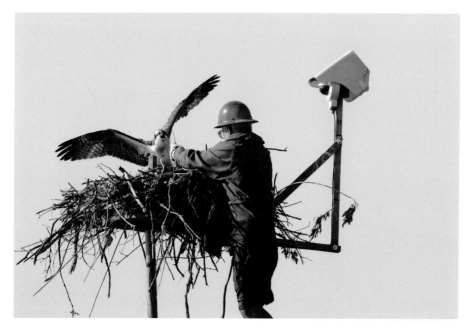

Richard Harrison removes discarded fishing line from an osprey chick tangled at the nest platform. *Courtesy of the Harrison family*

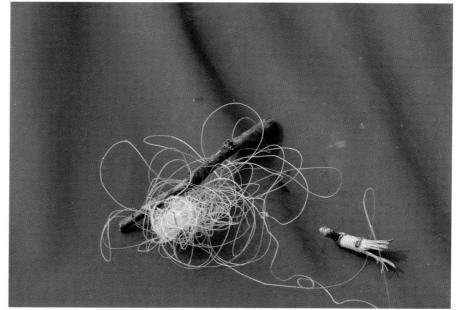

Wad of monofilament line cut from the chick's legs. *Courtesy of the Harrison family*

In 2004, the Chesapeake Bay Trust funded an outreach program that involved placing Angler Alert signs at public fishing and boating access areas in tidal waters of the Maryland portion of the Chesapeake Bay. In addition, the Maryland Department of Natural Resources handed out Angler Alert facts sheets with over-the-counter fishing licenses. The Angler Alert signs and facts sheets described the impacts of discarded fishing line and how to safely dispose of used line. With continued public education, harm to ospreys and other wildlife can be minimized.

—Peter C. McGowan, Environmental Contaminants Biologist/Poplar Island Wildlife Management Team, US Fish and Wildlife Service, Chesapeake Bay Field Office

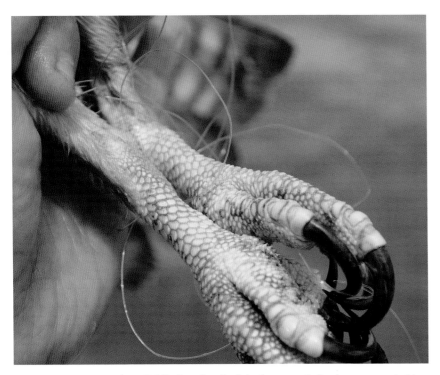

While foraging for fish, the osprey's feet became tangled in discarded fishing line. © *Craig A. Koppie*

Please properly discard unwanted fishing line.
Courtesy of the Harrison family

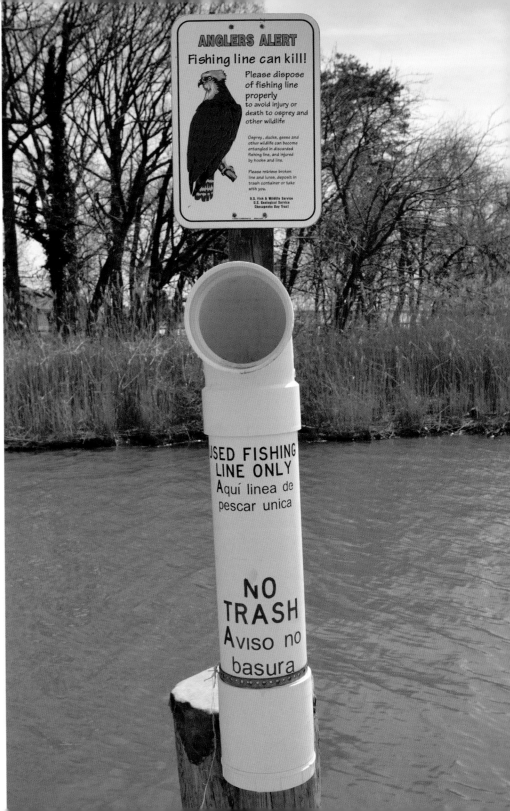

APPENDIX B: ABOUT THE OSPREY NEST

The story of our osprey camera began in 1989, when we moved to Kent Island, on the Eastern Shore of Maryland. Although the commute from our home to work in Washington, DC, was cumbersome, the chance to live on the water, and experience much of what Mother Nature had to offer was a tantalizing lure we were happy to grab. We couldn't help but notice the ospreys that were frequently flying behind our house and spending time on docks and nearby trees. We decided to erect an osprey pole in the water off our dock, and contacted the Chesapeake Wildlife Heritage for the installation. In March 1995, and we became the proud owners of a pole and nest platform located 143 feet away from our dock and 120 feet out in the water behind the house.

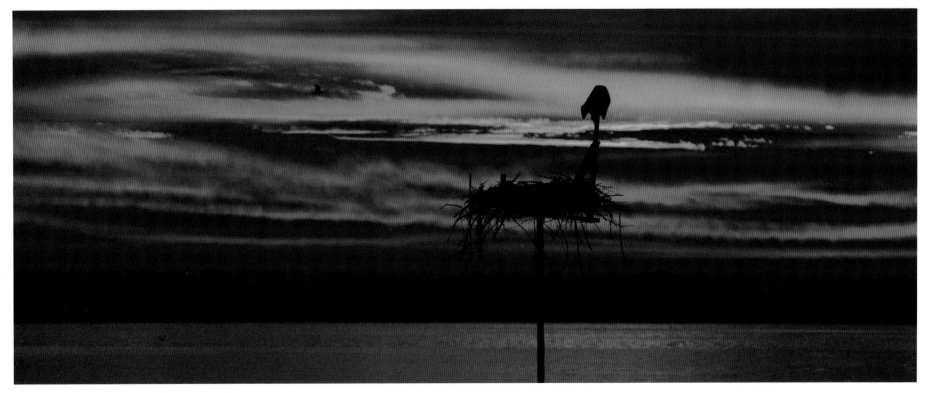

Sunrise at the nest. *Courtesy of the Harrison family*

Much to our delight, the day the pole went up, an osprey started checking out the new site. Nest building commenced two days later, and soon we were landlords to our first beautiful osprey pair. We named the birds Tom and Audrey after dear friends who are true lovers of the outdoors.

Many hours were spent that first osprey season observing the activity around the nest. In early June, there was much excitement when we saw the first little osprey head peeking above the nest. We ended up with two chicks that first year, named Thunder and Gulch after the 1995 winners of the Kentucky Derby and Belmont Stakes. Tom and Audrey continued to come back to our nest every spring and raised many chicks at their Kent Island home.

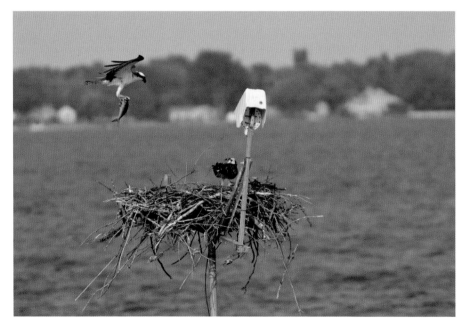

Another meal served. *Courtesy of the Harrison family*

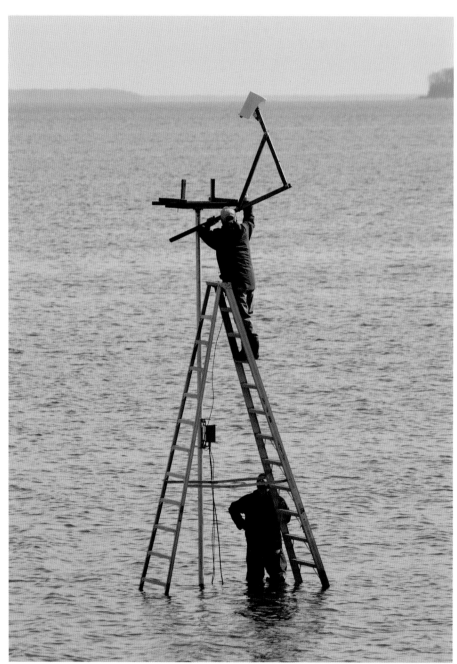

Webcam installation at the nest platform.
Courtesy of the Harrison family

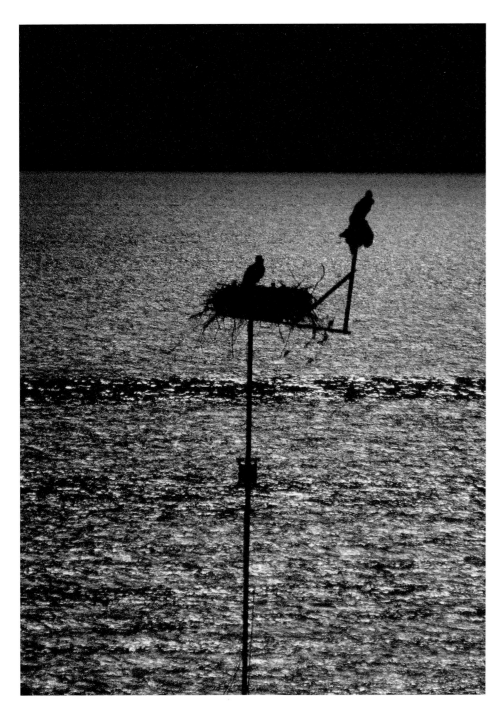

In early March 2002, before Tom and Audrey arrived back in Maryland from their winter residence somewhere in South America, we decided to install a video camera to observe the nest activity. We ran wire from inside the house, through a trench in the yard, and under the dock, to a garden hose at the bottom of a piling, then through the hose to the platform pole and up to the camera, which was perched on a wooden arm attached to the osprey platform.

Night osprey. *Courtesy of the Harrison family*

While all this was going on, Tom and Audrey had returned and were observing the activity from nearby trees and docks. Everything seemed to be going smoothly until the hose containing the wires floated to the surface of the water, as trapped air was not letting it sink to the bottom. So now we had a 143-foot "snake" writhing in the water under the nest platform. As eggs and nestlings are vulnerable to snakes, Tom and Audrey left and did not return that day or the next. We got some rebar and attached it to the floating hose with wire ties. The hose finally sank to the bottom, but Tom and Audrey did not seem interested in returning to the nest. We were sure our ospreys would never return, but fortunately they reappeared on the third day, and the rest, as they say, is history.

In early 2013, the Chesapeake Conservancy in Annapolis, Maryland, contacted us about expanding the camera capabilities. While researching the possibility of putting a camera on an eagle nest, they had been in touch with Earth Security, now part of Skyline Technology Solutions, who were helping us with our camera. Earth Security told the Chesapeake Conservancy folks about our private project. Around the same time, we were trying to figure out a way to share our camera with more viewers, particularly schools, but our computer capability limited how many viewers could watch at the same time. Discussions ensued with the Chesapeake Conservancy, and we formed a partnership that allowed thousands of new viewers to observe the daily lives of our osprey pair. With the arrival of a new camera and technical capabilities provided by the Chesapeake Conservancy, we began writing a blog that described the activities going on around the nest that could not be seen through the camera. We are currently at the end of our third season of partnership. The popularity of our osprey camera and blog has grown by leaps and bounds, and we expect viewer numbers to grow.

We want to thank Craig A. Koppie and Dr. Paul R. Spitzer for their expert assistance, Teena Ruark Gorrow for the opportunity to be part of this book, and the Chesapeake Conservancy for their partnership that has allowed so many to become a part of our osprey family. Most of all, we want to thank our daughter for putting up with her Crazy Osprey parents.

—The Harrison Family, October 11, 2015

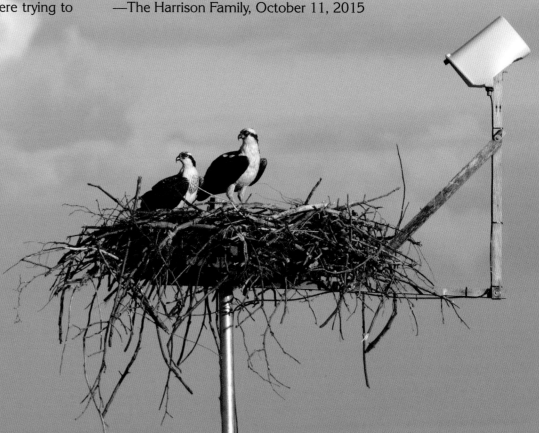

Courtesy of the Harrison family

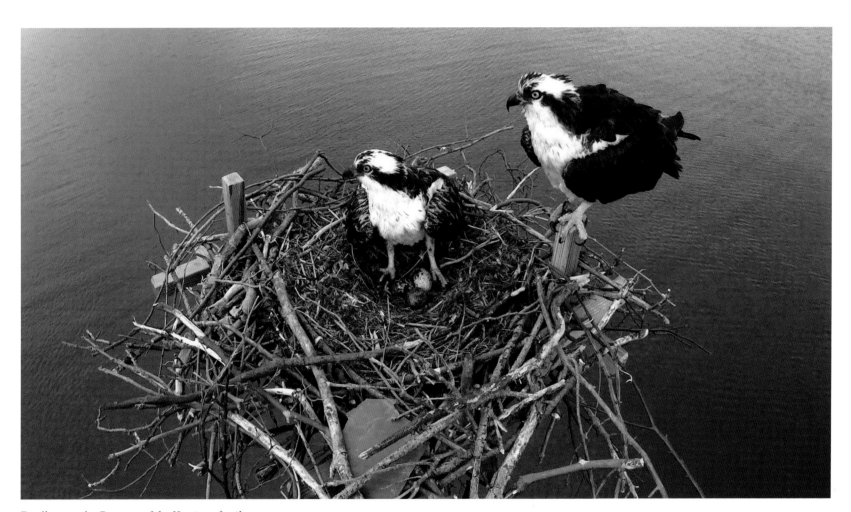

Family portrait. *Courtesy of the Harrison family*

APPENDIX C: ABOUT THE CHESAPEAKE CONSERVANCY

Chesapeake Conservancy is a nonprofit organization based in Annapolis, Maryland, dedicated to ensuring a healthier Chesapeake Bay watershed where fish and wildlife thrive and everyone enjoys healthy waters and abundant forests, wetlands, shorelines, and open spaces.

With the human population in the Chesapeake watershed approaching 18 million and growing, and with tens of thousands of acres of open space vanishing each year, the Chesapeake Conservancy works to connect people with its wildlife and history, conserve landscapes and rivers, and restore the region's natural resources.

The Chesapeake Conservancy serves as a catalyst for change, advancing strong public and private partnerships, developing and using new technology, and driving innovation throughout their work. From their founding, they have embraced the National Park Service's Captain John Smith Chesapeake National Historic Trail as an inspiration and framework for work in the region.

The Chesapeake Conservancy works in close partnership with the National Park Service Chesapeake Bay Office, the United States Fish and Wildlife Service, and other federal, state and local agencies, private foundations, and corporations to advance conservation.

Please visit www.chesapeakeconservancy.org to learn more about their achievements and their efforts to improve the health of the bay and its rivers. And consider joining the Chesapeake Conservancy's fight to preserve the integrity, stability, and beauty of our watershed, wildlife, and culture.

—Adapted with permission from the Chesapeake Conservancy

APPENDIX D: THE POPLAR ISLAND FOSTER PROGRAM

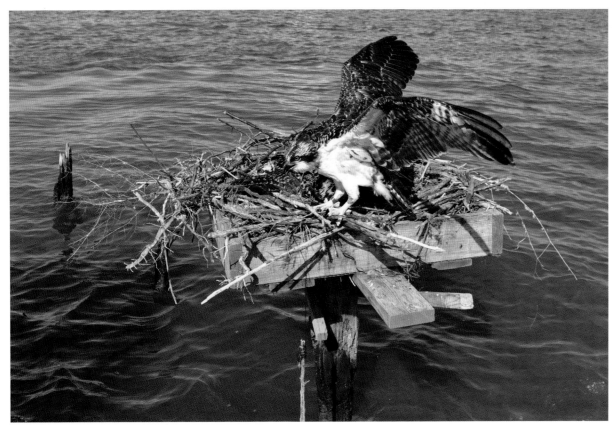

The remaining siblings at the Poplar Island nest also thrived.
© *Craig A. Koppie*

Each week during osprey nesting season in the Chesapeake Bay, US Fish and Wildlife biologists at the Paul S. Sarbanes Ecosystem Restoration Project at Poplar Island monitor all osprey nests on and near the island. As a result, biologists have an excellent database on the age and number of eggs and young in each nest at any given time, making Poplar Island an excellent site for fostering young ospreys.

During the past several years, Tri-State Bird Rescue and Research Inc., an internationally renowned wildlife rehabilitation facility, has worked closely with the US Fish and Wildlife Service to help locate appropriate foster nests for young ospreys that are injured, or whose nests were destroyed or abandoned. As a result of the Poplar Island osprey monitoring database, nests of the appropriate age can be immediately identified for any osprey young that need to be fostered, greatly improving their chances of survival. Between 2000 and 2015, more than twenty osprey young were successfully fostered at Poplar Island.

—Peter C. McGowan, Environmental Contaminants Biologist/Poplar Island Wildlife Management Team, US Fish and Wildlife Service, Chesapeake Bay Field Office

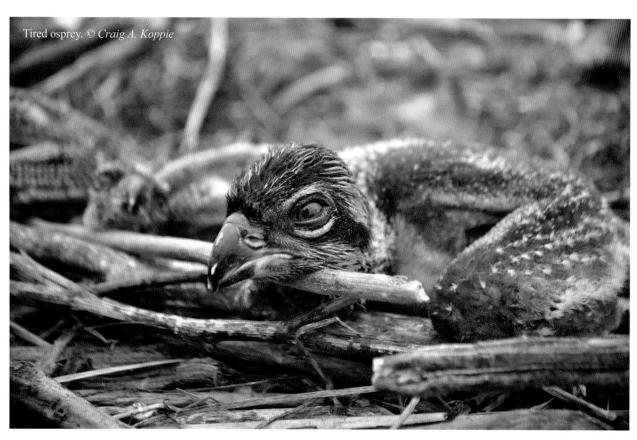

Tired osprey. © *Craig A. Koppie*

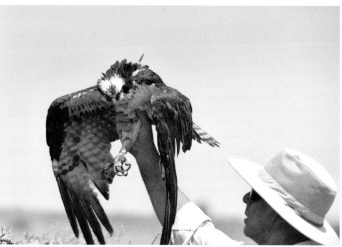

Peter McGowan releases an osprey with satellite telemetry. © *Craig A. Koppie*

APPENDIX E: GLOSSARY

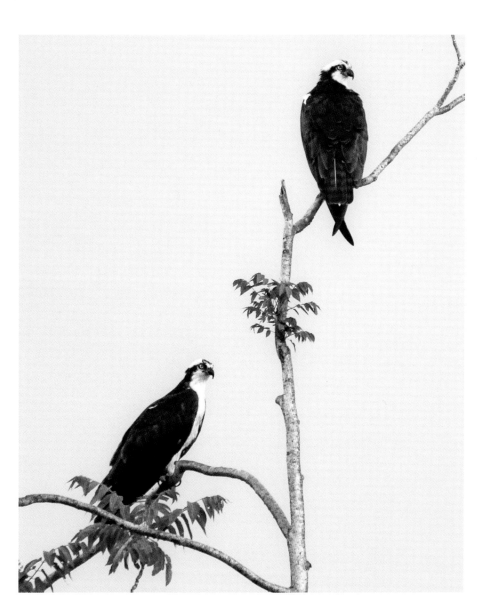

adult. An osprey at least five years old, usually identifiable by plumage patterns and color

aquatic. Being in the water

breed. To mate and reproduce

breeding season. The period during which a mated osprey pair prepares their nest, mates, lays eggs, and raises offspring

brood. The offspring from a single clutch of eggs

brood/brooding. The act performed by a parent osprey when using its body to warm, shade, or otherwise protect hatched offspring

channel marker. A navigational aid used by boaters to mark channels in bays or ocean inlets

chick. A young flightless osprey

clutch. A single set of eggs laid by a female osprey during nesting season

crest. Protruding head feathers

crop. An area between the neck and stomach where food is stored after consumption

down. The soft, fuzzy plumage on chicks

Picture perfect. © *Teena Ruark Gorrow*

egg cup. The soft cup formed inside the nest by parent ospreys where eggs are laid

egg tooth. The hard point near the tip of a young osprey's beak used during hatching to crack out of its shell

estuary. A body of water in which salt (tidal) and fresh water mix

first flight. An osprey's first attempt flying away from the nest

fledge/fledgling. An osprey that successfully experiences first flight and returns to its nest

food-begging. Communicating through calls for food

forage. To search for food

foster. To serve as adoptive parents and rear offspring

glide. To fly in a smooth, even manner with outstretched wings and little apparent movement

habitat. An osprey's natural living environment

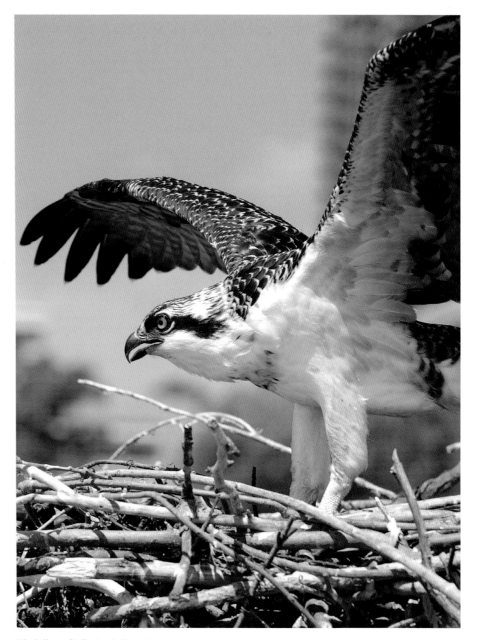

Fledgling. © *Craig A. Koppie*

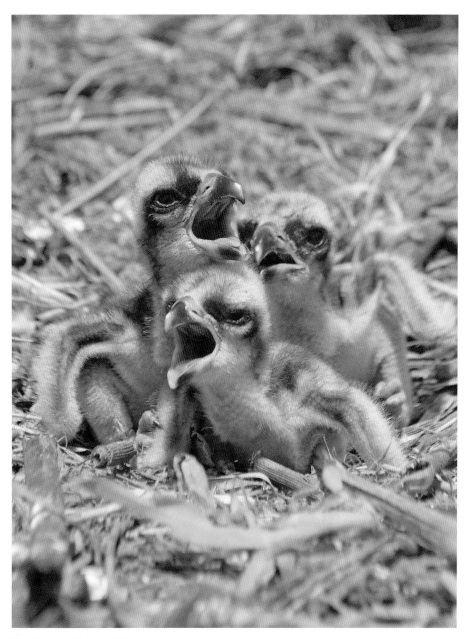

Nestlings. © *Craig A. Koppie*

hatching. A process during which an osprey fractures its shell and becomes free from the egg

hatchling. A recently hatched osprey; a newborn osprey baby

incubate. To apply body heat while sitting on a clutch of eggs

interloper. Intruder

juvenile. A young osprey, under one year old, that is experienced with flight and living away from the nest

malar stripe. Black line of feathers on each side of an osprey's head near the cheek and through the eye area

mantling. An attempt to hide a meal by hunching the shoulders and spreading the wings and/or tail over the food

migrate. Moving seasonally between regions

nares. Nostrils on the upper beak

nest. A structure consisting of sticks and soft lining prepared by a mated osprey pair for laying eggs and raising offspring

nestling. An osprey incapable of flight and confined to its nest; not yet able to fly

nesting season. The period during which a mated osprey pair prepares their nest, mates, lays eggs, and raises offspring

nictitating membrane. A clear, thin layer of tissue that slides over the eye for protection

offspring. The young osprey(s) produced by a mated osprey pair

perch. To rest, sit, forage, or stand watch from a high limb during daylight

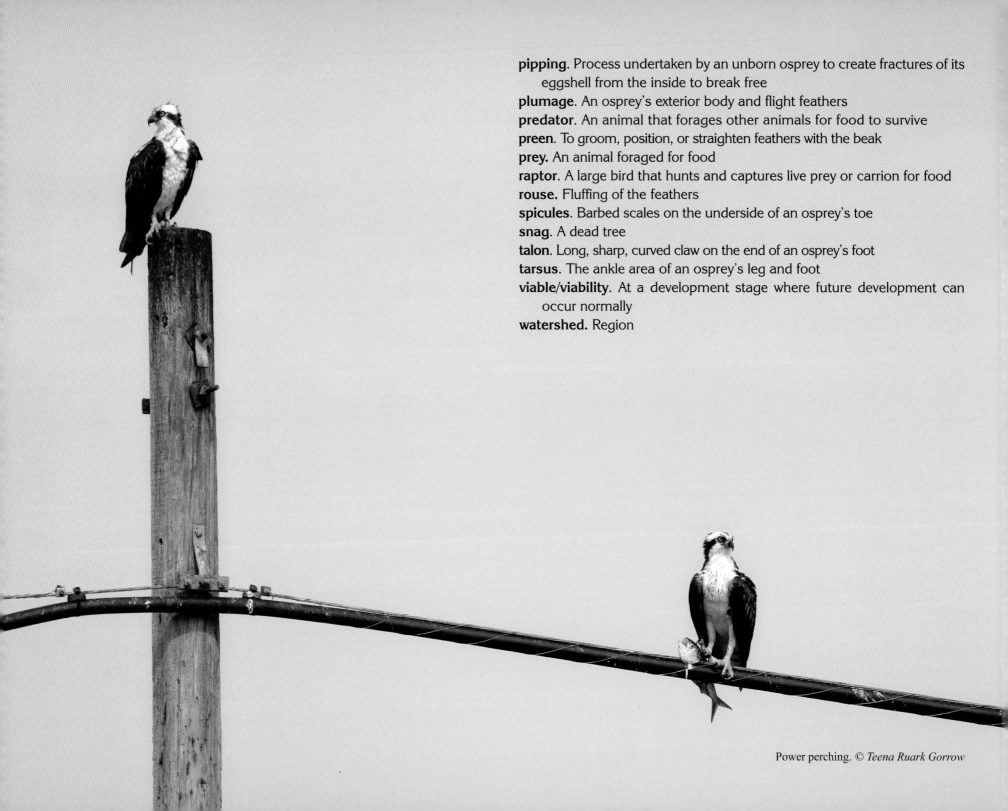

pipping. Process undertaken by an unborn osprey to create fractures of its eggshell from the inside to break free

plumage. An osprey's exterior body and flight feathers

predator. An animal that forages other animals for food to survive

preen. To groom, position, or straighten feathers with the beak

prey. An animal foraged for food

raptor. A large bird that hunts and captures live prey or carrion for food

rouse. Fluffing of the feathers

spicules. Barbed scales on the underside of an osprey's toe

snag. A dead tree

talon. Long, sharp, curved claw on the end of an osprey's foot

tarsus. The ankle area of an osprey's leg and foot

viable/viability. At a development stage where future development can occur normally

watershed. Region

Power perching. © *Teena Ruark Gorrow*

APPENDIX F: RESOURCES

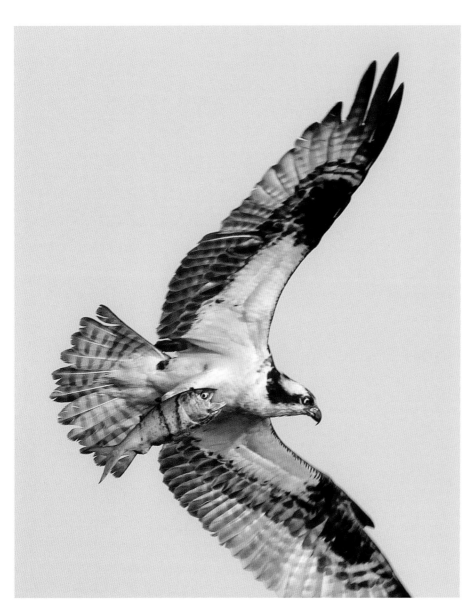

If you are interested in learning more about ospreys and other migratory birds, a wealth of resources can be found through avian organizations, at national wildlife refuges, and by searching the internet. Links to general osprey information, bird protection, bird banding, and citizen involvement are listed below:

US Fish and Wildlife Service Chesapeake Bay Field Office
Osprey
http://www.fws.gov/chesapeakebay/osprey.html

US Fish and Wildlife Service Migratory Bird Program
FAQs/Commonly Asked Questions
http://www.fws.gov/birds/faqs.php

Digest of Federal Resource Laws of Interest to the US Fish and Wildlife Service
Migratory Bird Treaty Act of 1918
http://www.fws.gov/laws/lawsdigest/migtrea.html

Migratory Bird Treaty Act: Birds Protected
http://www.fws.gov/birds/policies-and-regulations/laws-legislations/migratory-bird-treaty-act.php

Bird Banding
http://www.fws.gov/birds/surveys-and-data/bird-banding.php

Citizen Science
http://www.fws.gov/birds/get-involved/citizen-science.php

Angler. © *Teena Ruark Gorrow*

If You Find an Injured or Orphaned Bird

It is illegal to keep a migratory bird without proper permits. If you find an injured or orphaned bird, please call your veterinarian, a local wildlife agency, or the humane society for help. Injured and orphaned birds usually need professional care to survive and ultimately be returned to natural habitat.

Meanwhile, place the bird in a dark box with air holes. Keep the box in a safe spot away from noise and activity. Do not feed or handle the bird.

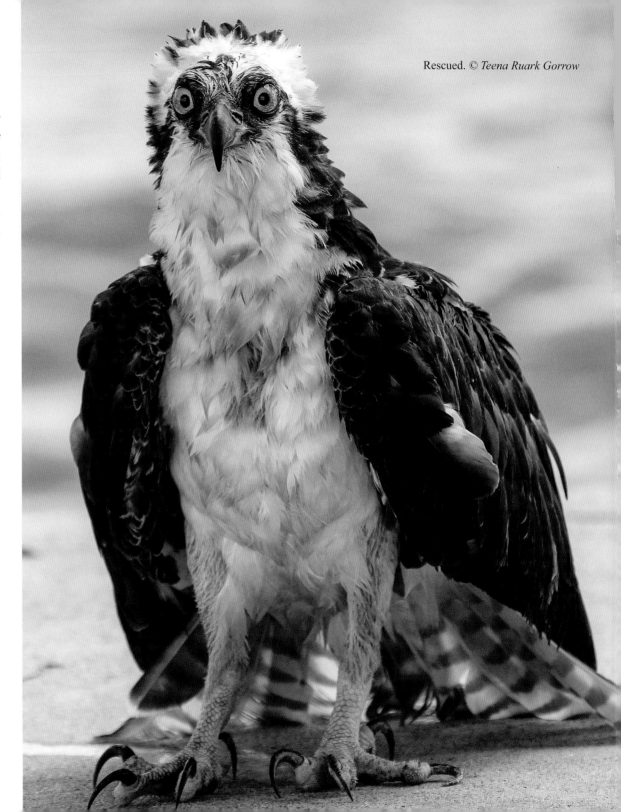

Rescued. © *Teena Ruark Gorrow*

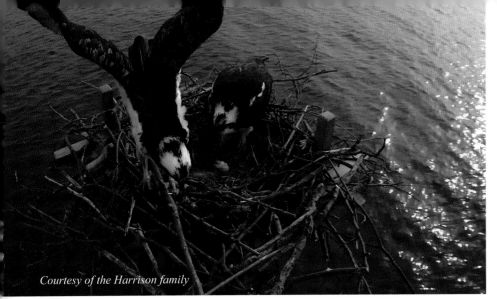

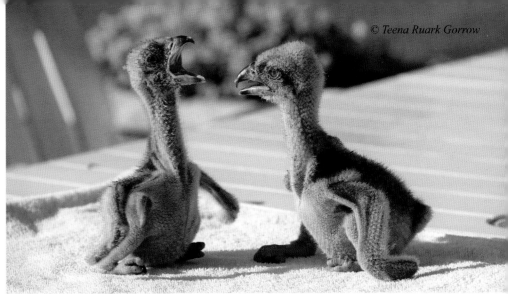

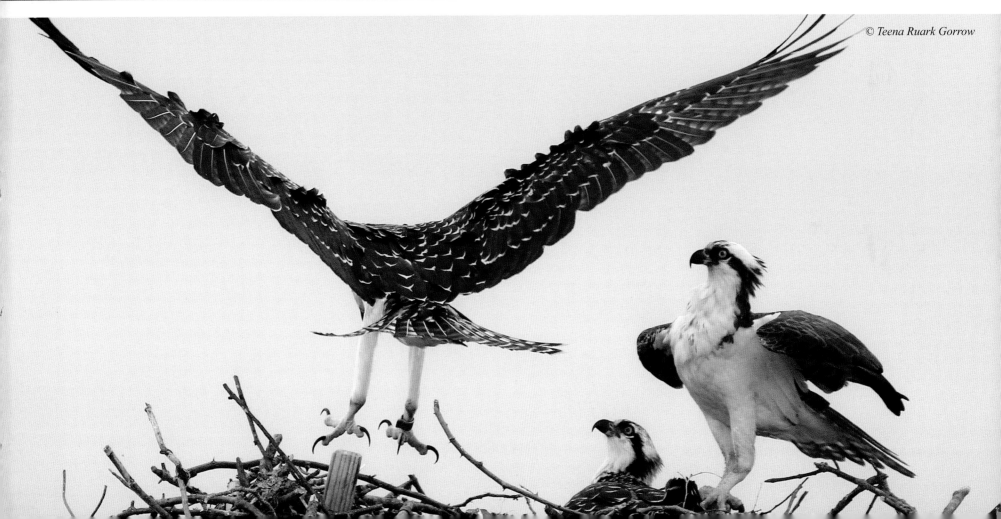

MORE *INSIDE THE NEST*
by Gorrow and Koppie

"Children learn from the stories we tell them. In their book *Inside a Bald Eagle's Nest: A Photographic Journey through the American Bald Eagle Nesting Season*, Teena Ruark Gorrow and Craig A. Koppie give an intimate glimpse of majestic eagles that awakens in our youth their natural affinity to protect our planet and all its inhabitants. We proudly bestowed the **2014 National Green Earth Book Award** to Teena and Craig for stirring our children's curiosity and inspiring environmental stewardship through the beautifully written text and compelling photographs. We are thrilled that they continue to write books that inspire our next generation."

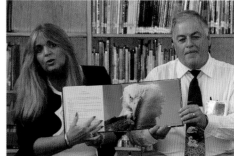

Teena Ruark Gorrow is a university professor of teacher education and Craig A. Koppie is a raptor biologist. Both are wildlife photographers. *Courtesy of Wayne Dennis Gorrow*

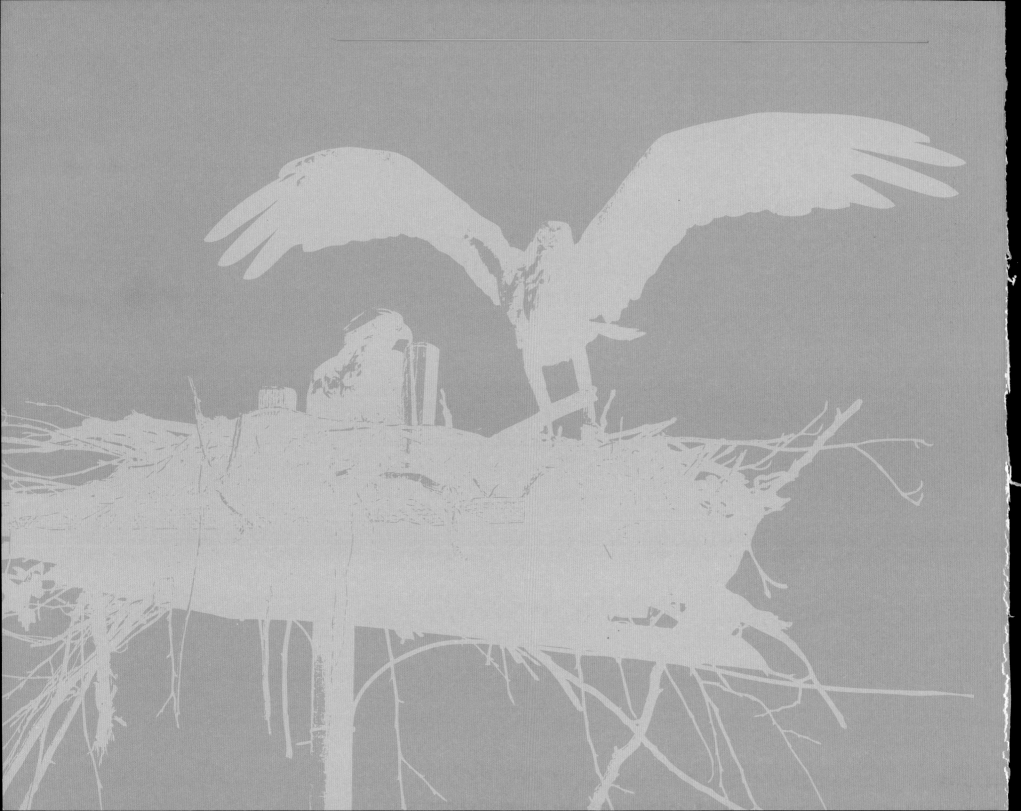